SMOKE FIRING

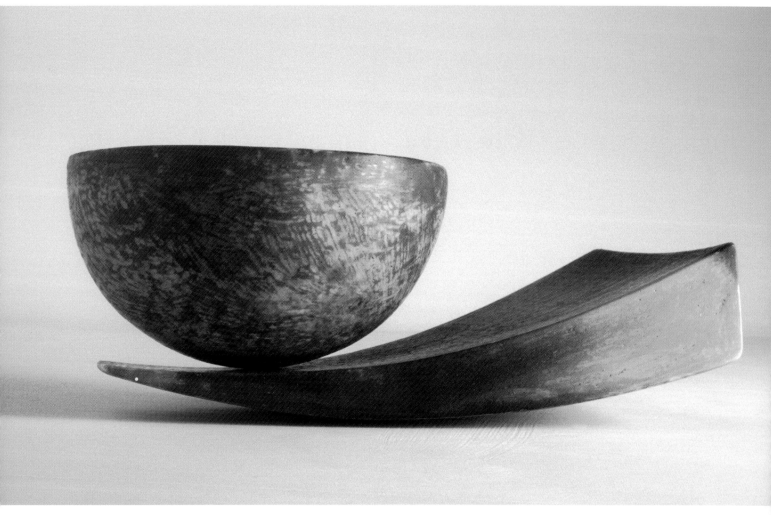

Jane Perryman, **Balancing Forms**. Length: 28 cm (11in). *Photo: Graham Murrell*

The firing was not a kiln at all. It was burning sticks! The fire was covered with ash so that the flame did not heat and smoke was made. It was the fact that there was not access of much air that caused the pots to become black. It rather depended on the will of the wind and the will of the fire.

(Bernard Leach describing his impression of Maria Martinez blackfiring in an open bonfire at San Ildefonso Pueblo near Sante Fe in 1952, from the introduction to *The Living Tradition of Maria Martinez* by Susan Peterson, published by Kodansha International Ltd, 1977.)

SMOKE FIRING

Contemporary artists and approaches

Jane Perryman

A&C BLACK · LONDON

UNIVERSITY OF PENNSYLVANIA PRESS · PHILADELPHIA

First published in Great Britian 2008
A&C Black (publishers) Limited
Alderman House
38 Soho Square
London WID 3HB
www.acblack.com

ISBN 978-0-7136-6985-5

Published simultaneously in the USA by
University of Pennsylvania Press
3905 Spruce Street
Philadelphia, Pennsylvania 19104-4112
www.upenn.edu/pennpress

ISBN 978-0-8122-4089-4

Book design: Mala Hassett
Cover design: James Watson

FRONT COVER (FRONT): **Blackfired Vessel**, by Jane Perryman. Height:
40 cm (16 in). *Photo: Graham Murrell*
BACK COVER (TOP): The pit-firing at Dillons Beach, northern California.
Photo: Jane Perryman
(BOTTOM): Installation of vessels by Jane Perryman. Height: 15 cm (6 in)
(each piece).
INSIDE FLAP: Potters' group at Dillons Beach, northern California, lighting
the fire. *Photo: Jane Burton*

For my father, who gave me his hands,
and Kevin, who showed me the way.

CONTENTS

PREFACE

It is eleven years since *Smoke-fired Pottery* was first published, in 1995, and at the time I wondered what the response would be. Blackening the porous unglazed ceramic surface with smoke was still a fairly innovative approach to working with clay and fire in the UK. Any awareness of smoke firing was mostly through its connections with ancient pottery, and its continued practice within the indigenous communities of Africa and America, but its use in contemporary ceramics was still fairly uncommon. I think it struck a chord with readers because of its technological simplicity and its contrast to the Leach tradition of high-fired stoneware and porcelain.

A few years ago I was asked to write a new edition, which has turned into a completely new book called *Smoke Firing: Contemporary Artists and Approaches*. This introduces the work of twenty-nine ceramicists who use smoke firing in different ways to express their art. As far as possible, I made personal visits to studios or arranged meetings with the artists to understand their development and ideas more fully. I have presented some of the original ceramicists again to investigate their development, but most of the artists are new to this book, and some of their techniques have surprised me. For example, Ellen Schopf from Germany has developed an effective low-temperature smoke firing (380°C/716°F) in her electric kiln with common kitchen ingredients such as oats and poppy seeds. Sadly, Pierre Bayle and Siddig El'Nigoumi have died since the original book was published, but their contribution to the development of smoke firing has been crucial, so I have included them again. It has been a pleasure to present several new ceramicists who were introduced to smoke firing through the original book and have since developed their own style.

Smoke firing is risky, messy and unpredictable. The results can lead to intense joy or disappointment, but in the end it is the element of not being in control that generates the sense of anticipation. It is waiting to see what the fire has given. Although the techniques are simple, success depends on years of patient experimentation and observation; of trial and error and the acceptance of failure as a tool for learning. There is no right or wrong approach and no correct outcome. You need to break the rules to discover new possibilities.

The material has been divided up into nine chapters. The first two explore the significance of smoke firing in antiquity and its continued use in traditional societies today such as those in Nigeria, India and America. Chapters 3, 4 and 5 present some of the smoke-firing techniques which can be carried out without the necessity of a kiln, including open firing, pit firing and firing in a simple improvised container. Chapters 6, 7 and 8 are concerned with saggar firing (which requires the controlled temperature within a kiln to achieve its specific qualities), smoke firing directly inside the kiln or post-raku firing. Because smoke firing is inexpensive, requires minimal equipment, uses renewable energy sources, and is adaptable and mobile, it is particularly suitable for educational or recreational groups. I have included a small section called 'Smoke Firing in Groups' with examples of various techniques and situations.

The global community of ceramicists represented here is from seventeen different countries, expressing diverse cultural influences. They employ a wide range of making and firing techniques, subject matter and context – including work that is figurative, conceptual, vessel-based, abstract, sculptural and installation-based. Their concepts range from the overtly political, as in the anti-war murals of Richard Notkin, to personal healing, as in the work of Pao Fei Yang, whose work symbolises her journey to recovery after a serious car accident. What unites them, whether they love it or dread it, is a commitment to using smoke firing as a creative tool to express ideas. Magdalene Odundo talks of being a nervous wreck during her saggar firing; others, like

Giovanni Cimatti (who has invented his own post-raku technique, called raku dolce), are passionate about the firing and view it as an enjoyable performance.

It has been difficult to make a selection of work to be covered. The publishing constraints of space and time prevented me from including several interesting variations – both in the background and amongst the ceramic artists included. The research for *Smoke Firing: Contemporary Artists and Approaches* took me on many journeys to different parts of the world, and it has been both a privilege and an education to meet the artists and discover their work.

Black-fired Vessel. Diameter: 32 cm (12½ in). *Photo: Graham Murrell*

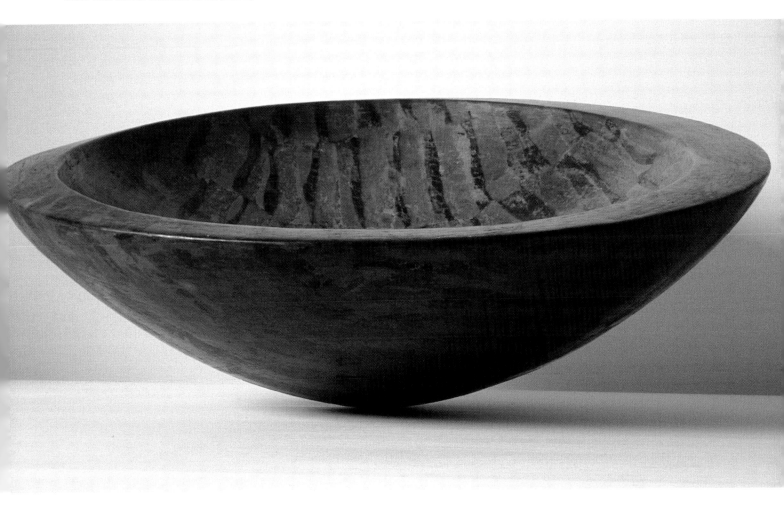

FOREWORD

Pottery is a deceptively simple art: dig up some clay from a river bank or from a cutting at the side of a road, fashion a shape, then, when the piece is dry, place it in a bonfire and keep adding sticks to the blaze until the clay has sintered enough to make it permanent. This action of fire on clay is the basis of all pottery and gives us the meaning of the word 'ceramics'. Smoke-fired pottery is at once the earliest form of ceramics and one of the most apparently simple to execute. The techniques of smoke-fired pottery are, however, capable of considerable refinement and artistic expression, as Jane Perryman describes in this book.

Gathering together the expertise of nearly 30 artists who use the methods of smoke-fired pottery, both with and without recourse to kilns, the author gives us a broad perspective on the possibilities of smoke firing to achieve a multitude of contemporary approaches and results. Many of the artists she has chosen are well known and it is of interest to learn more about their particular methods. Other artists are introduced for the first time to many of us and bring extra dimensions to our knowledge of the world of ceramics. Perryman's research has been extensive and we can learn details of processes as well as the background of the artists as they bring original thought to their work. Jimmy Clark, from the US, for example, finds a sense of history coming alive in his vessels, with he, as the artist, being just one of the three integral elements, along with the materials and the fire, that combine together to create the work. Perryman herself, has investigated many of the nuances of smoke firing, enjoys the limitations that the technique requires, focuses on the creative aspects of smoke firing and discovers the subtleties and combinations of decorative ideas. Her resulting works are gradually becoming more sculptural, incorporating balance, tension and dynamics. From Sweden, Eva Marie Kothe finds the techniques of smoke firing an ideal introduction to teaching, discovering at the same time a way of representing her own ideas. Smoke firing, with its natural and intimate ways of working with clay, has brought Kothe rewards to her artistic expression as well. But these are just three of the artists Perryman has chosen to include and the reader will be rewarded by reading all of the artists' stories.

The inclusion of technical notes by some of the artists will extend the value of the book to aspiring smoke-fire potters and offers a basis for experimentation and further research. The preparation of terra sigillata, a traditional coating of liquid clay slip, is outlined by Duncan Ross, UK, and the late Pierre Bayle, France, while photographs of firing methods are to be found throughout the book. From the studios of Munemi Yorigami in Japan, and Giovanni Cimatti in Faenza, Italy, Perryman's research demonstrates we can find much to learn, not only about smoke-firing methods but about culture as well. It also shows that the interest in smoke firing is world-wide.

The origins of smoke firing in antiquity and the traditional methods of smoke firing in India, a subject in which Perryman is an acknowledged expert, being the author of a book on Indian ceramics, continue to inspire potters throughout the world. A potter becomes an archaeologist, an anthropologist, a chemist and a combustion engineer through the investigation of ceramic art. With this study of ancient and contemporary ceramics, a potter can take particular methods, materials and ideas and make a contribution to the world of art and a satisfying and fulfilling life for him or herself at the same time. This book by Jane Perryman shows how.

Janet Mansfield, 2008.
(Editor of Ceramic Art & Perception)

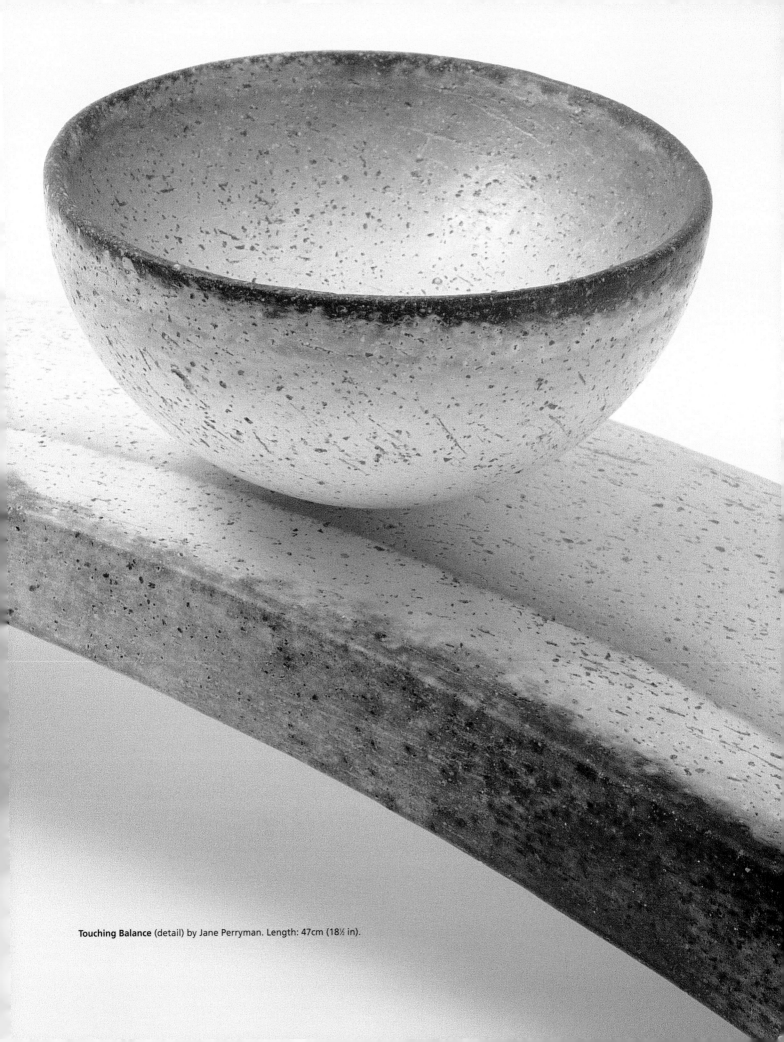

Touching Balance (detail) by Jane Perryman. Length: 47cm (18½ in).

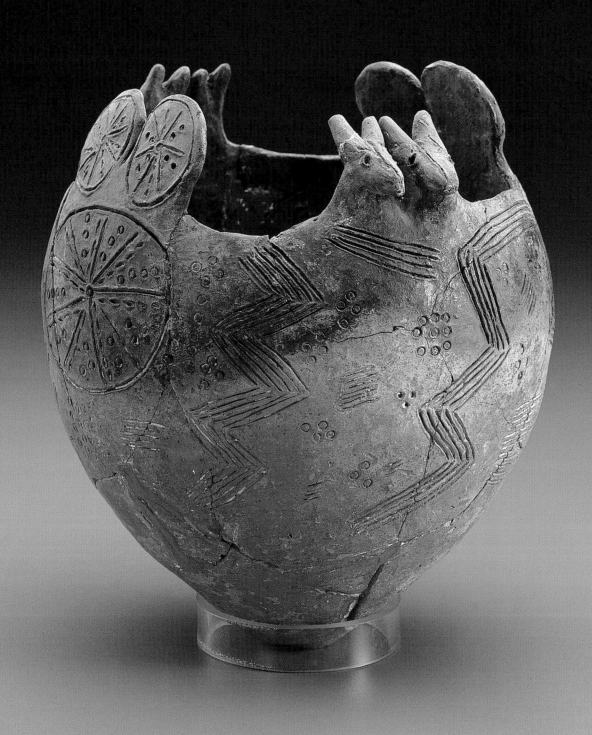

1 AN INTRODUCTION TO SMOKE FIRING

The archaeologist Stefania Cassini has said: 'The ancient and modern are often joined by a thread which is impossible to cut – the thread of technological evolution. One can follow it backwards, as does the archaeologist with his research, but one can also retrace the voyage from its starting point, or through investigating the technique itself, as anyone does when trying out earlier methods.

In both cases we discover that the time that separates us from antiquity has contributed to the forgetting of many techniques, behind which there were deep observations and tests, and successful or failed trials – all decisive steps along the line of technological progress. The secrets of today's ceramics are a common heritage only within non-industrialised cultures, where there still exist people who produce pots by hand. In societies where everything is delegated to industrial production, this type of knowledge is only available to those who undertake individual research.

Ceramics in the wide sense is part of our daily lives, and the contact so continuous and undervalued that we are almost unaware of its presence. But to dismiss it as something unworthy of note, to be taken for granted in everyday life, would be like ceasing to believe any longer in the miracle of the transformation of matter, which from the solid becomes fluid, then plastic, and with the effect of fire finally hard again and unalterable.'[1]

SMOKE FIRING IN ANTIQUITY

The use of clay was developed independently by peoples living in different parts of the world. It might have been originally used in its raw state as a material for strengthening shelters or for tribal identification marks. From early times, symbolic figures of men, women and animals were modelled in clay as part of the magic and religious rituals concerned with everyday life and fertility. Fragile

Cult vessel with animal heads. Red/Blackware from Vousnous, Ancient Cyprus. Height: 15.8 cm (6¼ in).
Museum of Archaeology and Anthropology, Cambridge.

pottery would not have been practical for nomadic peoples, and it was not until the New Stone Age that the making of pots started. These pots were not only easy to make and light to carry but also useful for cooking and storing food. They also performed an important role as ritual objects accompanying the dead during their afterlife. Moreover, the making of pottery vessels began to provide an important means of artistic expression through the treatment of shape and surface, as well as fulfilling strictly functional purposes.

According to present knowledge, the earliest known pottery, called Jomon ware, was made in 10,000BC in Japan. Early pottery was constructed by handbuilding techniques of coiling and paddling, which required the minimum amount of tools. Decorative effects could be achieved by applying simple designs with coloured clays and pigments, or by scratching and impressing the clay surface to create a relief effect. Burnishing or polishing was widely used to give a smooth shiny appearance and to partially seal the porous surface. The work was fired in the open and sometimes carbonised or black fired to achieve colour contrast.

Early examples of the use of smoke firing can be seen in the work of the Predynastic Egyptian and Sudanese potters (*c.*3500BC), who worked with Nile alluvial clay, which fired a reddish colour in an oxidising atmosphere. They created colour contrasts of red and black by developing their black-topped, red-burnished ware. It is generally thought that black-topped pottery developed either as an accident or in imitation of black-rimmed gourd cups – after the gourd had been cut the edge was burnt to make it smooth. However, recent research has shown that there is a difference in porosity between the black and red parts of the pot, and since the insides were usually black, the practice may well have been functional.[2] Predynastic kilns were rare, consisting of little more than an enclosed wall made of mud bricks, and theories vary as to how the potters achieved local carbonisation. One is that the pots were fired upside down with their rims (and insides) buried in a combustible material like

powdered animal dung or pulverised bark; this would produce a smoky blackening fire where the rims were submerged, but also a clean oxidised fire above. Another was that the vessels were fired upside down, their rims embedded in a mixture of carbon and ash which would have accumulated on the floor of the simple kiln after multi-firings.

Other examples of smoke firing can be found in the Early Bronze Age in ancient Cyprus (c.2500BC). This period was dominated by red polished pottery, with many variations including Red-/Blackware, where surfaces show a combination of oxidised and reduced colouring, resulting in black and red areas of different proportions. Sometimes the switch from red to black occurred halfway up the vessel, or inside a bowl; sometimes the whole piece was blackened. This pottery was covered with a red slip and then burnished (that is, rubbed with a hard, smooth object such as a pebble) to produce a high polish. Abstract patterns of incised lines were sometimes cut into the clay and filled with a lime 'whitener' to give contrast. It is thought that the vessel's black, smoked surface was achieved either by removing it from the firing and immediately rubbing it with grass, or by surrounding it with grass, setting this on fire and then covering it with a layer of dung.

Over the centuries pottery technology improved: simple kilns evolved from open firing, which in turn gave way to more sophisticated and higher-firing kilns. More control over temperature and atmosphere gave rise to new methods of decoration; glaze enabled pots to be made waterproof and more durable. In some parts of the world, however, pots are being made today which are not dissimilar in technique and general appearance to those made many millennia ago.

TRADITIONAL FIRING TECHNOLOGY

The transformation of clay into ceramic, with its qualities of hardness, porosity and stability, requires a temperature of 600°C (1112°F). Rate of temperature rise, final temperature and atmosphere (governed by the amount of air provided to burn the available fuel) are the variables which affect the firing. The terms 'oxidising', 'reducing' and 'neutral' describe whether there is an excess of oxygen, carbon monoxide or carbon dioxide surrounding the pots. An excess of air creates oxidising conditions; insufficient air allows carbon monoxide to form, creating reducing conditions; and a ratio of air to fuel that allows complete combustion creates neutral conditions. Smoked or carbonised ceramics are the result of carbon becoming trapped in the clay body, where the fire draws oxygen from the clay to assist combustion. In open firing the pot can be covered with an organic smouldering material to achieve this state; in kiln firing, smoking can be achieved by introducing a fuel into the firebox and preventing access of air. Either of these techniques leads to 'blackness'. Fuels used for traditional firing are agricultural and industrial waste. Depending on the geographical area, these could be straw, dung cakes, grapevine cuttings, grain stalks, cotton branches, flax straw, bean husks, sugar-cane pulp, oilseed pulp, olive-pressing pulp, sawdust, coconut fronds and husks or rubber tyres, to name but a few. Agricultural waste as a fuel has the advantage of being replenished annually, whereas wood can become a depleted resource.

Open-firing methods are still being used by traditional potters in many parts of the world, including India, Pakistan, South-east Asia, Africa, South America and North America. Some of these potters live in areas of low technology, and some live and work alongside developed or developing technology in both rural and urban locations. The kind of expertise required to make pottery from locally dug clays using handbuilding techniques with very few tools, and firing in the open or in simple kilns, cannot be learned in a lifetime but is handed on from one generation to another. Raw materials are dug directly from the earth, and clay temper such as ash, pulverised horse manure, sand or rice husk is added. The addition of temper will help to alleviate the effects of thermal shock brought on by the dramatic temperature differentials that occur during firing and cooling. The design of vessel shapes has evolved over many millennia, combining function, economy of materials and labour as well as the crucial consideration of damage limitation during firing and cooling. Through this process of continual refinement a stage is reached where no further improvement is possible. The British pioneer potter Michael Cardew observed that it was the 'cutting-out of the irrelevant which makes pottery not less but more expressive'.

OPEN FIRING
(vessels and fuel are set together)

Traditional pottery production is seasonal and weather-dependent – dry weather and sunshine are needed for drying and firing. Although open firing requires little or no building of structures, great expertise and observational skills are needed to achieve successful results. It is full of hazards – a sudden wind or unseasonal rain can be disastrous and cause ruin to months of work. The art historian Moira Vincentelli has said,

'The advantages of kiln over open or pit firing are often exaggerated. Most simple kilns are designed to fire with wood, whereas bonfires burn for a short period with many different fuels, including some that do not deplete the world of precious natural resources. Very little research has been undertaken on the differences, and the comparisons are made within too narrow a focus. A simple kiln does not necessarily fire at a temperature much higher than a bonfire. The problem is that the only people who are experienced in open firing are traditional potters, who do not write books or teach in colleges. In Bourdieu's terms they do not possess the cultural capital to influence systems of knowledge.[3] Their knowledge is limited to their own experience and particular conditions. Archaeologists, ethnographers and the odd studio potter who have experimented with the technique cannot hope to have the same kind of expertise.'[4]

In mountainous areas such as the Himalayas where the weather is unpredictable, potters can vary the size of the pile from a few hundred to as many as fifteen hundred pots so that smaller piles can be fired quickly in between rain showers. Preheating the pots before firing eliminates free moisture from the clay, limiting the effects

An open firing in the lower Himalayan area of the Kangra Valley, Himachal Pradesh, India. *Photo: Jane Perryman.*

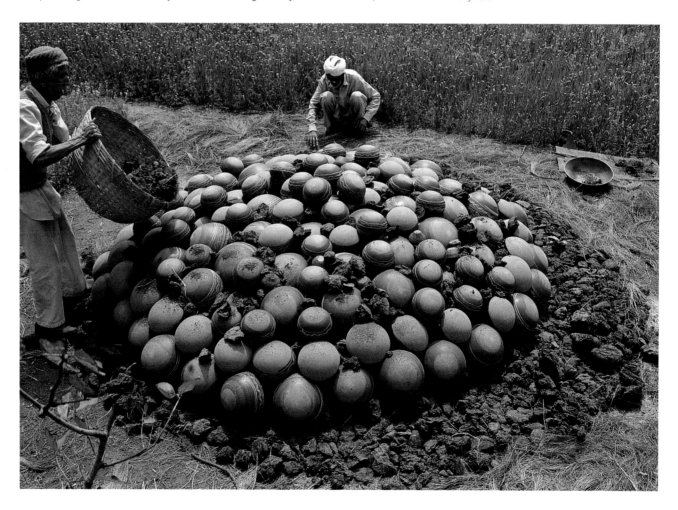

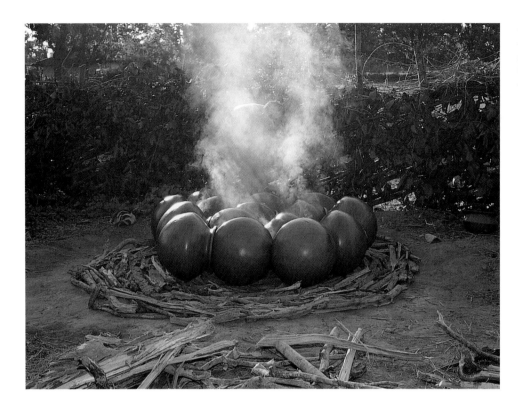

Preheating the pots before open firing limits the effects of thermal shock. Bastar region, Madhya Pradesh, India.
Photo: Jane Perryman.

of thermal shock; in Himachal Pradesh in northern India, lumps of burning buffalo dung are placed inside each pot, and in Tamil Nadu (southern India) the raw pottery is exposed to the hot midday sun so as to partially bake it prior to firing. The arrangement of pots within the pile is also crucial, for as the fuel burns away, vessels are exposed to cool air and the sudden drop in temperature can cause cracking. Placing them upside down means the rim heats up more slowly and is insulated by ash and embers during the cooling period. Thin-walled vessels favoured by traditional potters suffer less thermal stress and also have the advantage of being lighter to carry and requiring less raw material to make.

Pots and fuel are carefully placed together and covered with a layer of non-combustible insulating material such as shards, ash, wet grass or mud to conserve the heat. If holes are left in the covering, air can flow in underneath, up through the setting and out of these 'flues' so that more heat is captured. Circulation can be improved by placing fuel and vessels on shards or stones set far enough apart to encourage air to flow between them and up into the firing. More fuel can be stoked into these gaps to ensure even temperatures throughout. Some degree of temperature control can be achieved by adding or rearranging fuel. Buffalo and cow dung burn slowly and

uniformly so that the temperature rise is gradual, while grass, straw and twigs burn quickly, causing a rapid temperature rise. Temperature is monitored by observing the colour of the fire or the colour of the pots (a night-time firing can make this easier), and varies between 700°C and 1000°C (1292–1832°F). It is virtually impossible to maintain a true oxidising atmosphere throughout an open firing, which is why the pottery often has characteristic black 'fire marks'. These fire-marked pots may have inspired Western potters but are usually considered of less value than completely oxidised or completely blackened ware, which sells for a higher price in the marketplace.

There are several variations on open 'bonfire' firing, where the vessels and fuel are fired together. Pit firing, for instance, is well suited to black or smoked pottery; firing in a depression means it is easier to exclude air and produce a reducing atmosphere. In clamp firing, the pots and fuel are enclosed by piling earth, dung or vegetable matter on the burning heap. Black pottery can also be produced by placing fuel and pots inside larger sealed vessels.

TRANSITIONAL KILN FIRING
(vessels and fuel contained together)

Kilns where vessels and fuel are placed together represent a transitional stage between open firing and sophisticated up-draught and down-draught kilns. In these cases, a permanent structure is built which often has a circular wall or a three- or four-sided enclosure. The air and access may be provided by holes in the walls near ground level and through passages left while arranging the fuel and pots. Such structures allow the pile of vessels and fuel to rest against the walls, which conserves heat during firing and gives a measure of permanence to the firing procedure. This method represents an intermediate stage between open firing and kilns.

Notes

1 From a text by Stefania Cassini, Director of Archaeology at Bergamo Civic Museum, Italy, for the catalogue *Dialogues with Antiquity in the Ceramic Art of Giovanni Cimatti*, 2004. Translated by Ana Fitzpatrick.

2 Stan Hendrickx, Renee Friedman & Fabienne Loyens, *Experimental Archaeology concerning Black-Topped Pottery from Ancient Egypt and the Sudan* (Institut Français D'Archeologie Orientale, 2000).

3 Pierre Bourdieu, *Outline of a Theory and Practice* (Cambridge University Press, 1977).

4 Moira Vincentelli, *Women Potters, Transforming Traditions* (A & C Black, 2003).

A transitional kiln in Tamil Nadu. *Photo: Jane Perryman.*

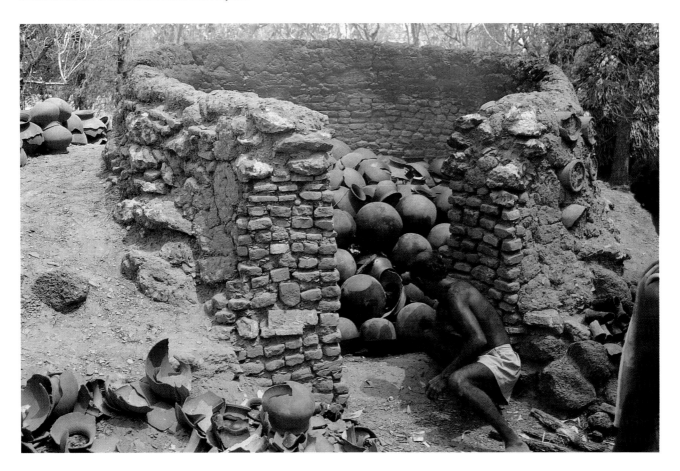

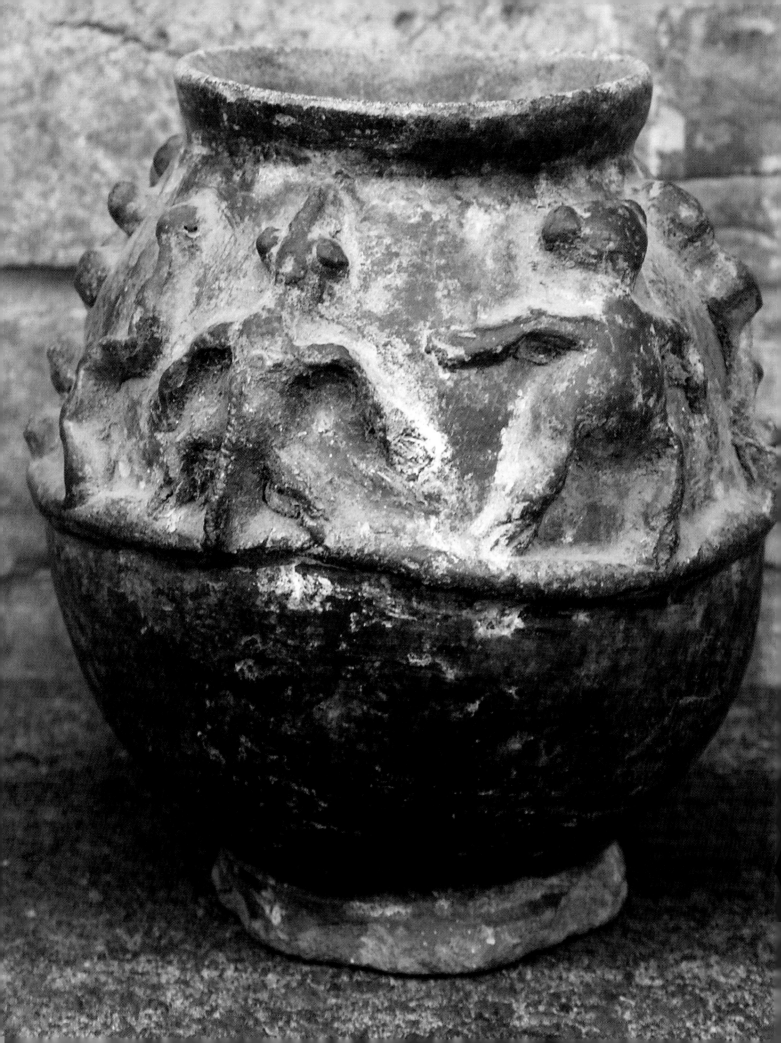

2 SMOKE FIRING IN CONTEMPORARY TRADITIONAL SOCIETIES:

Nigeria, India and Native America

Ancient pottery-making techniques in traditional soci-eties are rapidly disappearing due to the availability and affordability of mass-produced plastic, imported industrial ceramics and stainless steel. Where the pottery traditions continue to serve local needs, such as in India and Africa, they still perform important functions, including utilitar-ian, ceremonial and spiritual functions. The work of Native American potters mainly functions on a commer-cial level, to be bought by tourists and the art market. Through exhibitions, publications and museums, some of the traditional pottery from around the world is gaining global recognition.

NIGERIA

Pottery in Africa has an important role to play in society, and is used as a tool for communication, meaning and symbolism in everyday life. As well as fulfilling a wide range of utilitarian roles for containing and cooking food, grain and liquids, it is used to decorate clothing, as personal ornaments, and in the making of roof tiles and drainage pipes. Pottery is also used on ceremonial and rit-ual occasions. Nigel Barley has written, 'In conscious and unconscious symbolism, thinking with pots is extremely common in Africa.' In his book *Smashing Pots: Feats of Clay from Africa*, he gives an example: 'Pots may become an idiom in which the state and the major components

A woman potter from the Shani area holding a ceremonial vessel she has coiled.
Photo: Joy Voisey.

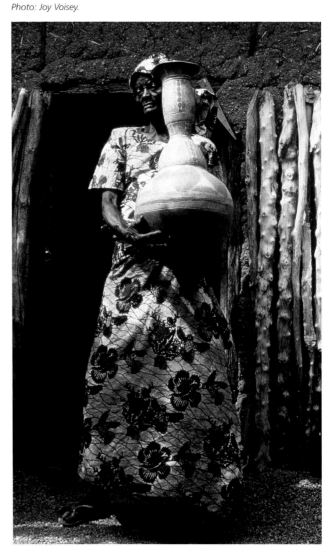

Shea butter jar, Benin, Nigeria, first half of 20th century. Terracotta, height: 17.2 cm (6¾ in). From the collection of Ann and Jean Michel Massing, Cambridge.
Photo: Jane Perryman.

of marriage are expressed. Thus, among the Hausa … should the groom discover on the wedding night that his bride is not a virgin, he smashes her dishes and hangs them upon a pole erected in front of her hut in an attempt to shame her and drive her away.'

Throughout most of Africa, traditional potters make the same pot over and over again; one person will be good at beer-brewing pots, another at stew pots, and so on. Within Nigeria pots are made mostly by women (except in the case of the male Hausa potters from the north), using a variety of handbuilding methods characteristic of their geographical area and ethnic identity. In the Gwari tradition, for example, the potter places some clay into a shallow calabash and beats it into a hollow shape with her hand, then builds up the shape by coiling and pulling up the clay whilst walking backwards around the pot. The Yoruba potters use an old inverted pot as a hump mould, which is covered with a 'blanket' of clay,

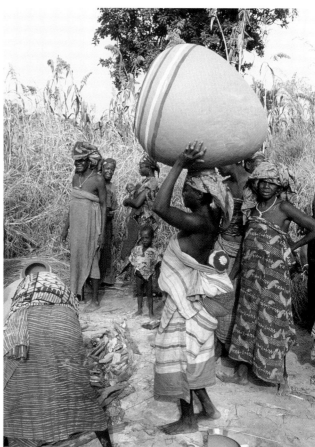

Open firing by women of the Nupe tribe. Carrying pots to the firing site.
Photo: John Leach and Nick Rees of Muchelney Pottery

Women from the Yoruba tribe forming pots over a hump mould.
Photo: Joy Voisey

gently beaten with a wooden paddle until hemispherical, then finished by coiling. Many different types of decorative treatment are used on Nigerian pottery including incised, impressed, raised and high-relief sculptural work depicting animal and human figures. Patterns often bear a close relationship to those traditionally applied to the human body, the calabashes and house walls. White-, red- and black-coloured slips provide colour contrast, sometimes in combination with burnishing, where rubbing the surface with beads or pebbles gives a compact, shiny surface. Some of the decorative applications have a functional purpose: the incised patterns allow a firm grip on a pot that doesn't have a handle, and are said to reduce cracking during firing; burnishing can increase strength and render the pottery less porous.

Raw pots are preheated by placing smouldering combustible material such as maize husks or grass inside or, by inversion, over the hot embers of a wood fire. The firing takes place in an area marked out with stones or

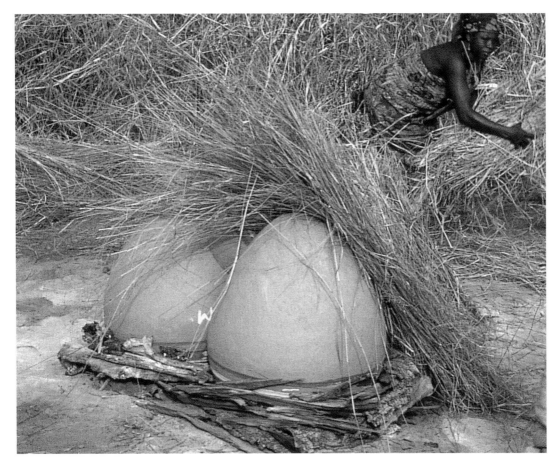

Pots are placed on a bed of wood and surrounded with elephant grass and rice straw.
Photo: John Leach and Nick Rees of Muchelney Pottery

The bonfire is stoked with more straw. This is a fast firing – within 30 minutes the fire begins to die down, until there is a glowing mass inside. Pots will be removed after 24 hours.
Photo: John Leach and Nick Rees of Muchelney Pottery

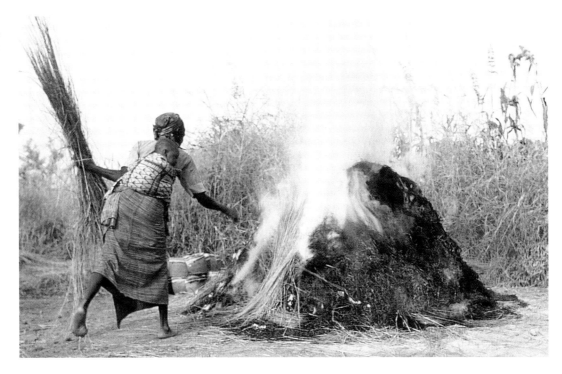

lumps of burnt earth and covered with a layer of brush-wood. The pots are stacked on this circular platform, with large ones in the middle, and smaller ones outside and on top up to a height of 2m (6½ ft) or more. The platform can be 3–5m (10–16½ ft) across, this measurement varying from one area to another. Pots are sometimes protected by a low mud wall or a ring of large, unserviceable water pots, or even fired inside old pots used as saggars. The pile is covered with dry grass or palm fronds, and once ignited burns quickly (it can take as little as 20 minutes).

The ability of a pot to tolerate the thermal shock of this method of firing is partly due to the coarse texture of the clay body, but mostly to the method of preheating the pots before they are fired. Black lustre pots are produced widely using a reduction firing technique. When a pot is nearly dry, a design is burnished onto its surface with a pebble. Damp grass is used for the firing, and when a pot is red-hot it is picked out of the fire and covered with wet leaves which catch fire and smoulder. After a few minutes the pot is dipped into a liquor made from locust-bean pods, which boils on the hot surface and seals the carbon into the pores. Where the pattern has been rubbed on, the carbon now shines with a bright black lustre, while the rest of the pot remains a dull black.

INDIA

Despite the diversification of many potters into other occupations, there are still more traditional potters living in India than anywhere else in the world (around a million in the year 2000). Many households still use unglazed earthenware for all their cooking and storage requirements; it has the advantage of being both practical and biodegradable due to its low firing temperature, as well as being affordable. Because of its porosity it can be placed directly onto the flame for cooking, and will keep water cool by evaporation through its thin walls. Earthenware pots also perform important ritual and ceremonial functions at birth, puberty, marriage and death. Traditional potters live in extended family groups within potter communities on the outskirts of a village near to a source of clay. The strictures of the Hindu caste system divide society by occupation; there are four castes, and potters, artisans and manual workers are all from the lower fourth caste called Sudra. Their status is low, and I believe this to

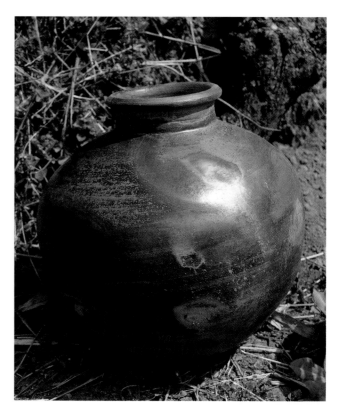

Water pot, Himachal Pradesh, India. Terra-sigillata slip, open fired in buffalo dung.
Photo: Jane Perryman

be the reason for their art and skills remaining uncelebrated in India and the West.

Most earthenware vessels are made by a combination of either throwing and beating or coiling and beating. Wheel designs and techniques to spin the wheel vary depending on geographical location; the spoked wheel

Beating thickly thrown pots with a stone anvil and wooden mallet. Himachal Pradesh, India.
Photo: Jane Perryman

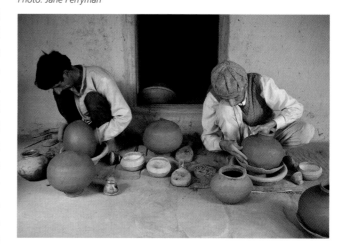

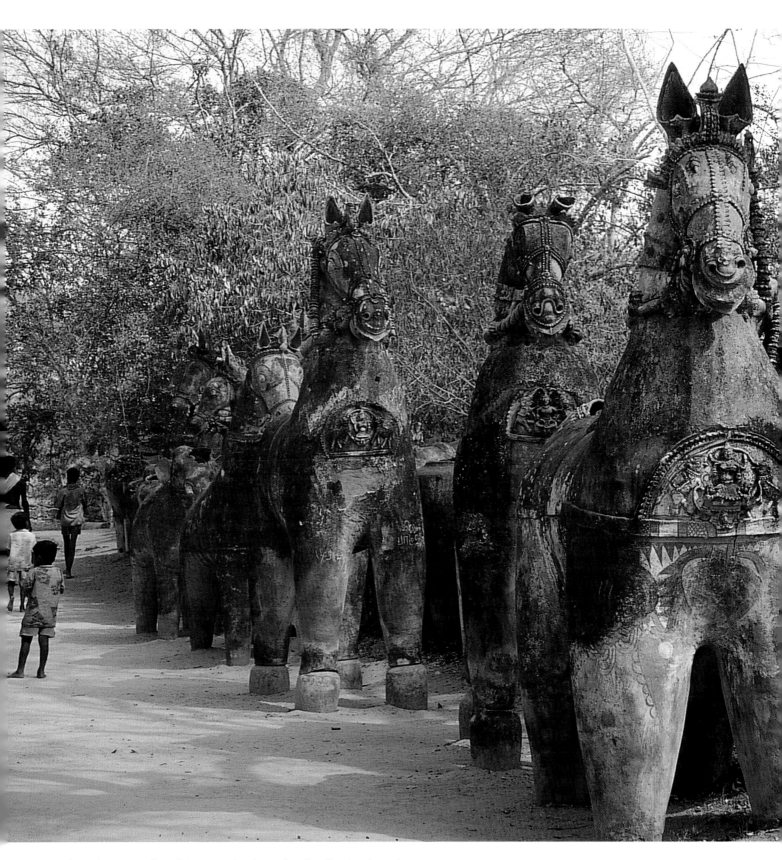

Life-size horses in a village shrine in Tamil Nadu, South India, offered to the god Ayanaar.
Photo: Jane Perryman

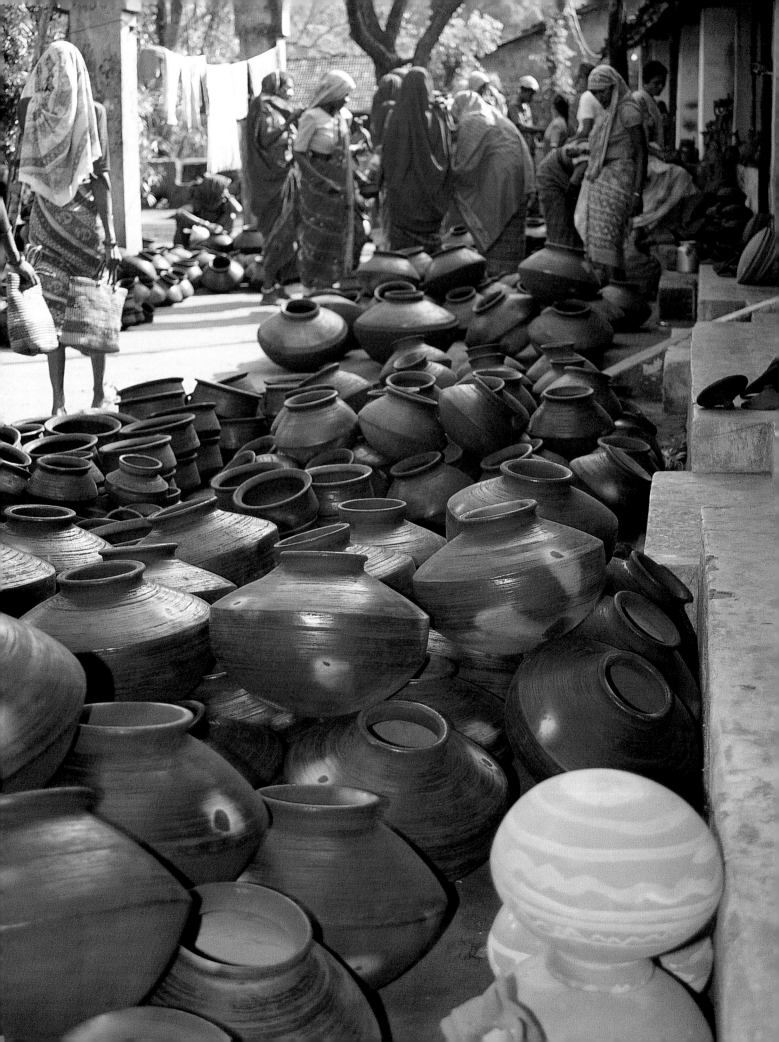

from Himachal Pradesh is made from wood and a mixture of compressed clay and coconut fibre. It rests upon a wooden pivot set into a stone embedded in the mud floor, and is turned by slotting a stick into a hole in the rim and spinning. Forms are thrown on the hump, with thick walls of 2-3 cm (¾ - 1¼ in), and the momentum will be enough to throw one large or two small pots before it has to be turned again. After drying to leatherhard, the thrown forms are beaten to two and a half times their size in three separate stages using a stone anvil and wooden mallet. The beating process reduces the final thickness of the clay walls to between 2.5 mm and 1 cm (⅛ and ⅜ in) thick, depending on size, and will both shape the form and give it strength by compressing the clay particles.

Various decorating techniques are used, such as terra sigillata, burnishing, and applying patterns with earth pigments – often these linear designs of patterns and stylised imagery have remained unchanged since ancient times. Firing methods vary from area to area and can be carried out in the open or in simple kilns. In Himachal Pradesh up to 1500 pots are fired in an open pile using buffalo dung as fuel. Pots are arranged in concentric circles in an inverted position, with mouths facing inwards and covered with dung, followed by layers of shards, rice straw and ash to prevent the flames from escaping. In the middle of urban Delhi there is a community of potters who fire in cylindrical kilns made from fired brick covered with a liquid cow-dung mixture. Members of the family employ the labour-intensive technique of taking it in turns to continually throw handfuls of sawdust into the stoking chamber until the correct temperature is achieved. I have seen several different black-firing techniques used throughout India, both for domestic pots and for votive sculpture. In Uttar Pradesh pots are fired in an ash pit inside a fired clay container which is sealed with a lid and covered with buffalo dung fuel. After a couple of hours of firing the lid is opened and some dried goat dung is thrown into the container, whereupon it is resealed. The goat dung ignites, causing a strong local reduction and a blackening atmosphere. In Himachal Pradesh potters have developed a method to carry out both an oxidised and a black firing at once. Oil drums are packed with pots and resinous pinewood, then sealed and

Black-fired pots for sale in a market in Gujarat, India.
Photo: Jane Perryman.

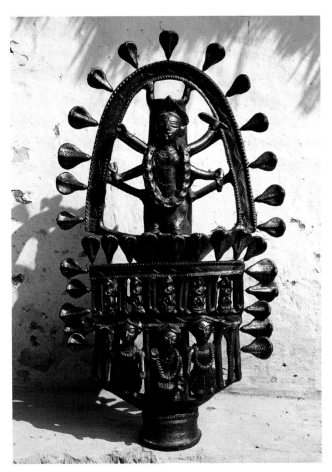

Black-fired 'tree' dedicated to the snake goddess Manasa, West Bengal, India.
Photo: Jane Perryman

black fired inside a horseshoe-shaped kiln containing pots that will be fired with wood and dung to retain their red earthenware colour.

Hindus are required to make regular offerings to a vast pantheon of gods for appeasement or to fulfil a vow in return for a favour. In the villages this practice entails the offering of terracotta statues of animals and figures. The devotee buys or commissions his offering from the potter depending on affordability and the importance of his request to the god. Small statues would be offered to grant a personal wish, and the largest commissioned collectively by a whole village to prevent a disaster like an epidemic or a drought. In South India potters from Tamil Nadu make the largest terracotta sculptures anywhere in the world – some as high as 5m (16½ ft) high. These life-size horses and elephants are offered to the god Ayanaar, a protective deity who is worshipped all over South India. They provide transportation for Ayanaar's spirit

soldiers, enabling them to travel through the fields and villages at night to protect against evil. The terracottas are built with the same coiling and beating processes the potters employ for pot-making, using local clay mixed with coarse rice husk and ash to make it strong. A 3-4 m (10-13 ft) horse will be coiled in four connecting sections so that it can be carried; the largest structures are built and fired *in situ* at the shrine. The firing takes place in a horseshoe-shaped kiln using palm-tree roots as fuel, and after being decorated with earth pigments the horse is offered to Ayanaar during the spring harvest festival.

In West Bengal black-fired terracotta 'trees' are made as offerings, dedicated to the snake goddess Manasa. They contain figurative imagery of the goddess and Lord Shiva surrounded by snakes. They are made to commission, then donated collectively to the shrine by whole communities. They are constructed from a system of architectural cantilevers emerging from thrown pieces, which support elaborate tiers of modelled figures and decoration. Firing takes place in an enclosed cylindrical kiln constructed from a mixture of mud and straw; after being stoked with dried leaves for several hours to attain the right temperature, cow-dung cakes are pushed inside, and the stoking chamber is sealed.

NATIVE AMERICA – NEW MEXICO

Since the early 20th century, Native American pottery from the pueblos of New Mexico has gained international recognition and status. During the 19th century, requirements for utilitarian pottery within the pueblos decreased, due to the availability of industrially produced ceramics and metal. The opening of the Sante Fe railway in the 1880s brought tourists to the area, and the Pueblo Indians responded to commercial demands for mementos, giftware and collectables.

The museum at Sante Fe encouraged certain Pueblo potters they considered to be gifted to make pots based on their own archaeological finds from the ancient traditions of the Anasazi and Mimbres cultures. Moira Vincentelli has said in *Women Potters, Transforming Traditions,* 'The museum staff began a policy of offering 25% more than the potters' asking price if they made the kind of pot that they thought was particularly "good". Thus they encouraged the production of large, well-made, carefully finished pieces, creating price differentiation on the basis of aesthetic judgement.' Summer schools were set up at the museum, and selected potters such as Maria Martinez demonstrated their techniques before audiences, selling what they made at the end of the week. As well as the familiar all-black, monochrome and polychrome ware, new techniques of black-on-black (matt and shiny blacks) and carved blackware were developed. These black pots come mainly from the San Ildefonso and the Santa Clara pueblos in New Mexico.

Pueblo potters treat the clay with respect, having learnt its limitations through centuries of experience. They talk of allowing the clay to form into whatever shape it wants, without their conscious control, and then simply painting on the design dictated by the form. The author Stephen Trimble quotes Nora Naranjo Morse: 'It makes sense that whatever emotion I bring to the studio is released into the clay. You're touching it. It's a circle, the connection between me and the finished product. People that react to my pieces enter the circle. They are involved in the experience. That's what pottery is all about for me.'

Pueblo potters often speak of 'picking' clay as they would pick flowers. Clay is seen as having a soul of its own, being a gift from Mother Earth. Rituals of prayer and offerings often surround the activity of digging and gathering clay, and some locations are guarded closely. After collection, it is dried in the sun, slaked down with water and sieved to eliminate small rocks and organic matter. A temper of volcanic ash, also collected locally, is mixed with the clay by hand and foot on the floor inside the house. Addition of this non-plastic material 'opens out' the clay body and assists an even drying and firing. Potters often work in the kitchen rather than a separate area, and pots are begun in a *puki* (made from a dry or fired clay shape), which acts as a supporting mould for the round bottom of a new pot to be formed. The shape is built up from the base in the *puki* with coils of about 5 cm (2 in) diameter. The coils are squeezed and pressed into position with the aid of moulding spoons, or *kajapes,* to smooth and thin the clay wall. When the pots are dry, usually after a week or two, they are scraped with knives and pieces of metal and carefully rubbed with sandpaper.

Some pots, known as polychrome ware, are burnished then decorated with mythical symbols and stylised patterns in earth-colour combinations. Others are treated with smoke to achieve the lustrous black surfaces of the

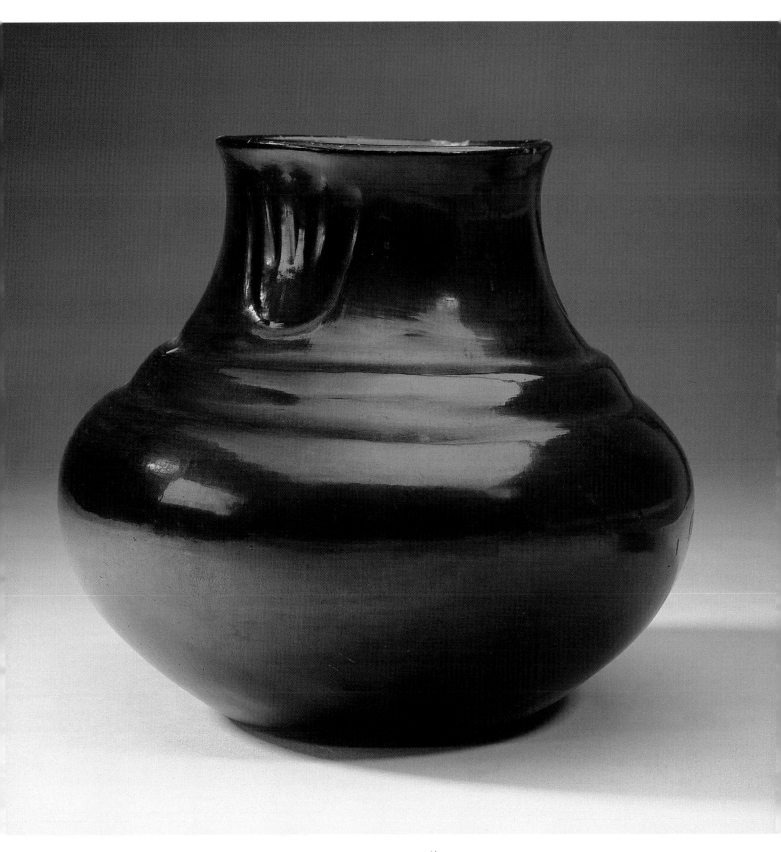

Black-on-black vessel by Mario Tapoya from Santa Clara, New Mexico. Height: 29 cm (11½ in).
Photo: Museum of Archaeology and Anthropology, Cambridge.

black-on-black ware or the carved blackware. After the pot is sufficiently covered and dampened by the slip (made from locally dug iron-red clay), it is burnished with polishing stones, which are highly treasured and handed down from one generation to the next. Once the entire vessel has been polished, a thin coat of chicken or turkey grease is applied (to encourage a higher shine), then the burnishing process is repeated until a mirror-like glossy surface has been achieved with no visible polishing marks. At this stage, after burnishing, some pots will be left plain, while others are decorated with another, more re-fractory greenish-grey slip that leaves a matt finish against the polished surface after firing. This will result in a matt design on a shimmering black background. Known as black-on-black ware, the style was developed by Maria Martinez and her husband in the mid-20th century. The decoration for carved blackware is cut out during the leatherhard stage, before the slipping and polishing stages.

The open firing is raised slightly above the ground to achieve better air circulation, and is begun early in the day or in the evening to avoid the wind. Sometimes a small fire is lit the night before to completely dry out the earth. The large tin cans are placed upright and sur-rounded with the kindling, which is saturated with kerosene; then a metal box constructed from corrugated tin is placed on the upright cans, with care being taken to close any gaps so that the fire does not touch the pots from underneath. The pots are placed on a grille in the bottom of the kiln, and pieces of tin are bent to fit over the top and around the sides. Bark is propped upright around the edges and placed over the entire top of the tin structure. Lastly, wood and cow dung are packed against the tin and ignited; the heat is so intense that the tin be-comes red-hot within 20 minutes. Once the fire has reached the right temperature, it is smothered with fine horse manure, which causes the smoke from the smoul-dering dung to turn the pottery black. A pile of ash is shovelled over the manure to prevent smoke escaping, as this would cause the black pots to be marked with oxi-dised spots. After 30 to 45 minutes the pots are lifted from the kiln with a long pole, and when cool the soot is wiped off with a rag.

Inspired by these ancient techniques, the contemporary Western ceramicists presented in this book are reinterpret-ing them in the context of 21st century modern society.

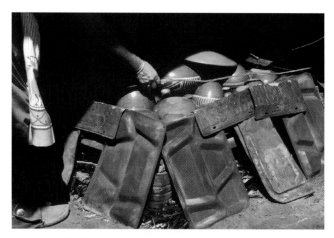
Covering stacked pots with license plates and army mess trays.
Photo by susan Peterson.

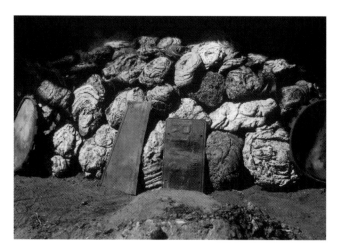
Placing dry cow dung for firing.
Photo by susan Peterson.

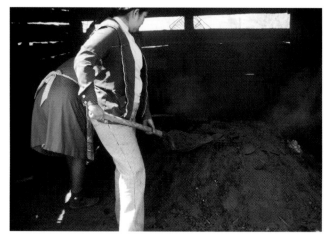
Shovelling ash over firing to prevent smoke escaping.
Photo by susan Peterson.

I
Smoke firing
without a kiln

- **Smoke firing in the open**
- **Smoke firing in a container**
- **Smoke firing in a pit**

Detail from work by Jane Perryman.

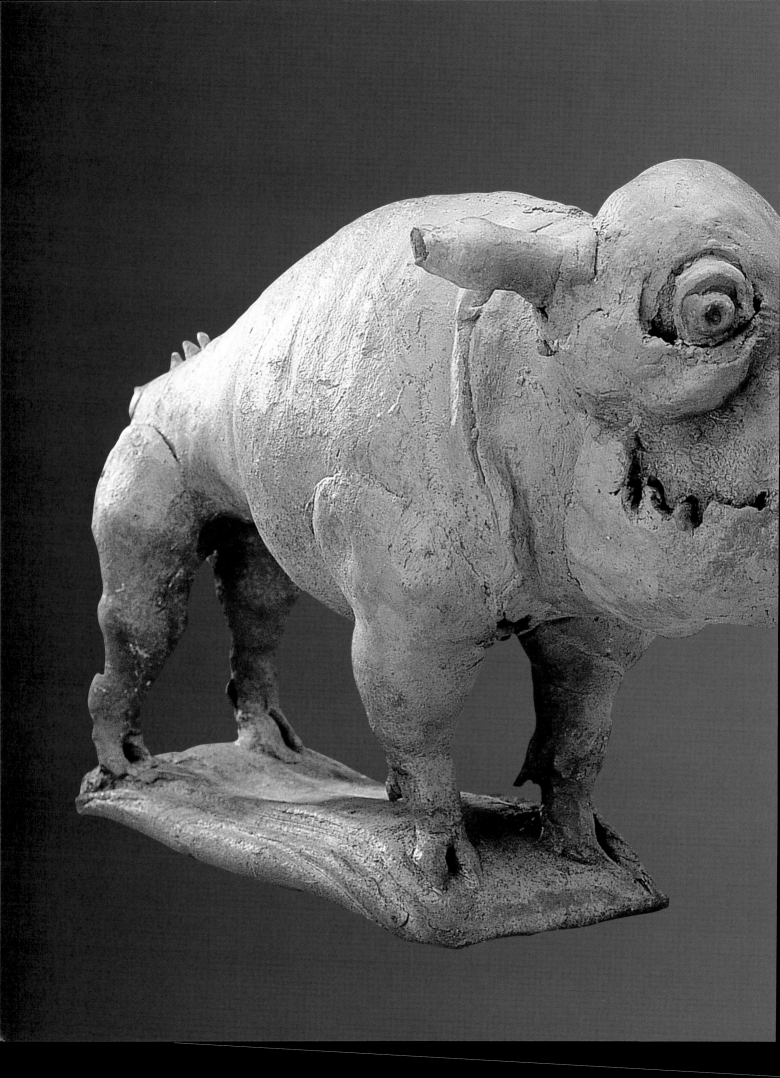

3 SMOKE FIRING IN THE OPEN

Firing in the open, inspired by ancient firing technology and traditional potters from such countries as Africa, India and Native America, is the simplest method of smoke firing. Whereas the typical smoke marks generated by open firing are usually regarded as defective by these potters, the ceramicists from westernised cultures have evolved ways to capture and develop them in an expressive way. Siddig el' Nigoumi developed his technique through knowledge of bonfire firing in his native Sudan. He discovered that by holding flaming newspaper against the porous surface of burnished pottery, he could achieve black fire marks. With this kind of open firing, it is easy to see the progression and intensity of the smoking, and simply stop when the desired results are achieved. There is no equipment, and materials are minimal, consisting of a few sheets of newspaper and a stick to support the pot and control the burning paper. Susan Halls surrounds her sculptures with newspaper, wood shavings, and straw, and fast fires them in a depression in the ground. By multi-firing with small amounts of combustible material and using smoke resists, she can gradually build up the intensity of smoke marks. Smoke firing in the open gives immediate results and can be completed within minutes. It involves the artist directly in all the drama and excitement of playing with fire.

Boar-Type, by Susan Halls, 2005. 20 x 33 x 10 cm (8 x 13 x 4 in).
Photo: Susan Halls.

SIDDIG EL'NIGOUMI

Siddig El'Nigoumi was the most successful of his generation of ex-patriot Africans at synthesising British and African cultures.

El'Nigoumi means stargazer. Siddig El'Nigoumi's star shone from three cultures: he grew up in African Sudan, where his first language was Arabic, but lived in Britain for nearly half his life. He died here in 1996 and was a major influence in the resurgence of interest in low-temperature, burnished, smoke-fired ceramics. Sebastian Blackie, Nigoumi's teaching colleague for many years at Farnham School of Art (now University College for the Creative Arts) says, 'In Magdalene Odundo's view he was the most successful of his generation of ex-patriot Africans at synthesising British and African cultures.' His distinctive earthenware, incised with graphic patterning and imagery, expresses the multicultural elements of African pottery traditions, Arabic calligraphy and British literary and illustrative content. During his lifetime he developed an international reputation, exhibiting widely, and his work is represented in various public collections and museums. The legacy of Nigoumi's influence on the contemporary ceramic world lives on through his work, as well as his teaching and demonstrating both in the UK and abroad.

Nigoumi grew up in a village near the White Nile, where some of his earliest memories were of making toy trains from river clay and discovering with his childhood friends decorated storage pots from an abandoned settlement that were hidden in the sand. Hoping to find treasure, they broke open the pots and destroyed their find. Years later he recognised that this early experience may have been an important influence on his work as a ceramicist. Whilst training to be a teacher an opportunity arose to learn calligraphy, equipping him with the basic skills he would later develop for his incised illustrative decoration. In 1957 he won a scholarship to study ceramics at the Central School of Art in London, where he met his wife Vicki, a textile student. They returned to Sudan in the early 1960s, where they raised a family and Nigoumi taught at the art college in Khartoum. Typically

Siddig El'Nigoumi working in his studio.
Photo: Adriano & Moira Vincentelli

in those early post-colonial years, the teaching faculty was mostly British and the ceramic curriculum was inappropriate to Sudanese students. Nigoumi encouraged his students to look at their own culture and traditions, but finally resigned through problems with internal policy, and in 1967 he returned to England with his family. He began working at Farnham School of Art, initially as a technician in the ceramics department, and later as a teacher.

During the 1970s he worked with unglazed stoneware, echoing the dry, sandy landscapes of Sudan and incorporating patterns from Nubian house decoration. During these early years of readjusting to an unfamiliar culture, he experienced what he described as 'a child's wonder' at everything new – instead of taking things for granted he saw them with fresh eyes and expressed this through slip-decorated pictures on open dishes. He remembered walking through a car park and noticing arrows painted on the tarmac to direct the flow of cars, a phenomenon unknown to him in Sudan. He said,

In Khartoum they have spaces for cars, but everywhere cars are parked in a dreadful haphazard way.

Sebastian Blackie has described his ability to express these observations as 'dignifying the insignificant', a phrase which greatly amused Nigoumi.

Living and teaching in Farnham, Nigoumi soon experienced an increasing need to 'connect with his roots'. He began to notice a ceramic coffee pot sitting on a shelf in his living room which he had brought back from the Sudan. It was low-fired and burnished with a limited sgraffito pattern (otherwise it would become porous). Nigoumi recognised this coffee pot as an important symbol of his upbringing – the pot was Sudanese African, but the tray it was served on was covered with Arab calligraphy.

This Sudanese coffee pot became pivotal in marking a change of direction in his work. It was in the early 1980s that Nigoumi found the style which became his hallmark. He decided to explore his African heritage and began to adopt the traditional techniques of hand-building, burnishing and low-temperature firing. In his native country, the coffee pot would have been fired in the open using wood and dung for fuel, causing black-fire marks from patches of carbon. He began firing this new burnished work in an electric kiln, but needed to find a way of introducing smoke marks to express the African connection. He began investigating ways of carbonising the pots and discovered the simple but effective solution of localised smoking with newspaper. He said,

I prefer to use the tabloids. The content of the resin in the pulp is greater, and the results are better. You have

Greenham Common, 1983. Diameter: 20 cm (8 in). Nigoumi family private collection. *Photo: Nigoumi Family*

Siddig El'Nigoumi smoke firing with newspaper. *Photo: Jane Perryman.*

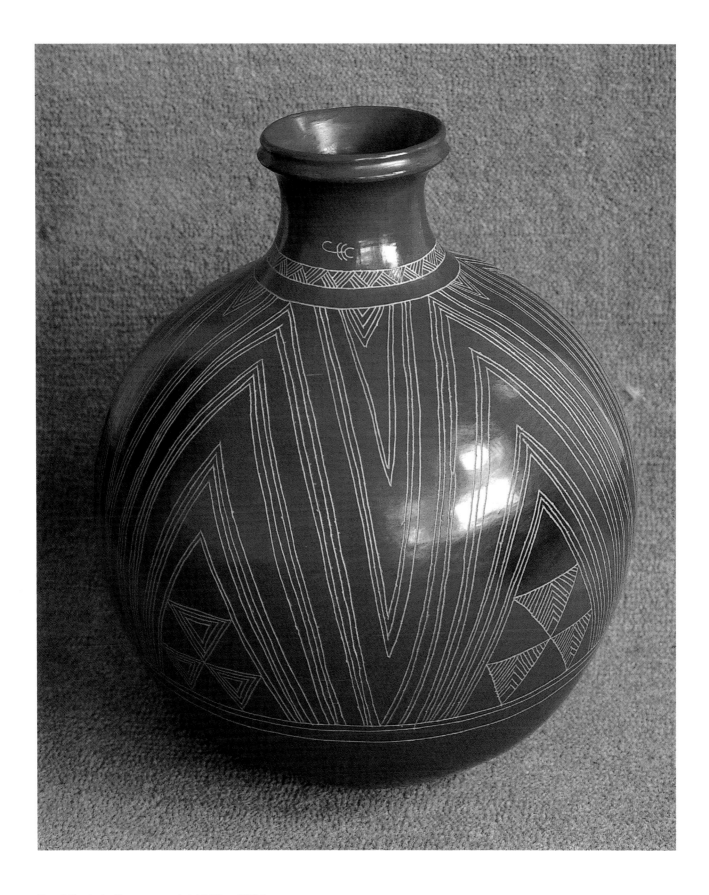

Vessel. Smoked with newspaper, height: 30 cm (12 in).

to use a lot of paper with quality newspapers, but not so much with the tabloids. The vapour from the resin helps the shine.

Sometimes the newspapers he opened up as fuel before igniting them became the source of his literary inspiration, as with a dish decorated with the Guardian crossword puzzle.

Nigoumi worked with a fine Fremington clay (mined in North Devon); pale-reddish in colour, which lent itself well to incising techniques. He used combinations of handbuilding and throwing techniques, and after an application of slip he burnished the surface several times with spoons and pebbles. His calligraphy skills enabled him to incise crisp, precise lines which contrasted with the soft burnish. After a low-temperature bisque firing to 800°C (1472°F) he carried out the smoking on the open ground with minimum fuss and, during the times I watched him, wearing a suit jacket. He would hold the flaming newspaper (without gloves) about an inch from the ceramic surface, taking care to avoid contact between the newspaper and the pot, (if this happened, gum could mark the surface). A rag was used to wipe away the soot and buff up the surface. During later years he solved the problems of cracking due to thermal shock by emulating the carbon flashes through applying patches of dark slip before bisque firing.

Some dishes have a representational image of an animal or fish or landscape, referring back to the time he studied painting at art school. These are usually surrounded by abstract patterns remembered from his childhood – the patterned weaving of basket ware and carpets, especially the prayer mats and covers for food his mother used to make. Other dishes have a central symbol of Western culture, again surrounded by pattern, such as the CND sign repeated to represent the women at Greenham Common, the crossword puzzle or the Rolls Royce logo:

We don't have crossword puzzles in the Sudan or luxuries such as the Rolls Royce.

Siddig El'Nigoumi introduced the technique of carbonising with newspaper to Britain, a method which has now become a recognised part of contemporary ceramic practice. The impact of seeing him in action demonstrating his techniques at the South Wales Potters' Festival in 1983 has remained with me ever since.

Technical notes

Black slip		Red slip	
Clay	95	Clay	90
Manganese oxide	3.5	Precipitatory iron oxide	10
Cobalt oxide	1.5		

Incised Vessel.

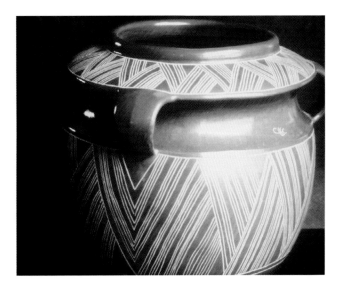

SUSAN HALLS

I want to break down the form and put it back together again…

I have met Susan Halls twice: once in 1998 at her exhibition with Mo Jupp at the Lynn Strover Gallery in Cambridge, and again at the end of 2005 at the Museum of Fine Art in Boston, USA. The intervening years have seen a change in her outlook from the high expectations of youth to the wisdom and realism of a mature artist. The journey has not, however, diminished her passion or her search for new challenges and depths. At our second meeting she talked with great animation of a recent breakthrough inspired by teacher Jak Kovatch at his adult-education drawing classes in Connecticut. Attending these classes for two years has enabled Halls to visualise three-dimensional form from multiple perspectives. Through a similar approach to technical drawing, she learnt how to break down the structure and geom-

etry of simple forms such as cylinders and cubes, significantly increasing her understanding of internal volume and anatomy.

> *Now I can deconstruct things and put them back together. I wanted to break away from the animal form without stylising it. If I want to work with a pig I want to reinvent the pig without losing the pig. I want to break down the form and put it back together again to make it twice the pig it was. Now I can go hunting because I have this power.*

As a child growing up in Kent, Halls already had an intense curiosity for three-dimensional objects. She remembers a fascination with her grandmother's sock-darner and with general junk and rubbish stored in

Spikey Pig, 2005. 18 x 28 x 10 cm (7 x 11 x 4 in). *Photo: Susan Halls*

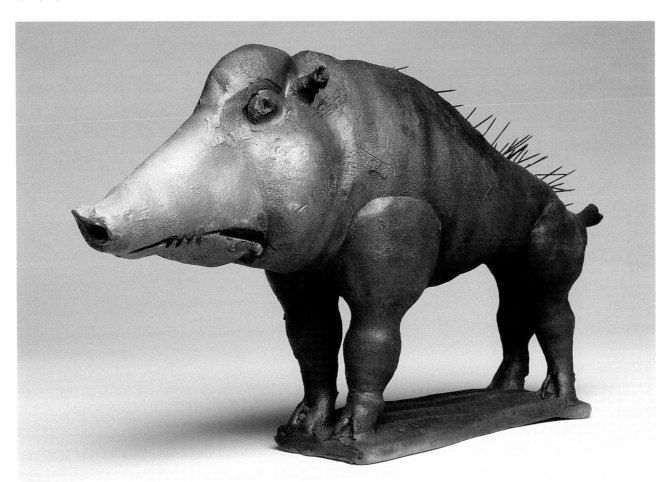

Skull Studies, 2003. 46 x 61 cm (18 x 24 in).
Photo: Susan Halls

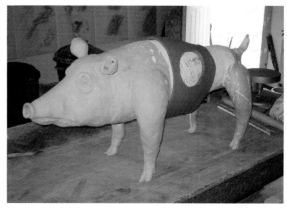

Preparing for smoke firing. Soft clay sheet wrapped around the body will resist the smoke.
Photo: Susan Halls

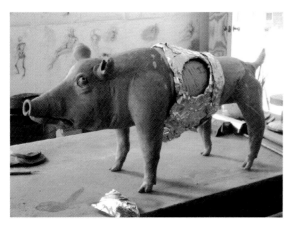

Aluminium foil wrapped around the soft clay to contain local explosions in the clay due to thermal shock.
Photo: Susan Halls

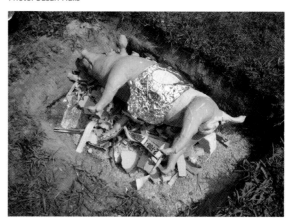

The sculpture is laid on a bed of sawdust, straw and newspaper.
Photo: Susan Halls

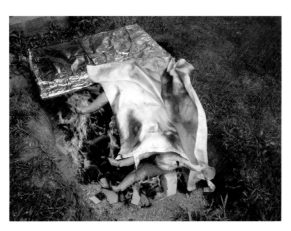

Once ignited, the fire is partly covered with aluminium foil and a fire blanket to retain control of it. The piece will be turned and multi-fired until the desired intensity of smoking is achieved.
Photo: Susan Halls

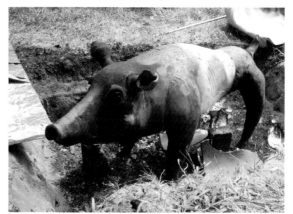

After the firing.
Photo: Susan Halls

boxes; and she also liked to look at china stored inside her grandmother's cupboard.

When I was five (or maybe six) years old, I stole a large stuffed donkey toy on wheels from a front garden. I sneaked it home, removed its casters and chalked white lines all over it. This helped disguise its origins by turning it into a pretty convincing zebra! I still do not know why I did it. I just had to have it.

Her subject matter was in place from this early age and a consuming desire to be around animals has informed the art of Susan Halls and carried her through life.

The beauty of some creatures going about their daily business just makes me salivate.

An exceptional art teacher at secondary school encouraged her to attend Medway College of Art in Kent, and from there she went on to the Royal College of Art, from which she graduated with an MA to a chorus of praise and press interest. She had emerged from college with a new and distinctive voice. By fusing idea and process with great flair, her animal sculptures expressed something beyond the essence of an animal, conveying the heart and soul of its instinctual nature. The critic Peter Dormer talked of Halls demonstrating a truth that has been de-

nied by current art theory: 'Current art theory, which is anti-craft, assumes you think of an idea, then you make it. None of the modern masters of art – Picasso, Braque, Matisse – believed this but then they were craftsmen. The reality is that in art the idea, the intention you have at the beginning, is changed as the process continues. Intentions are not static, they evolve, but they only evolve as a result of what you can do practically. This is the critical difference between industrial manufacture and art. It is the fact that intention does change during the course of making a hand-crafted work that makes it of particular interest to us.'

A Crafts Council grant enabled her to set up a studio in London, and for several years she combined studio work with teaching, and exhibiting in the UK, Europe and Japan. Halls explored her subject matter through animals, birds, the human figure and hybrid creatures of mixed gender or animal/human combinations. The work was ambiguous, enigmatic and often provocative. A move towards human figures evolved from her investigations into monkeys, an exploration of the middle ground where the simian human element and the primate side of human beings come closest. She developed a series of ambiguously gendered dolls with painted-on underwear who have developed monkey heads and missing

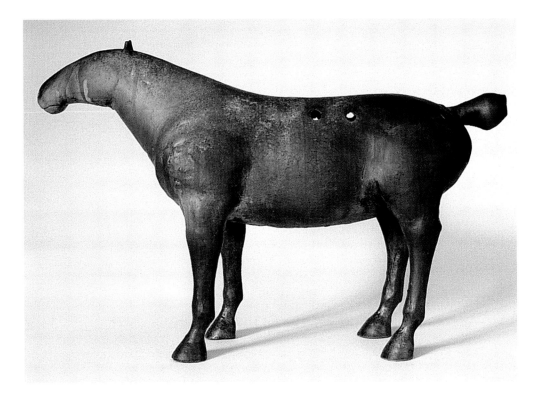

Large intelligent horse.
Height: 33 cm (13 in).
Photo: Susan Halls

limbs. Another series of small figures at this time used the torso of a Cindy doll but with masculine, muscular legs. While at the Royal College Halls had won an open competition sponsored by Campbell's Soup Company of New Jersey in the USA, and during a subsequent visit met her future husband. Conducting a transatlantic relationship is hard, and in 1998, after ten years, she married the illustrator Chris Murphy and moved to Connecticut.

The culture shock of living in America can be difficult, and I imagine that what has kept Halls grounded is her drawing. She draws prolifically and has methodically kept notes and drawings of her sources in her sketchbooks, which she alludes to as being her most valuable possessions. Halls has compared the importance of drawing to the reconnaissance before military action, with a move into the next making stage happening only when a sufficient sense of urgency has developed.

My successful work emerges from a near hypertension between myself and the clay.

Halls researches her subject matter deeply. She finds starting points in mythology and from early civilisations, regularly visiting museums in New York, Washington and London as well as her local natural-history museum – she speaks of the difficulty of seeing live animals in New England because of the long harsh winters. She also draws inspiration from 20th-century artists such as Picasso, Miró, Kandinsky and Henry Moore.

The vitality of Halls's sculpture stems from her ability to draw and play music with the plastic clay.

Clay has its own voice and if this does not inform the piece, it might as well go in the reclaim bin. More than anything else success seems a case of handling least to achieve most.

Working with any stoneware clay mixed with grog, wood pulp and chopped nylon fibre, she mixes and matches a wide variety of handbuilding techniques – moulding, pinching, coiling, soft slabbing and dowelling. The additives will give the soft clay slabs some of the qualities of fabric, and will burn out during the firing – making little difference to the strength of the fired piece while substantially decreasing its weight. Colloidal slips and raku glazes are used in conjunction with smoke firing, and more recently she has applied ready-made brush-on glazes with a firing range of between 960-1000°C (1760-1832°F).

Halls began smoke firing as a student at Medway College – a natural development from raku, which she found too 'glazey'. Her birds, zebras and cat sculptures needed pattern work without much colour.

Smoke firing reminds me of the ancient ceramics that I have always marvelled over in the museums – I find so many questions answered when I look at these artefacts.

The fast smoke-firing and masking techniques she developed are still used today. Sheets and strips of clay are wrapped around the form, then pierced for the smoke to penetrate. The soft clay sheets can also be secured with wire or wrapped with aluminium foil, which is also pierced through (and which functions to contain the local explosions in the clay caused by thermal shock). A shallow depression in the ground will suffice to arrange the fuel and sculpture together for the firing. The piece is placed on props several inches above the floor then surrounded with hay, straw, newspaper and wood, and ignited. Once the fire is going, it is partly covered with aluminium foil and a fire blanket to keep it under control. The piece can be removed to determine the intensity of the smoking, then turned and the process repeated if desired. By using small amounts of combustibles and multi-firing, Halls can gradually build up the smoke marking, although the whole process rarely takes more than 30 minutes.

I like the second chance you get with smoke firing;[1] *the immediate results, the uncertainty and the adrenalin rush that is all part of the process. The one thing I would really like to try is smoke firing with tobacco – would I get the same golden-orange hues that I remember seeing on many a pub ceiling?*

Notes
1 Smoke-fired ceramic can be re-oxidised by refiring it to around 600°C (1112°F) – most ceramicists simply place the work into the next bisque firing.

Russian Lap Dog, 2005. 30 x 22 x 15 cm (12 x 8¾ x 6 in).
Photo: Susan Halls

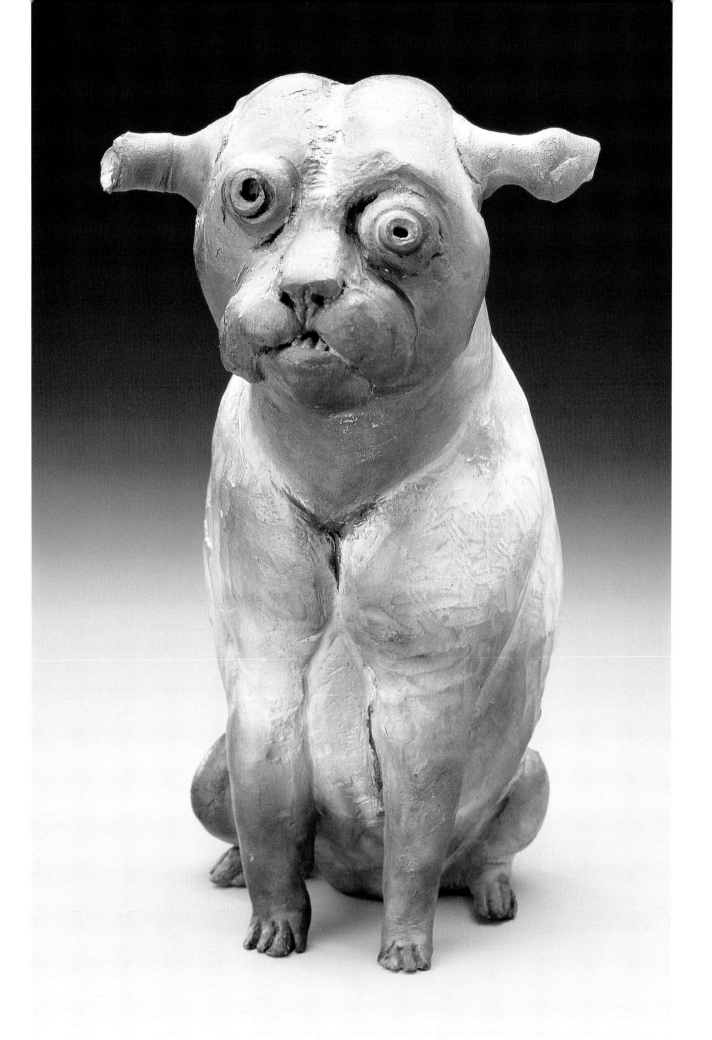

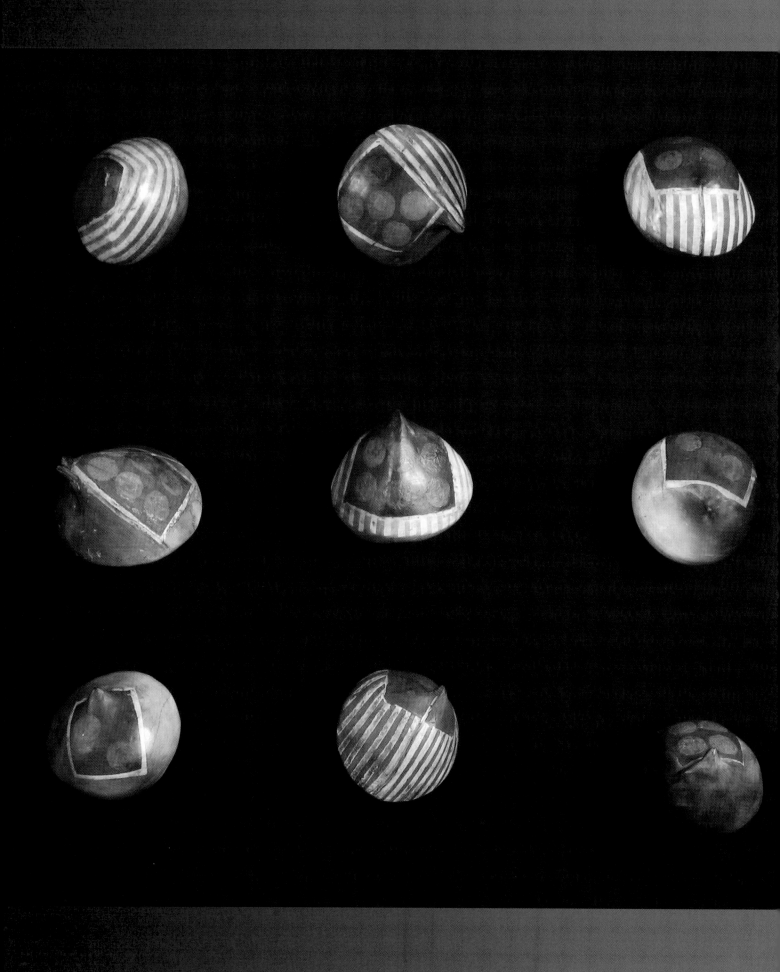

4 SMOKE FIRING IN A CONTAINER

The ceramicists in this section use a container to enclose the fuel and pieces together, firing combustibles such as sawdust, wood and newspaper either singly or in combinations. During the late 1940s the Scottish educator Seonaid Robertson introduced sawdust firing into British schools as a cheap way to fire raw pottery during a time of postwar economic depression. It was through her influence that the American potter Paulus Berensohn took up sawdust firing and presented it in his book *Finding One's Way with Clay* helping to inspire interest and experimentation in the technique. Building a brick chamber can be improvised, whereas found containers such as metal bins or drums offer a preconstructed firing space and can be re-used many times. Antonia Salmon and Jimmy Clarke build their kilns from bricks, adapting the dimensions to accomodate the quantity and size of pieces; Inger Sodergren and Gabriele Koch line their brick containers with aluminium foil to avoid too much air entering. Ann Marais and Madhvi Subrahmanian use open metal containers with plenty of air circulation to facilitate fast firings. Gabriele Koch, who also uses galvanised metal bins, fires slowly by shutting off the air with a lid to avoid thermal shock.

The mixed atmosphere (oxidised and reduced) in this kind of firing results in typical patches of contrasting smoked and oxidised marking on the surface. These artists have developed individual smoke-resist techniques using materials such as clay, paper, sawdust and shards to control the intensity and distribution of the smoke.

Madhvi Subrahmanian, **Random Wall Pods**. Wall installation, 76 x 92 cm (30 x 36 in). *Photo: Craig Philip.*

INGER SODERGREN

I like to work with forms in the exciting intersection between functional and sculptural expression.

Inger Sodergren lives and works in Kisa, a small town situated amongst hills, lakes and woodland in central Sweden, considered to be an area of great natural beauty. I met her in 1992 when she attended one of my first smoke-firing workshops in Cambridge, and since then she has been developing her own distinctive style. While her strong forms, with their dynamic surfaces, refer to ancient processes of burnishing and smoke firing, their inherent sense of Scandinavian design give them a contemporary edge. She says,

I am (primarily) interested in the form, and I like to work with forms in the exciting intersection between functional and sculptural expression.

Sodergren's vocabulary is one of restraint. Her concepts have been realised through the investigation of simple vessel-based forms and the restriction of a monochrome palette of black through to white for the surface decoration.

My work with dishes has been going on for about ten years and has turned towards the

Black Eye, 2004, 56 x 44 x 22 cm (22 x 17 x 8½ in). *Photo: Nisse Peterson*

Kiln packed with newspaper and pine. Dishes partly covered with resist clay and turned upside down.
Photo: Inger Sodergren

Inger Sodergren controlling the flames by opening and closing the metal lid.
Photo: Christina Wassberg

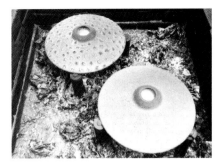

After the firing.
Photo: Inger Sodergren

questions, 'What is a dish, what does it look like and when does it stop functioning as a dish?' My first dishes were round with graphic black-and-white patterns. Then came a period with thick and square plateau dishes. They were slab-built and often inspired by the urban environment.

The influence of large cities developed from a trip to New York followed by a project to interpret Stockholm's subway into her work. For a week she travelled continuously under the streets of Stockholm – it was crowded and stressful but informed a point of departure for the subsequent exhibition. The 'plateau' dishes which evolved challenged the traditional dish form by metamorphosing into architectural cubes tapering slightly from their round-bottomed bases to a concave shape at the top. They

Plateau Dishes, 2000. 25 x 25 x 17 cm (10 x 10 x 6½ in). *Photo: Inger Sodergren*

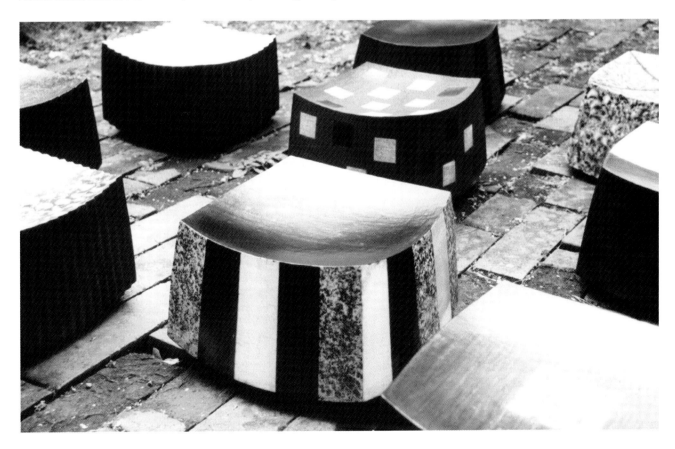

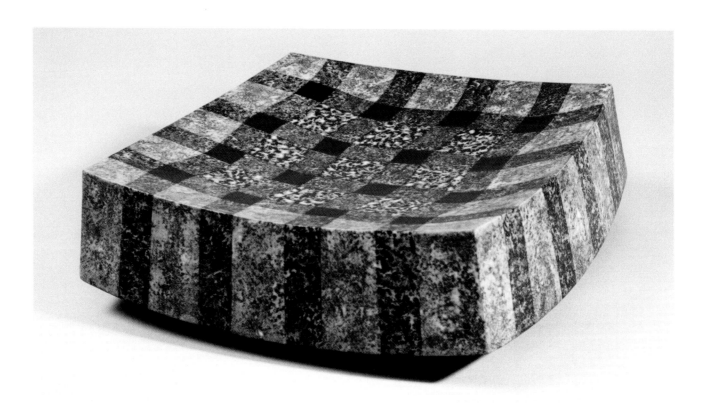

Fingal, 1998. 50 x 50 x 17 cm (20 x 20 x 6¹/₂ in). *Photo: Niklas Forslind*

were designed to sit directly on the floor, without stands, and displayed as an installation.

Other projects have involved a collaboration with the percussionist Peter Bruun, which involved travelling to Africa and studying the instruments of Benin and Nigeria. Sodergren made a variety of *udus* – a kind of coiled drum made of clay.

> *By experimenting I learned how they work, their requirements and principles. The tradition was only the starting point.*

She reinterpreted these traditional drums through her aesthetic of austere, controlled forms and geometric surface patterns, and Bruun prepared a recording of the sounds of the *udus* which was subsequently played during the exhibition. Recently, Sodergren has looked to organic forms of different plant species for inspiration. These pieces are basically black-fired undecorated oval forms treated with sharp cuts at the leatherhard stage to form a rhythmic, linear surface.

Sodergren works with the handbuilding techniques of coiling and slabbing, using a mixture of T-Material and white stoneware clays. The surface is covered with a ball clay slip and burnished before bisque firing to 1000°C (1832°F). She then applies a masking technique to the surface with a combination of tape and clay slip, using a range of slips, consistencies and brushes to give different results (where the slip is applied thickly, it will be more efficient at blocking out the smoke). Smoke firing is carried out in a simple brick kiln wrapped with aluminium foil (to avoid too much air entering) and covered with a metal sheet. Fuel is a mixture of newspapers, glossy-magazine paper and wood from the garden. The piece is placed above the burning material and the fire controlled by opening and closing the lid or by adding more fuel if necessary. Finally, after cleaning, the piece is polished with beeswax.

> *With the smoke firing I can reach results that are impossible with glazes, subtle variations between black and brown and unexpected marks from the smoke.*

ANTONIA SALMON

It is the qualitative feeling of the form that is my guide.

Antonia Salmon uses a quote by the 20th-century American clergyman H.E. Fosdick as a metaphor to illustrate her work: 'I would rather live in a world where my life is surrounded by mystery, than live in a world so small that my mind could comprehend it.' Her timeless sculptural forms contain references to her sources of inspiration evoking impressions rather than literal recognition. Elements and memories of landscape, standing stones, organic forms and ancient artefacts, as well as 20th-century sculpture, can all be detected in her pieces. She says,

> The landscape is a great source of inspiration. I feel, as I move through the folds of hills or up along ridges, that I am moving over a giant sculpture, exploring the gradient, the colour and texture. With the change of light there is a newness even in familiar surroundings. I may pick up a rock, a piece of bark, and a seed. I do not ask myself why I am drawn to that particular form when I first see it. The small object may sit on the studio shelf for many months or years before I return to it as a source of inspiration. At that point there is a more conscious observation about the quality of the shape. It is the qualitative feeling of the form that is my guide.

Salmon's work expresses qualities of contemplation and stillness through its clarity of line and its burnished surfaces marked by smoke. An ongoing primary concern has been to explore themes of containment and holding where the composite pieces are linked together through symbiotic physical support. Earlier examples manifested this idea through a kind of ceremonial blade balanced across a boat-shaped bowl, which later developed into a small shallow bowl suspended between the two sides of an enclosed vessel. More recently, the bowl form supports a thrusting vertical 'sail' by means of a visible dovetailing – like two parts of a jigsaw puzzle. Another area of exploration for Salmon has been to create movement and stillness within one form. She uses finely carved lines and textures which move within the form, often leading the eye to rest at a focal point emphasised by an opening.

Salmon comes from a strong visual background: her father is an architect and her mother a sculptor, and as a child she was encouraged to take part in artistic activities. While at Sheffield University reading geography she attended pottery evening classes and spent her holidays working with a potter, gaining general workshop experience. By the end of university she was 'driven by a desire to express things that academic life didn't fulfil', so she attended the pottery course at Harrow (London) during

Touch Point. Height: 33 cm (13 in). *Photo: Antonia Salmon*

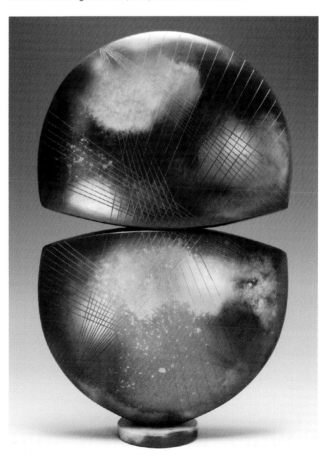

Using a cardboard template.
Photo: Antonia Salmon

the early 1980s, learning to throw and intending to become a domestic potter. However, she soon realised that her interests lay in the form rather than the function of ceramics. Through the influence of visiting lecturer Elizabeth Fritsch, who showed her that 'simple techniques could produce magnificent work', and Siddig El'Nigoumi, who introduced her to low-fired, incised, burnished work, she discovered the pleasure of working with low fired clay. She started to make a series of burnished red earthenware screens which were pierced and relief carved.

Egyptian sculpture in the British Museum and Islamic screen work in the Victoria and Albert Museum became a source of inspiration, and led her to spend ten months travelling from Spain through the Middle East to India, absorbing the gradual change of European into Islamic architecture and culture, and recording it on camera and by drawing. Further inspiration came from stone and flint artefacts in the former Museum of Mankind and in the British Museum, which influenced her first smoked pieces, fired in a small fireplace in her studio. In 1986 she began to develop these experiments, handbuilding sculptural forms and experiencing a sense of liberation from the functional ware she had made at Harrow. A move to Sheffield, close to the Pennines, in 1989 gave Salmon accessible connection with an ancient landscape, and she was able to set up a studio, where she continues to live and work.

Salmon's approach is that of disciplined dedication – she has described her day to Sebastian Blackie as,

Winged Form. Width: 55 cm (21½ in). *Photo: Antonia Salmon*

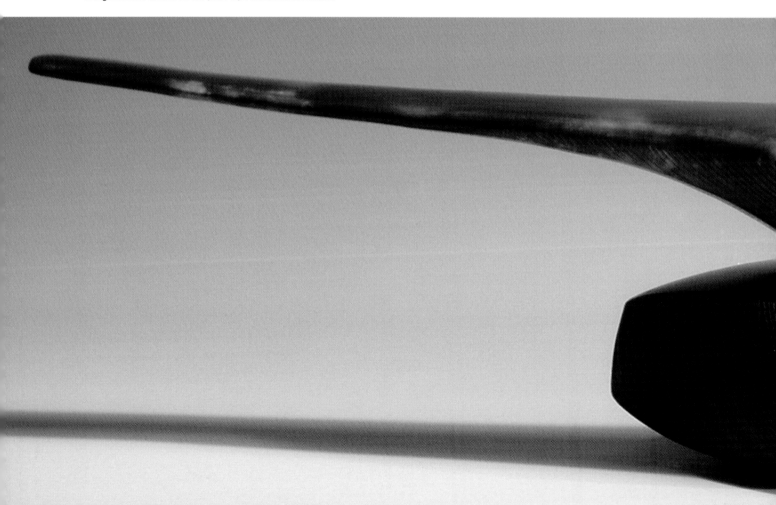

'work and work and work, then bed'. Since the birth of her son in 2000 she has learnt a more playful approach, but the long hours and the solitude remain essential to producing her work.

> *When I start a new work I do not always know what the intention is. I want the form to emerge from the background of my observations and experiences. There is often a considerable struggle to find the form, but when it appears it seems as if it had been waiting to emerge all the time – there is a kind of obviousness about it. The nature of the process of making influences the shapes that are produced. Because the works are hand-burnished several times they quite literally express the hand of the maker. There is a kind of ritual nature to the burnishing.*

Salmon uses a white, tight-bodied stoneware clay, enabling her to carve and incise linear designs with great precision. Large pieces are made from T-Material stoneware and covered with a slip. She uses a combination of forming techniques: throwing and altering through cutting and construction at leatherhard stage,

Lighting the sawdust-firing with newspaper. *Photo: Antonia Salmon*

as well as coiling, slabbing and carving. After forming and carving, the pieces are burnished and fired to around 1100°C (2012°F). Although this temperature fires away the visual burnish, the strength gained from the high firing gives her the confidence to make delicate shapes. Even so, the fine clay yields a high loss rate, which she accepts as inevitable.

Smoke firing takes place 20 minutes' drive away in a friend's field in Derbyshire because of environmental

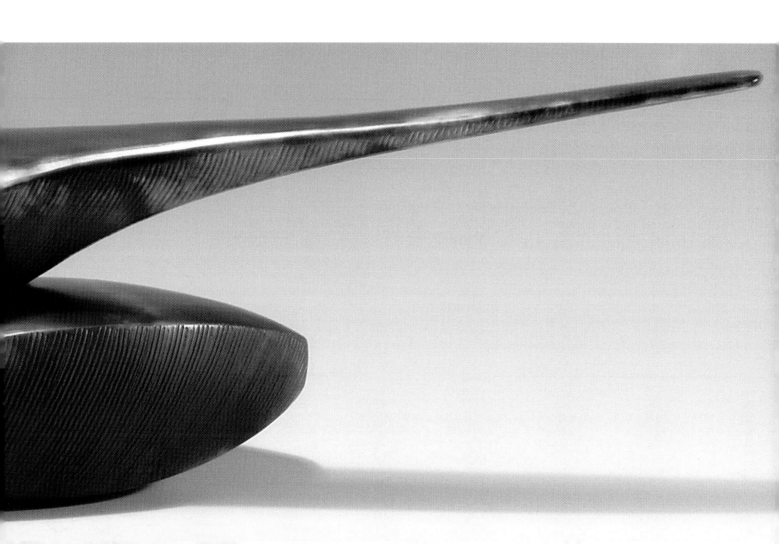

restrictions within the city. The smoking kiln is a rectangular brick construction divided into two chambers and surrounded by steel plates to give it protection against the Pennine wind. Fuel is a mixture of coarse and very fine sawdust; the proportions are changed depending on the intensity of carbonisation required: the coarse sawdust fires quickly and gives dramatic markings, whereas the fine sawdust gives dark, dense results. The wood is a mixture of softwood and mahogany. Pots are packed carefully in relation to one another so that areas can be blocked off from the carbonisation; air holes are created in the sawdust by touching or resting one pot against another. Most pieces are smoke fired in this way at least twice, sometimes three or four times, until the result is satisfactory. Finally, the surface is wax-polished.

The element of spontaneity and chance from the sawdust firing is a quality Salmon enjoys.

When the sculptures are offered up to the smoke firing the sense of ritual is reinforced. By sawdust firing I'm allowing an outside element to enter in a much looser way. The element of unpredictability is healthy, and a dynamic contrast to the controlled forms. Sawdust firing has taught me how to accept things as they come.

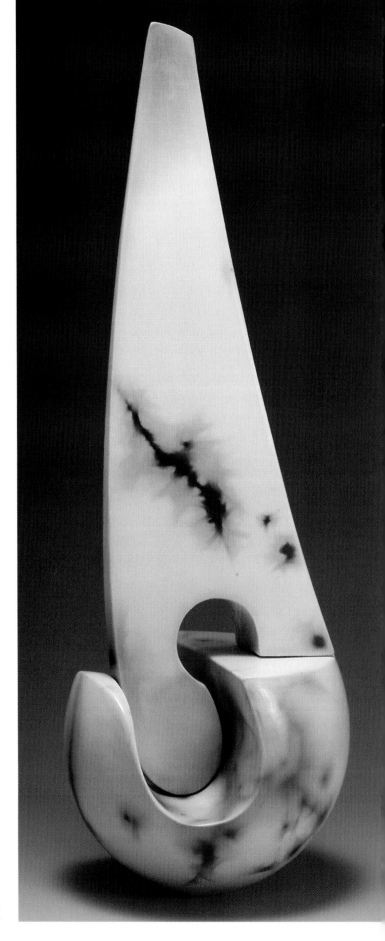

Light Sail. Height: 35 cm (13¾ in).
Photo: Antonia Salmon

ANN MARAIS

I want to keep alive the creative energies of past craftspeople...

As part of an international global community, ceramic artists today draw their inspiration from multiple sources, both conscious and unconscious. The ceramics of South African potter Ann Marais, for instance, have grown out of the historical effects of European colonialism on the indigenous cultures of Africa. She says,

> *I am the product of two continents – European and African. My European education schooled me in the*

music of Mozart, in the arts of the Renaissance, and I learnt about Father Christmas and cold misty snowy-white landscapes in winter. As a young girl growing up in tropical Africa, all this was theoretical. The real world, the world of senses, taught me the delicious taste of hot ripe mangoes, the haunting cry of the fish eagle on Lake Victoria in Uganda, the red and purple brilliance of hibiscus and bougainvillea, the smell of

Warrior Dreams Headrest. 29 x 41 x 31.5 cm (11 ½ x 16 x 12 ½ in). *Photo: Ann Marais*

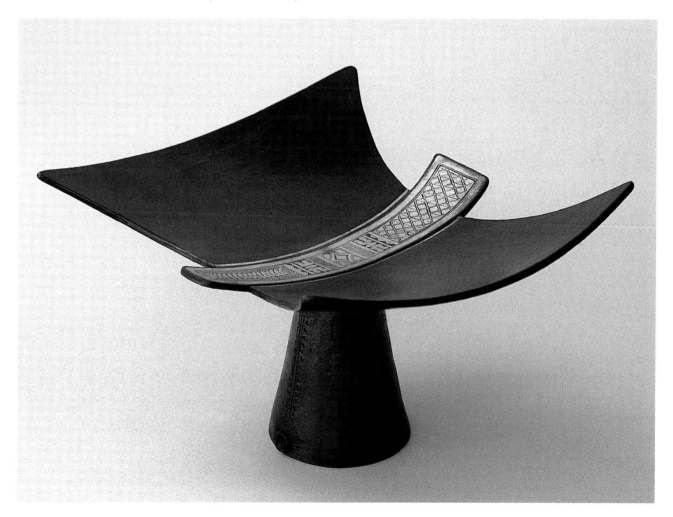

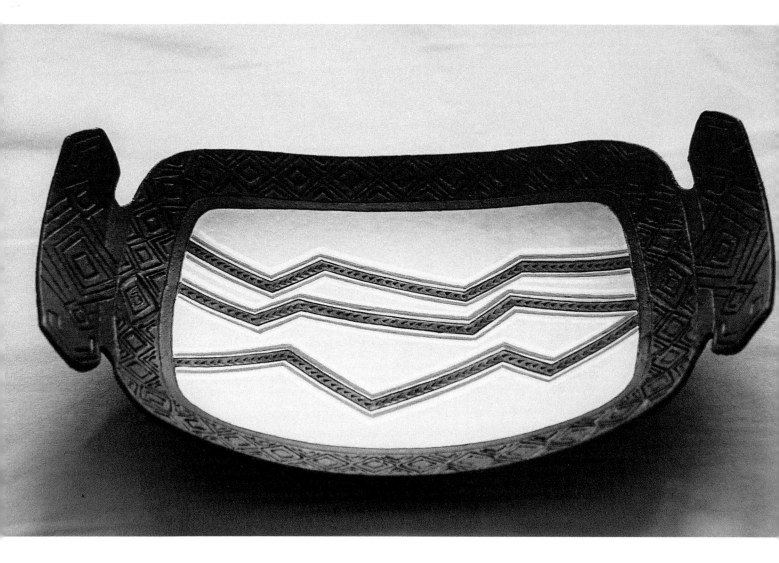

Untitled. 11 x 44 x 26 cm (4¼ x 17 x 10¼ in). *Photo: Ann Marais*

raw earth washed by a short sharp burst of tropical rain, and the sunburn of a hot tropical day.

Marais refers to her cross-culturalism as 'Neo-African', a fusion of traditional Africa with contemporary Western aesthetics and practices. It is this dual consciousness which defines her work. Her work owes its emotional and spiritual allegiance to Africa, but is equally informed by formal Western art education and ceramic studio training.

Marais was born in Burma and grew up in East Africa, finally settling in South Africa, where today she lives in Cape Town. Her experience at a Dickensian boarding school in Kenya left her with an aversion to formal education, and it was not until the age of 39 that she returned, studying for a degree in sculpture and art

theory at Rhodes University in the Eastern Cape. As with so many potters, her first introduction to clay was by chance at a pottery evening class – so beginning a life-long passion for ceramics. During the last 30 years she has developed from early wheel-thrown functional ware to the more personal style of handbuilt vessels and sculpture she makes today.

Ann Marais is not Afrikaans; her ancestors were English settlers and she talks of her initial shock at apartheid and her struggles against it. During the 1980s, when Mandela's name was taboo, she caused a public conflict by entering a piece into a national exhibition entitled Mandela. Although the piece was ultimately accepted, it led her to becoming a persona non grata within certain sections of the ceramic community. Marais

slowly became aware of traditional African pottery via her involvement with the post-reduction firing of raku techniques.

For 20 years I used the Oriental / American processes of raku firing with post-firing reduction in sawdust to produce work. The blackness of the reducing smoke was, for me, the black of an African process. Smoked pots have been produced in Africa for centuries through bonfire and pit-firing technologies. There was a need for me to understand from where the pottery traditions had sprung. For a time, I searched my ancestral roots in Celtic art. But Africa always looms large. In the past three decades I have explored cultural and physical facets of this continent: body adornment in beadwork, rituals and spiritual beliefs, weapons, musical instruments, wood carving, vernacular architecture, weaving patterns and cloth, furniture and jewellery.

Marais's work embraces several themes. The open vessel forms provide a canvas for rich painted decoration inspired by textiles and the rough textures of woven reeds and bark. Wooden carved artefacts worn to a silky sheen through use are another source of reference. Her burnished surfaces, which still bear the marks of the making process, resemble chisel-marked wood carvings. The countless marks left by the burnishing tool carry the notion of time – both literal in the physical labour involved and metaphoric in their link to ancient pottery.

I want to keep alive the creative energies of past craftspeople here, of their creative visions, so that there is an unbroken stream of consciousness where time is not fixed but moves back and forth.

The series of *Drum Plates* is inspired by carved wooden split drums interpreted into an oval dish form bisected by a dramatic slash of decoration or contrasting colour. *Sharing Bowl* was made in response to the transition to democratic society in South Africa as a visual metaphor for the spirit of *Ubuntu* (Let us build together, share together). The oval bowl form references a ritual container used by pre-urban societies for sharing food, its stark white empty space within waiting to be filled by the community, for the community. Its gold-lustre handles bear homage to the gold artefacts and decoration used by the royal metal workshops of the Ashanti kingdoms.

Recently, Marais has been investigating the archetypal headrest form, which traditionally served to protect an elaborate hair coiffure or aid spiritual connection with ancestors during sleep. The piece *Warrior Dreams Headrest* is a curved open form shaped like a double axe-head, bisected by a flat strip of ornate linear decoration. It rises up from the ground supported by a cone. Marais describes it as a postmodern piece, carrying with it metaphysical meanings and messages of conflict, past and present, traditional and spiritual.

The pieces are handbuilt, using slabbing techniques, from an open-bodied stoneware clay formed inside drape moulds or a giant Chinese wok. Both impressed and applied decoration are used to define borders or bisect an area. Slips are made from a white or red clay body to which are added stains and oxides. Many of the colours reflect the landscape of South Africa and neighbouring countries, particularly Namibia, which is a rich source of subtle ochres, yellows, browns, reds and muted mauves. The slips are applied by brush and separated by fine lines drawn into the wet clay, which act as retaining walls. Burnishing is important to create a smooth surface for the later application of lustres, and is carried out with a silver teaspoon. The surface is then buffed with soft plastic. After a bisque-firing to 985°C (1805°F), the lustres are applied with fine brushes and re-fired to 747°C (1376°F).

Smoke firing is conducted in a large galvanised iron bath – the pieces are fired on small tiles or stilts to allow for burning and smoke around the whole piece. The bath is warmed initially with a brief fire of paper,

Sawdust is placed inside the bowl as a smoke resist during the fast firing with newspaper.
Photo: Ann Marais.

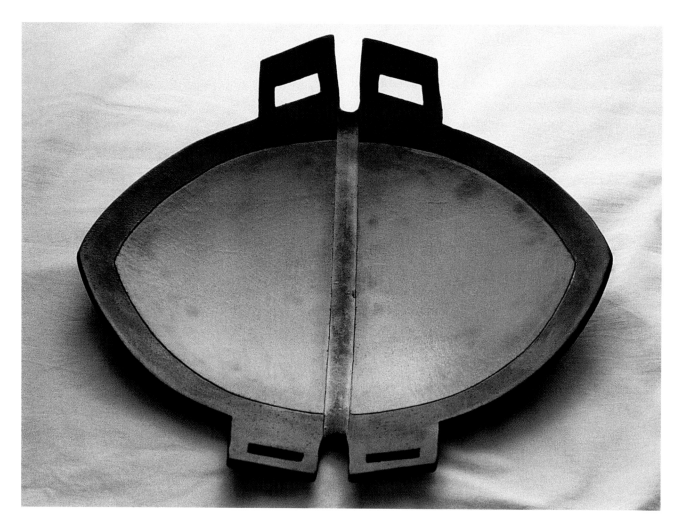

Split Drum. 12 x 50 x 57 cm (4³/₄ x 19³/₄ x 22¹/₂ in). *Photo: Ann Marais.*

then a little sawdust is sprinkled on the floor and crumpled newspaper placed around the walls and floor. Pots are placed on the props and more newspaper is placed loosely around the bath walls to the top edge. Marais employs several smoke-resist methods. One is to fill the hollow form with sawdust, which is not entirely efficient, as some smoke filters through. A clean resist is achieved by the use of tin foil weighted down or the application of kiln wash. The latter is made up of 50% silica and 50% feldspar mixed with water. It is especially successful when applied over gold leaf or to the parts where foil is difficult to attach, and will be washed off after the firing. A final light sprinkling of sawdust covers the paper before ignition. Firing is rapid, but tended carefully to make sure that each piece receives adequate smoking – more newspaper is stoked when necessary. After

washing, pieces are left to dry out before black boot polish is applied to the plain areas to increase the contrast of dark to colour and lustre.

I like the soft, muted colours of earthy tones one gets with low-fired ware; the way the smoke subtly reveals or hides parts of the designs – it's like discovering half-buried treasure.

GABRIELE KOCH

The essence of my work is the vessel as sculptural form.

Gabriele Koch's work has been described by Sir David Attenborough as 'elemental', a word traditionally associated with the four elements of earth, water, air and fire. These are the four elements necessary for making pottery, of course, but the word also suggests a second metaphysical meaning, 'motivated by and symbolic of powerful natural forces or passions.' Koch's work is a potent union of physical elements with artistic vision, which she describes as 'her pleasure, her joy, her love'.

Koch has been exploring the vessel as an abstract sculptural form for 25 years, and during that time she has developed a distinctive voice. Her taut burnished forms marked by smoke clouds express physical stature and resonate with the forms of ancient pottery as well as contemporary sculpture and architecture.

Koch comes from an academic background in the Black Forest, on the Swiss/French border of Germany. She describes her upbringing as existing in an atmosphere of intellectual enquiry and appreciation of the arts – with frequent visits to art museums and contemporary buildings as well as expeditions into the local landscapes of forests and mountains. Whilst at the University of Heidelberg studying languages, history and political science, she also spent time in central Spain, leading to an immediate love affair with the landscape and culture. The experience was to be a catalyst for beginning life as a potter. She was struck by the contrast between her native lush Black Forest and the red earth and simplicity of rural Spain; between affluent hi-tech Germany with its factory-made porcelain, and the low-fired dishes with rounded bases commonly used in Spanish cooking and serving.

The rounded bases fascinated me – the fact that something is not standing firm but is flexible and that it's swivelling around but doesn't fall over. This idea of being flexible but balanced is also an idea of Eastern philosophy.

Further significant impressions from Spain which have filtered into her work over the years are the cubist architecture of simple white villages, the organic quality of Gaudí's buildings, the paintings of Antoni Tàpies where he uses mud to give surface texture, and the sculpture of Eduardo Chillida.

After graduating in 1973 she came to London to gain teaching experience and enrolled at pottery evening classes. She learned to throw and soon joined a pottery cooperative, where she began making domestic pots and learning from the other potters. A visit to an exhibition of North American Indian art, called Sacred Circles, at the Hayward Gallery in London was a major factor in her decision to begin burnishing.

My heart gave a jump whenever I saw American Indian and African pots in museums, and when

Vessel. Height: 41 cm (16 in). *Photo: Kelpie*

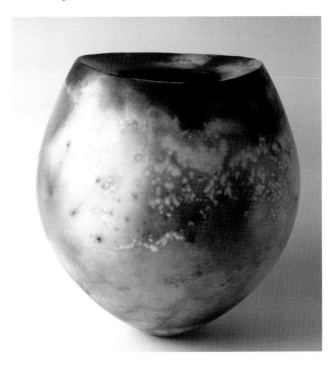

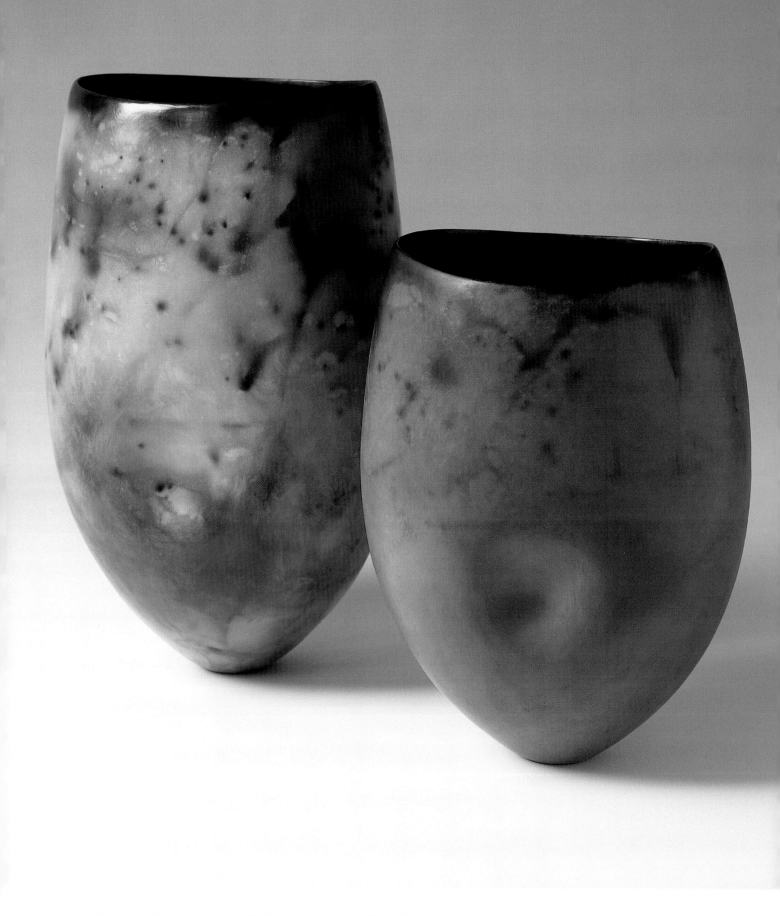

Red Vessel with Dimple, Grey Vessel with Dimple. Heights: 26 and 33 cm (10¼ and 13 in). *Photo: Kelpie*

I picked up a burnished object made by a fellow potter and held it in my hands, I knew this was to be my way.

Later, in the late 1970s, Koch attended a part-time postgraduate ceramics course at Goldsmiths College, and with the support of her teacher, David Garbett, she started to handbuild, adopting the theme of the vessel. Discovering sawdust firing via raku, Koch began the painstaking journey of discovery through trial and error. Along with the African potters Siddig El'Nigoumi (from the Sudan) and Magdalene Odundo (from Kenya), who began to exhibit their handbuilt burnished and smoke-fired work in the early 1980s, she was part of a new direction in contemporary ceramics in the UK. She describes her early work,

These pots for me had a double identity. On one hand, of course, they were pots; on the other hand it was symbolising pots – going back to the early pot, the simple pot. Everything at that time was about simplicity: simplicity of form, simplicity of technology, about immediacy. My thinking was very conscious at that time – I was very much aware of what I was doing.

After Goldsmiths she was awarded a setting-up grant by the Crafts Council to equip her studio, and was ready to begin work.

The essence of my work is the vessel as sculptural form. The visual and physical experience of the inner volume and outer space demonstrated by Le Corbusier, Gehry, Libeskind, Gaudí, Brancusi, Anish Kapoor, Richard Serra, Ruth Duckworth, and many more, as well as all the wonderful pots and sculptures of early and so-called primitive cultures, like Cycladic figures, are part of my visual experience. But I do not feel that I would want to copy any of them. I need to make my own forms, I feel my way into the form as I build it and hope that I apply the same principles as the artists I admire, be they known or anonymous, to my work as I make it. The excitement lies in making a new discovery every time, urging the development of the form and finding just the right solution. It is the eye that judges, and there are minute and minimal aspects in the development of the contour line in its

360-degree turn around the form that need to be considered, the tension and balance that is created, the relationship of the inner volume to the outer space, the access into the enclosed space. Does it speak to you, can it inspire you?

Over the years Koch has investigated a limited repertoire of forms which she has alluded to as being her 'family'. The early spherical vessels, with their squatting or crouching emphasis, gradually became taller and more elegant as she explored bisymmetrical amphora, bottle and vase shapes. The opening was always a focal point and was carefully considered so as to draw the eye inwards or upwards or to maintain a level static gaze. In the late 1990s she began to work with more sharp-edged bell and tower forms, reflecting her interest in architecture, and more recently with cylindrical beaker forms which flare outwards slightly at the top.

Although I want to express stillness in the form, I do not want it to be static. I want it to be alive and moving, and I try to achieve this by the way the form lifts off the base, by creating movement lines pushing the clay in and out of shape and giving it a slightly curved bisymmetrical opening.

Dynamic movement within the form is expressed by Koch's surface treatment – the repeated burnishing marks remain discernible, and sometimes she uses a single incised line, a gentle ridge, a small round bump or a texture to emphasise this quality.

Koch has gradually acquired a high level of expertise, so that the results of her careful planning are more or less as anticipated. Although she is working with so-called low-tech processes, her studio practice is carried out with the precision of an engineer. She keeps her studio at tropical temperatures so that the clay will not dry out too quickly, and each stage of the process is carefully and methodically orchestrated – in fact, she talks about using 'the utmost economy of means' as a political statement about globalised excess. She uses the highly refractory T-Material clay, which is sometimes mixed with other clays such as porcelain or red earthenware. The form is begun by either pinching a bowl shape or rolling out a flat disc. Coils are rolled vertically

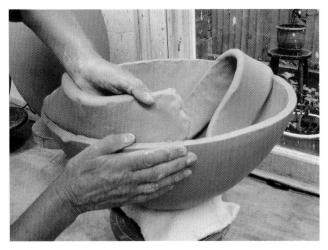

Putting the new flattened coil inside the built form.
Photo: Kelpie

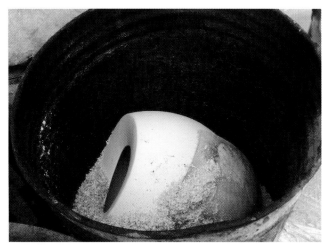

The pot is filled with sawdust and shards placed against the surface to block out the smoke.
Photo: Kelpie

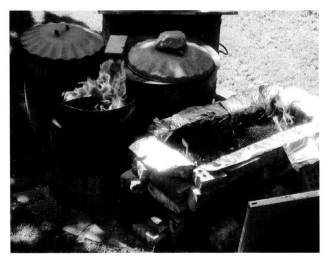

Setting the sawdust firings alight before covering them with lids.
Photo: Kelpie

Opening the metal bin after firing.
Photo: Kelpie

between the hands and then lain on the bench, where they are flattened by the hand and joined to the inside of the rim.

> I join the clay first on the inside by pushing the clay from the new coil down into the existing form with my right thumb, supporting the form from the outside with my left hand. I then reverse the process on the outside by pushing the clay from the bottom up, this time supporting the form from the inside. The process continues right up to the rim, which I usually cut to shape with a palette knife.

Koch builds up the form organically by eye, reshaping the whole each time she applies a coil and, like the Indian potters, thinning and shaping the form by beating with a wooden plank. For the final refining she uses a metal kidney to scrape the surface.

A thin slip made of the clay body sieved to eliminate grog is applied in several layers (sometimes coloured by adding oxides or body stains), and then the pot is repeatedly burnished with the back of a spoon or with polished stones. It is then bisque-fired to 950°C (1742°F) over a 24-hour period, extremely slowly, in order to minimise cracking. The smoke firing takes place in her back garden using metal bins and aluminium foil-lined brick

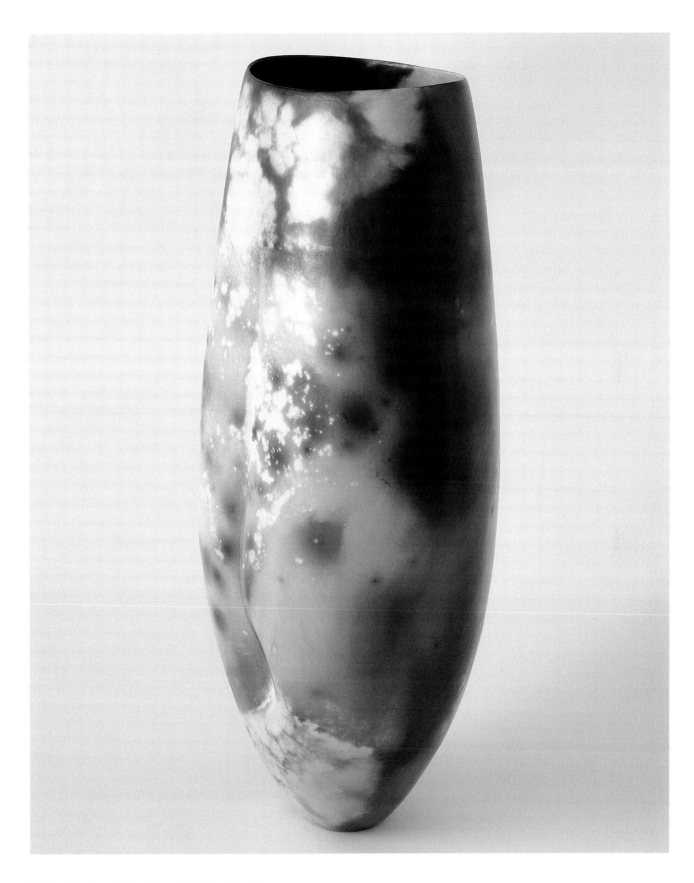

Tall Standing Form. Height: 58 cm (23 in). *Photo: Kelpie*

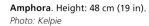
Amphora. Height: 48 cm (19 in).
Photo: Kelpie

constructions as containers, packed with a mixture of hard – and softwood sawdust. The rich and varied markings are achieved by careful packing of the pots – taking account of how one touches another, placing shards against the surface, and creating air pockets. Sometimes pots are withdrawn early from the burning sawdust, where fewer smoke marks are required, and of course the form of the pot also determines surface marking. The kiln is lit with a blowtorch from the top, and after about 15 minutes it is closed with a pile of metal lids to protect against rain and rapid cooling. Finally, the pieces are wax-polished.

JIMMY CLARK

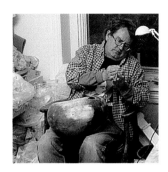

I strive to instil a personal story into each piece that reflects its creation …

The American ceramicist Jimmy Clark has said,

> *My work is about history. I strive to instil a personal story into each piece that reflects its creation, allegorical purpose, and an undefined passage of time.*

Clark's asymmetrical forms are built almost exclusively from pinching, a handbuilding technique associated with Native American and African pottery. He works with the opposing forces of strength and vulnerability, and of male and female expressed through the swelling forms, the scale of his pieces (many are exceptionally large for the pinching technique) and the delicacy of their thin walls.

Surfaces are marked randomly by fire and the flashing of muted colours, evidence of a literal passage of time during the smoke firing. Clark has learnt to 'embrace breakage' as a natural by-product of his technique by exploiting accidents, cracks and holes as a way of celebrating the history of each work's creation.

> *More recently, I have begun to employ more purposeful breakage. I allow cracks to grow in the greenware or raw stage. This often results in warpage, which leaves pronounced fissures after the pot is rebuilt, indicating a sense of excessive force or violence.*

Autumn Equinox.
Height: 28 cm (11 in).
Photo: John Carlano

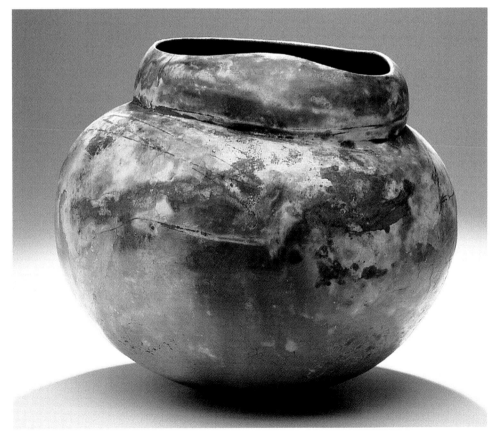

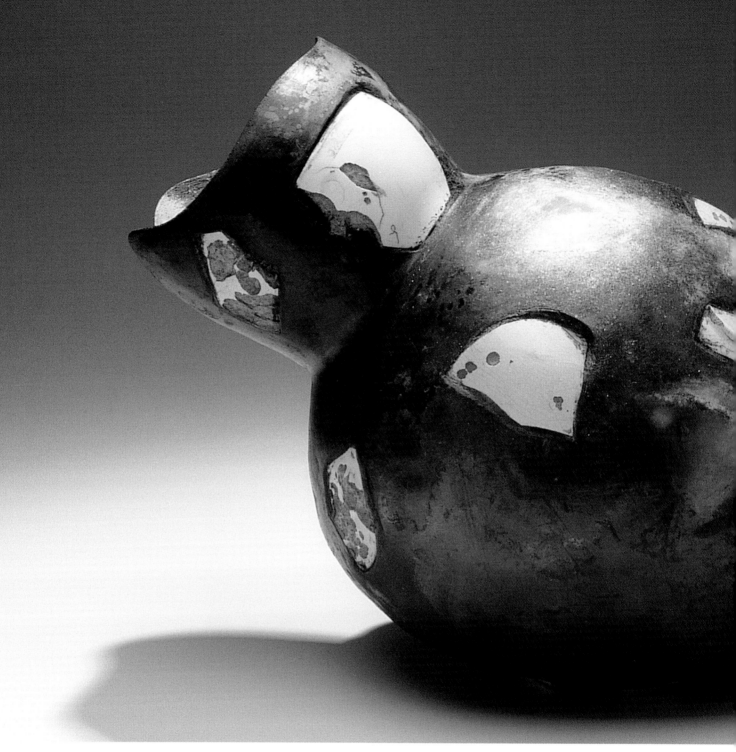

Leda. Height: 31 cm (12 ¼ in). *Photo: John Carlano.*

There are obvious historical references to Anasazi burial pottery, where holes were deliberately made to allow freedom for the spirit.

Clark began his career in the theatre and like many other potters discovered pottery by chance as a hobby. He thought pottery was made exclusively on a potter's wheel, but when his first teacher introduced him to the pinching technique, he felt an immediate affinity with it, realising it was something he could practise at home without any equipment. He discovered Paulus Berensohn's book *Finding One's Way with Clay* and was soon able to make long cylindrical forms by pinching and pulling the clay, incorporating a sense of scale from the very beginning. In the late 1970s and early '80s he went

Preparation for smoke firing with wet newspaper wraps using sulfates and salts.
Photo: Jane Perryman.

Wrapping a sheet of soft clay around a pot to encourage resist and marking contrasts.
Photo: Jane Perryman.

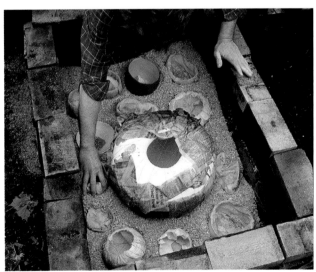

Packing the sawdust firing.
Photo: Jane Perryman.

to live in West Berlin with a theatre company and was able to establish himself there as a potter, making functional glazed ware using his pinching technique. Back in the United States, he concentrated solely on ceramics and in 1986 became the Director of the Clay Studio in Philadelphia, whilst maintaining a parallel career as a

studio artist. Today he directs the ceramics programme at Peters Valley Craft Centre in New Jersey.

Clark's primary influences came from the pottery of numerous cultures and eras, particularly pre-Columbian Latin America, Crete, China, Africa and Egypt. His position as a director of a large ceramic-art centre enabled him to travel to many countries, and during these trips he would collect shards as part of his fascination with 'found' history. He was aware of the paradox that one person's discarded rubbish can be another's treasure. Gradually, he began to incorporate the shards into his work – at first matching the curvature of the shard to the finished piece and cutting out 'windows' in which they could be inserted. This developed into pushing shards into the soft clay so that the position of each one would help define the form. By incorporating shards with a figurative identity such as a human face, or a functional purpose such as a cup handle, he was literally reconstructing history. Recently, he has begun using shards of non-ceramic material such as shells or glass milk-bottle necks. He says,

Early in 2002 I began to notice an abundance of pottery shards in the woods near my home, where most days I went walking with my dog Spencer. I began to collect them, and this compulsive gathering has (since) garnered well over 2000 shards, each found individually. The shards struck me as mysterious time markers, physical manifestations of history. Where did they come from? What caused them to break? What kind of vessel or object did they come from? Who used them?

I purposely decided that I would not dig for sherds but rather restrict myself to collecting them from the ground's surface. The 'harvesting' or 'hunting' for the sherds became intertwined with nature and its cycles. The absolute best time was following a severe rainstorm. The flowing water would wash away the upper layer of topsoil, bringing the shards to the surface. The fallen leaves of autumn followed by winter snows pretty much shut things down until spring. As spring turned to summer other obstacles presented themselves, ticks, thorns, poison ivy and brambles – all extracted a price for the treasure-hunting.

The shards also revealed nature's ageing process. Some, particularly the porcelain ones, were seemingly untouched by time; others, particularly earthenware ones, were often deeply stained or in the throes of returning to the earth. I sometimes pondered whether they welcomed their 'redemption' at my hands or whether I had rudely interrupted one of nature's most basic cycles of death and rebirth. Yet it is precisely rebirth that I seek – it seems a natural extension to me to begin to incorporate these found 'histories' into the created 'histories' of my vessels. It is my hope that both they and perhaps myself will once again be 'whole'.

Clark uses a fine white-firing raku clay, making his forms from pinching and scraping, and working from a single lump of clay over a considerable length of time. The process requires 'resting periods' between work sessions, which he refers to as 'locking in the form'. Although there is some preconceived idea of a defined form, Clark allows the clay to guide him to the ultimate shape of the vessel, giving the pieces a quality of spontaneity, of 'having a life of their own'.

I work best when I don't think too much about what it's supposed to look like in the end. If I can get into the mode of following the clay, it will lead to very beautiful forms, and forced repetition of a clay form kills it for me.

A terra sigillata slip is applied on greenware before a bisque firing to 1060°C (1940°F); sometimes he burnishes the surface and fires to a lower 900°C (1652°F) to retain the burnish.

For many years Clark used fine sawdust in an oil drum, allowing the fire to burn slowly through a reduced airflow, which resulted in deep blacks with the odd flashing of fire marks. Recently, he has been investigating the effects of using coarser sawdust and shavings in a container built of stacked bricks, where the airflow is higher and the firing much faster. The use of salt, copper and iron sulphate sprinkled directly onto the sawdust (he finds that spraying the dry materials with water helps to activate them) can produce surface colour of rusts and ochres. Another method of introducing these oxides and salt into the firing involves sprinkling them onto damp paper, then wrapping the paper around the

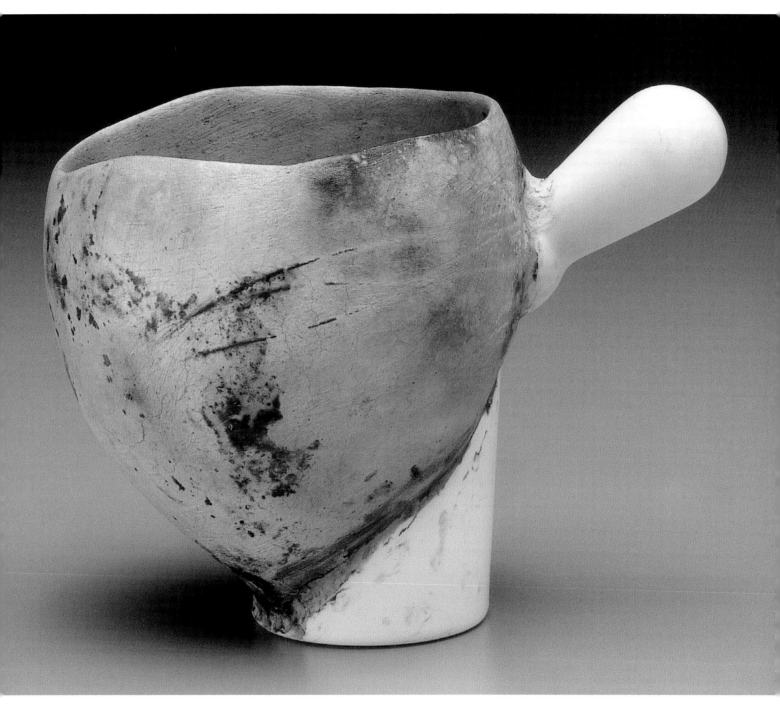

Barbara's Mug. Height: 13 cm (5 in). *Photo: John Carlano.*

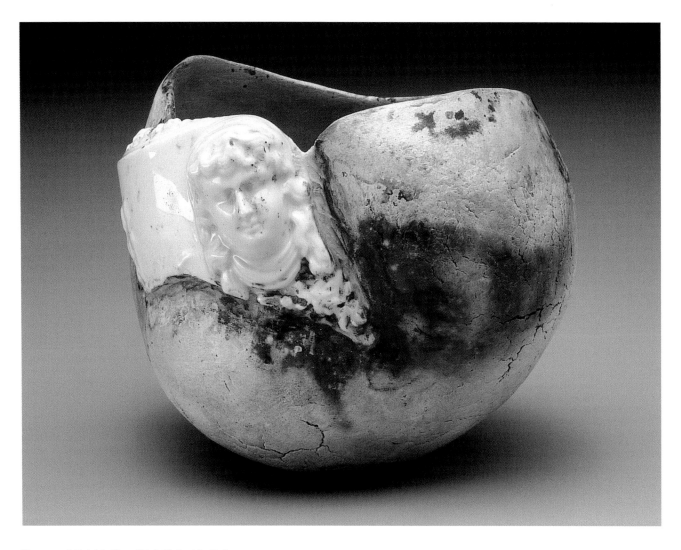

Monument. Height: 13 cm (5 in). *Photo: John Carlano*

pot like a parcel and securing it with wire, a process he refers to as 'wet newspaper wraps'. He also applies terra sigillata to the bisque surface, which will wholly or partially peel off in the sawdust firing, leaving spider-web patterns and lines resembling cartography.

> *I find that these more varied surfaces increase the sense of 'history' for the vessel. The desired result is timeless mystery, a sense that the pot has had a long life of its own, independent of its creator. Despite the many techniques that I have begun to use in my firings, the supreme joy of the method is ongoing unpredictability and a refusal to be controlled. I think of myself as but one of three integral elements that share equal responsibility for the creation of the work: artist, material and fire.*

MADHVI SUBRAHMANIAN

There has been a consistent theme in my work about expressing the idea of 'containing'.

In my kitchen there are two pickle jars bought from the village potter Jaswant Singh in the Kangra Valley of Himachal Pradesh. They are thrown and turned, curving outwards from a narrow base, and swelling to form a belly before returning back towards an elegant neck and lidded top. The surface is painted with terra sigillata slip, transformed during the firing of buffalo dung into a rich patina of oranges and ochres, broken up by fire marks. During the dark months of an English winter they glow with the heat and brilliant colour of India and bring some sunshine into our lives. In a similar way, Madhvi Subrahmanian's exuberant ceramics express the spirit of

Smoke-fired Bowl. Height: 20 cm (8 in). *Photo: Craig Philip*

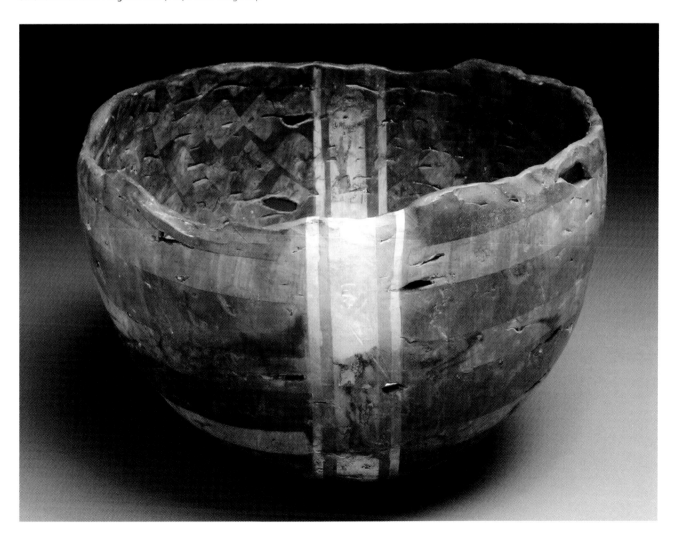

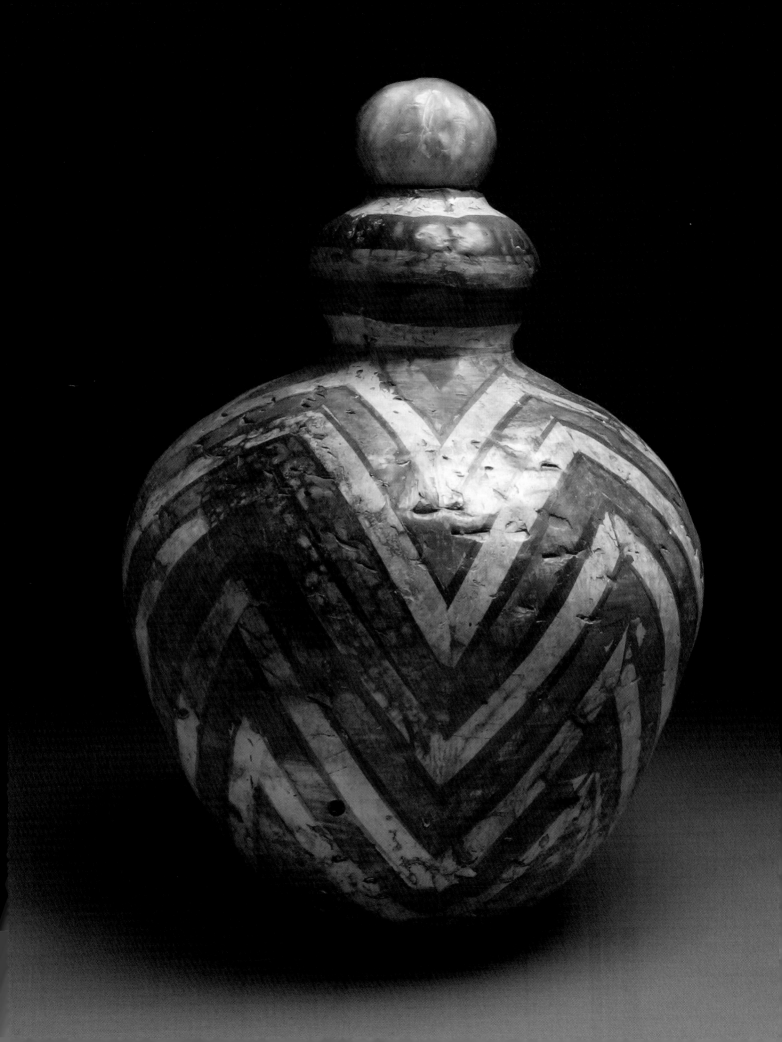

India, particularly the city life of her native Mumbai (Bombay) where the busy streets burst with colour, sound and smells.

Subrahmanian remembers searching as a child for bits of black clay in the grounds of the coal-processing plant next to her father's factory. She loved to fashion it into shapes, but it wasn't until 1985 when she had completed a degree in business and commerce that she was able to learn studio pottery at Golden Bridge Pottery in Pondicherry in southern India. The course is run by Americans Ray Meeker and Deborah Smith and is underpinned by a strong Bernard Leach work ethic. Returning to Mumbai, Subrahmanian set up her first studio, building a wood-fired kiln and making utilitarian glazed ware. In 1989, she accompanied her husband to live in Dallas in the United States, where she carried on making and selling her functional ware at craft fairs.

A pivotal moment presented itself when a customer asked, 'What's special about your pots?' She had to answer, 'Nothing.' Subrahmanian realised she wanted to develop a more personal language through clay and began searching for a way. She worked for a while with a potter who coiled African drums and was further influenced by the traditional techniques of another American potter Martha Otis, who used burnishing and smoke firing with sawdust. Later, her interest in these processes was kindled further by attending a Native American pottery summer school in Taos, New Mexico, where open firing and simple handbuilding methods were taught.

In 1992 she began studying for a graduate degree in Fine Arts and Ceramics at the South Methodist University in Dallas, where her professor encouraged a final move away from utilitarian ware towards developing handbuilt sculptural work. It was here she began experimenting with terra sigillata and brightly coloured glazes, representing for her a crucial 'bit of India' amongst the dull colours of the Western culture she inhabited. During the last 17 years she has moved several times with her husband and children between India, Germany and America, following postings from his company. It can be a lonely and isolating experience to live in another country, but like many other artists and writers, the geographical distance has enabled Subrahmanian to capture something of her native land all the more poignantly.

Fertility Jar. Height: 50 cm (19 3/4 in). *Photo: Craig Philip.*

At graduate school she began 'free-coiling' open organic vessel forms which sprang upwards and outwards from a narrow base. By abandoning any concern with making the coils even or symmetrical, the form grew with natural holes and gaps in the walls. Like ancient Anasazi pottery, where the holes represent a physical opening for the spirit to pass through, they became significant in Subrahmanian's work too. The holes and gaps which came out of the process gave a sense of passage and space between inside and outside, literally allowing the piece to breathe. This open form developed into a lidded form, which in turn led to an exploration of architectural forms – what she calls 'the space you call home'. She says,

There has been a consistent theme in my work about expressing the idea of 'containing'. The hollow space within contains a sense of life, and the outside a sense of protection and nurturing.

During a period of living back in Mumbai, Subrahmanian was introduced to smoke firing when she attended a talk I gave to the studio potters' group. She recognised that smoke firing would suit her mobile existence, readily lending itself to improvisation wherever she found herself living. She started using primal pattern systems from African Tribal Art, along with Indian Rangoli patterns,[1] on the surface of her forms, applying the designs with masking tape before a light smoke firing with newspaper. Subrahmanian talks about the 'punch' of Indian colours. By using a painterly approach, she is able to build up layers of brightly coloured glazes, rubbing down between the layers so that the glaze remained in the pits and crevices before applying terra sigillata slip in the same way. It can often take several firings and applications until she arrives at the desired effect.

The lidded jar has remained a theme, but by adapting the lid to become part of the form the jar has metamorphosed into something more akin to a seed or pod. Her experience of pregnancy and motherhood has reinforced the containing and nurturing qualities she wanted to convey in her work. During her last pregnancy she used the swelling of her stomach as a model for a plaster mould that she used to make an enclosed ceramic form, literally holding the essence of life. More recently, she has been working with the relationship of two forms presented together and with families of forms which become wall installations.

Building up the design with masking tape.
Photo: Madhvi Subrahmanian

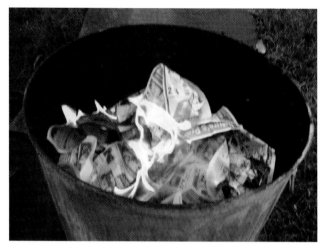
Fast-firing with newspaper in a metal bin.
Photo: Madhvi Subrahmanian

After the smoke firing the tape has partially burnt away and resisted the smoke.
Photo: Madhvi Subrahmanian

Duality is a big part of life – male/female, traditional/ modern – and I have to live with both demons.

She uses a white earthenware clay and begins the form with a slab of clay pressed into a *puki* (a bisque-fired dish). The free-coiling technique gives the work a sense of fluidity and movement. Handbuilding with coils requires time for the clay to dry slightly before more height is added. Subrahmanian smoothes and shapes the clay wall with curved flat tools as she builds it up, in the same way that village potters from India and Native American potters have done for centuries. Terra sigillata is applied with a brush before a bisque firing to 955°C (1751°F). A design is applied to the surface with masking tape and a second application of terra sigillata (a contrasting colour) added before a second firing to the same temperature. Before smoke firing inside a metal bin with newspaper, Subrahmanian builds up another pattern with tape which will act as a resist, lending dark outlines and sections to the surface. Finally, the piece is cleaned and waxed.

Notes
1 Sacred patterns formed with rice powder on the threshold and mud floor of an Indian house.

Technical notes
White terra sigillata
Water	2100gm
OM4 ball clay	200gm (fine-grained)
EPK	75gm (white-firing kaolin)
Talc	150gm
Ultrox	50gm (Zircopax)
Calgon	25gm

Red terra sigillata
Water	2400gm
Red art	300gm (red-firing earthenware)
Red iron oxide	300gm
Calgon	30gm

The terra sigillata is not ball-milled but simply mixed together, and therefore imperfect.

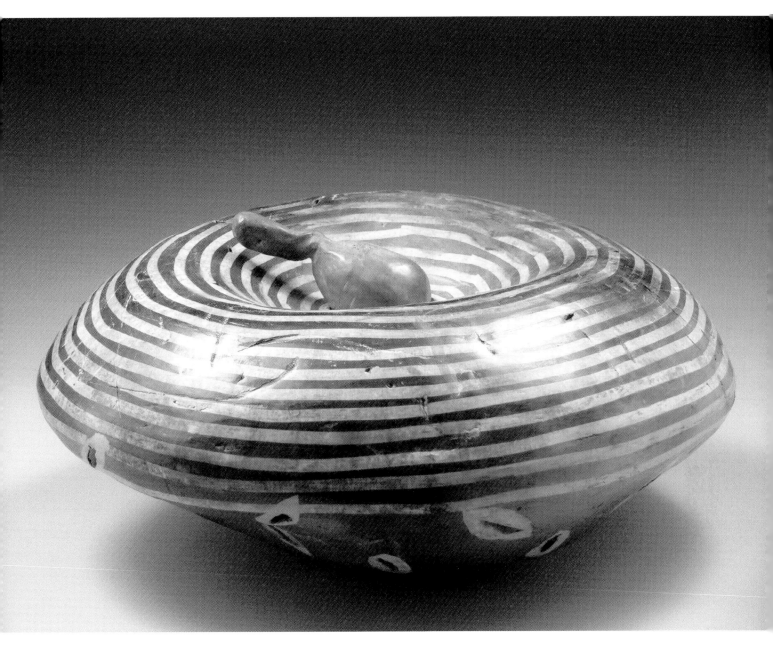

Mortar and Pestle. Width: 30 cm (12 in). *Photo: Craig Philip*

5 SMOKE FIRING IN A PIT

The ceramicists in this section fire their work in a dug-out pit in the ground. The practice developed in California during the 1970s and '80s, partly inspired by the explorations into low-temperature firing techniques by the ceramicist and educator Hal Riegger. Pit firing was seen as a more immediate pottery experience than firing in a standard kiln, reflecting an interest in practising and teaching ceramics as a 'happening' event in itself. Because a large number of pieces can be fired at once, pit firing is an ideal opportunity for communal firing and socialising. The size and depth of the pit will depend on the quantity and size of the pieces to be fired, and can be dug into earth or sand. Gudrun Kainz built a permanent structure, a brick-lined pit, to withstand the severe Austrian winters. The small earthen pit of Signe Lassen is covered with metal sheeting to restrict smoke pollution in her residential neighbourhood. Jane Burton digs a temporary pit in beach sand for each firing (whose salt content probably enhances the colours), which is reinforced with metal sheeting to avoid the danger of collapse.

Fuel is usually a combination of sawdust, wood and cow dung; the quantities used will affect the colour as much as the use of organic materials, salts and oxides. Kainz and Burton partly cover their pit-firings with metal sheets and achieve a range of vivid colours through volatisation, while Lassen's pit is completely covered, resulting in darker, muted colouring.

Jane Burton, **Rip Tides** (detail). *Photo: Sibila Savage*

JANE BURTON

My pieces deal with layers of time and space

Jane Burton is an American ceramicist who lives in the suburbs of San Francisco, where she has been investigating pit firing for ten years. She has adopted the Californian tradition of firing on the beach because of the state's environmental fire restrictions. The drama of pit firing is always exciting, but when it takes place with the expansive backdrop of the Pacific Ocean it becomes an event. Burton works with simple large-scale vessel forms, building up layers of patterns and marks with terra sigillata slips, applications of copper, salt and organic materials. The surface effects display qualities which are not unlike oriental carpets, with their rich patina of colours and designs. Golden ochres, rusts, deep crimsons and magentas are broken up by swirling linear patterns softened by smoke marks ranging from black to grey. Burton says of her practice,

I am pulled towards working with the vessel form, for its simplicity. It represents the body as a shell, a means of transportation through the layers. Like the human figure, it is universally understood throughout cultures and civilizations. Yet it is devoid of the features to which we usually attach meaning. My pieces deal with layers of time and space, the power of the soul to

Rip Tides (detail). *Photo: Sibila Savage*

endure throughout the ages, to struggle, to battle, to grow, and ultimately to transcend both time and space.

Burton initially trained in fine arts, followed a postgraduate degree in graphic design in the 1970s, and it was not until 20 years later in 1996 that she discovered clay and fire. During a holiday at the Ghost Ranch in Abiquiu, New Mexico, she was encouraged to take a Native American pottery class in pit firing. Burton's inner fire was kindled by this experience, and once back home she joined the local Civic Arts Centre in Walnut Creek, where she immersed herself in classes and workshops. She concentrated on the ancient techniques of pinching, coiling and burnishing, and of open firing and pit firing. She quickly became addicted. Ceramics provided her with an immediate tool for self-expression, something she had not experienced in the graphic arts. Never attracted to glazing, she preferred the naked clay body to remain visible, and enjoyed the direct contact with process she discovered through pit firing.

Her work is mostly handbuilt by coiling and slabbing processes, using a white or buff stoneware clay. A white terra sigillata slip is applied, then a design built up with masking tape or wax followed by a second sigillata application of a contrasting colour such as red terracotta. The bisque firing to around 900°C (1652°F) is followed by the application of a wide range of materials to the surface, which will develop into rich colours and patterns during the pit firing (see below).

Burton uses a local beach to dig her pit. The soft sand has the obvious advantage of making it easy to dig a pit quickly, the size of which is also easy to alter according to different requirements. The pit is rectangular in shape and dug to a depth of about 120 cm (48 in); the sides are lined with sheet metal, which is kept in place with steel poles to avoid collapse. The bisqueware is placed onto a bed of sawdust 30 cm (12 in) deep; where it is resting directly against the sawdust it will turn a deep, sometimes metallic black. Salts and copper oxides are sprinkled liberally in between the pieces, and the pile is covered with dried cow dung. This will insulate the work from the burning wood when the fire is first alight, and from the cool air as it dies down (it can also produce an orange colour during firing). Layers of wood and kindling are piled on top of the dung and ignited from the top using lighter fluid. After 20 minutes of

fierce burning the pit is covered with sheets of corrugated steel to allow a slower, hotter fire and to encourage darker colours. Spaces are left at either end to facilitate a cross-draught.

The fire takes about six to eight hours to burn down, having reached temperatures of up to 920°C (1688°F) at its height. Retrieving the pieces from the ashes gives the sense of anticipation experienced by archaeologists working on a dig or unearthing treasure.

I prefer pit firing for the excitement of the process, its unexpected results, its historic beginnings and ancient qualities. I am constantly experimenting with new methods and materials that create depth, colour, pattern

Rip Tides. Height: 62 cm (24½ in).
Photo: Sibila Savage.

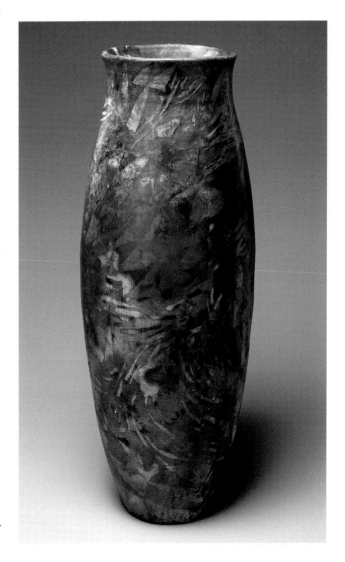

Preparation – wrapping the pot with seaweed inside a cloth soaked in salts (then dried).
Photo: Jane Perryman

The pot has been wrapped with newspaper and tape to keep the surface in close proximity to the salts, and is being laid onto a bed of sawdust inside the pit.
Photo: Jane Perryman

Igniting the pit, which has been packed with dried cow dung and wood.
Photo: Jane Perryman.

– juxtaposed against the richness of the naked clay body. My passion is for the process: the creation of the work, and discovery of new and unrevealed ideas.

Technical notes

Pit firing materials suggested by Jane Burton:

Copper wire: wrapped tightly around the piece, this will create black, red or green lines.

Copper foil: sticky-back copper foil, used for stained glass or as snail-repellent, creates black shapes and red flashings.

Copper scrubbies: kitchen scrubs, cut apart and wrapped around the piece, create red and orange flashing.

Copper pens: available from art/craft suppliers, these are useful for writing and for drawing fine lines, and create red and orange flashing.

Copper ink: available in bottles or ink pads.

Copper or gold spray paint: can be used in conjunction with stencils.

Steel wool: a few strands taped to the ceramic surface can produce orange lines.

Seaweed: wrapped around the piece, this can produce orange, peach and red.

Copper or iron dips (submerge piece in solution and dry before firing): Take 2 - 4 gallons of water (US measurement). Saturate with table salt until it won't dissolve anymore. Add 1 - 2 cups of copper carbonate (US measurement), or as an alternative add ½ – ¼ cup of iron oxide.

Most of these materials release fumes which create the colour effects and dramatic marking. The materials need to touch the ceramic surface as much as possible during the firing in order to effectively trap the fumes – this can be achieved by wrapping the piece in newspaper and securing it in place with tape or wire.

The pit firing at Dillon Beach, N. California.
Photo: Jane Perryman.

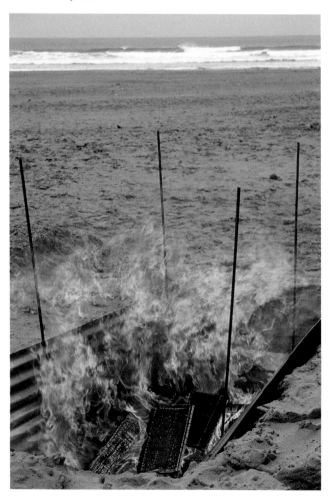

GUDRUN KAINZ

Leaving my work and its surface to the random firing is a challenge and a need at the same time.

The Austrian ceramicist Gudrun Kainz lives and works in Wiener Neustadt near Vienna, where she has been exploring pit-firing techniques since 1998. During this time she has developed expertise in the alchemy of combining combustibles, salts, oxides and fire to produce a range of vibrant colours and designs. These are defined by dramatic rippling and swirling patterns that can appear on the surface like storm clouds or the movement of volcanic lava. Her simple forms are a blank canvas for the explosion of colours, from cobalt blues, purples, crimsons, pinks, oranges and yellows to the deepest blacks. The surfaces express the excitement of pit firing, with its raging open fire and the chemical reactions taking place through the fuming and migrating of oxides and salts. She says,

My work is a symbiosis between shape and coloured surface. The first part is my task – bringing this material into organic shape. To work with clay, with its characteristic condition, means to me that I lead the soft material into shape. The second part is done by the fire. My influence is little and just approximate. Leaving my work and its surface to the random firing is a challenge and a need at the same time. It sometimes changes the character of the piece totally.

There are many similarities between musicians and ceramicists, both in the long practice needed to acquire skill and also a shared language of expression that can stir the emotions. Kainz pursued both disciplines – at the

Boat. Length: 27 cm (10½ in). *Photo: Gudrun Kainz.*

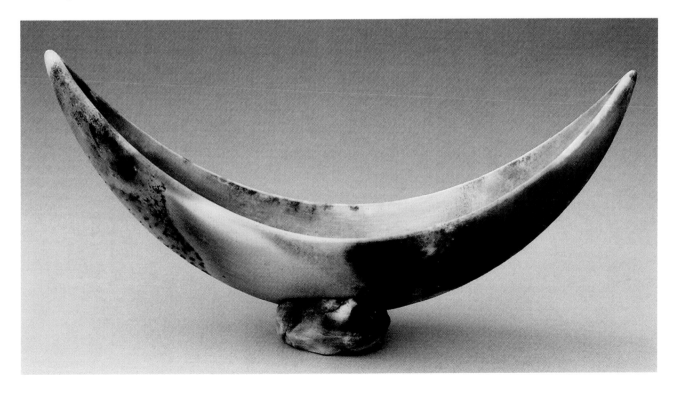

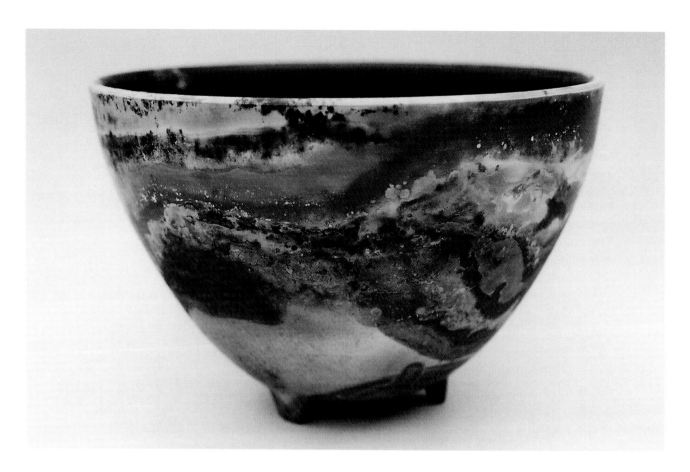

Bowl. Height diameter: 17 cm (6¾ in). *Photo: Gudrun Kainz*

School for Ceramics in Stoob, Austria, and at the Konservatorium in Wiener Neustadt, where she studied classical guitar. Today she combines studio practice with art therapy, as well as playing in small concerts. Kainz began her ceramic career by producing thrown functional tableware fired in an electric kiln, but after attending some workshops in England given by Richard Wilson and Seth Cardew, she saw other possibilities. She also attended one of my summer workshops in handbuilding and smoke firing, which further encouraged an interest in low-temperature firing methods. She says,

> After my experiences in England I changed my shapes to abstract forms more and more. Bowls first lost their feet and then turned to boats, stones, horns, cones ... I love to explore the tension between vessel and object. Building vessels out of slabs enriched my possibilities. The vessel is still a very important theme to me, the inside in relation to the outside, the ability to hold and hide ... I like to give my objects this characteristic

smooth surface by polishing them several times with a pebble. The surface not only becomes more tactile, this treatment also makes it more dense, gives the piece some kind of 'clothing' which is light enough to let the object breathe. Touching the piece should be a part of experiencing the work, and opens up the possibility to be touched.

Kainz uses a white or red Westerwalder stoneware clay, which she mixes with Limoges porcelain (ratio 3:1), or for larger pieces a grogged clay is used. Forms are either wheel-thrown or slabbed, and are then further manipulated by hand using a wide range of techniques such as pressing, pulling, pinching, cutting, hitting and grating. Some pieces are treated with coloured slip before being burnished with pebbles and then bisque-fired to between 870–950°C (1598-1742°F). The pit she has built (5 m/16 ft 4 in long x 2 m/6 ft 7 in wide x 1.6 m/5 ft 3 in deep) is rather like a sunken bath lined with bricks, with steps leading down into the base. A raised bench surrounds

Making a newspaper/clay slurry 'parcel' containing salts, oxides and organic material.
Photo: Gudrun Kainz

Placing the 'parcels' on a bed of sawdust inside the pit.
Photo: Gudrun Kainz

The pots have been covered with wood and will be ignited.
Photo: Gudrun Kainz.

the top, where the ceramic work can be placed prior to and after the firing. For several years the pit was just a hole in the ground, but because of severe Austrian winter weather conditions it expanded, and thus it was necessary to build a permanent structure.

At first I put a layer of sawdust on the ground (fine or coarse, about 10cm/4in. high). Then I place the

bisque-fired work. Underneath and between the pieces I sprinkle salt, copper carbonate, red iron oxide, copper sulphate, as well as organic material such as banana skins, avocado skins and stones, straw, dried grass, seaweed and so on. I like to soak these things in salt and oxide solutions, but also use them as they are, fresh or dried. The salt solution I use to prepare sheets of fabric, which I wrap around the ceramic work after drying. In addition I like to work with saggars made out of newspaper and slurry; a few layers of newspaper, each painted with clay slurry. On the last sheet of paper I put salt and all the other oxides and organic stuff, as mentioned above. I wrap the layers of newspaper around the pot and fix it with masking tape or string. These packages I put into the sawdust in the pit. These kinds of saggars can also be made out of just a paper bag, without slurry, but it gives different effects. To wind copper wire around the piece, steel wool or soaked string, gives lines from red to black. Strips of soft clay protect the surface from smoke. If I want the surface to be broken by a crackly design, I paint on slip made out of different clays, sometimes containing salt and oxides. This layer of slip is washed down after the firing.

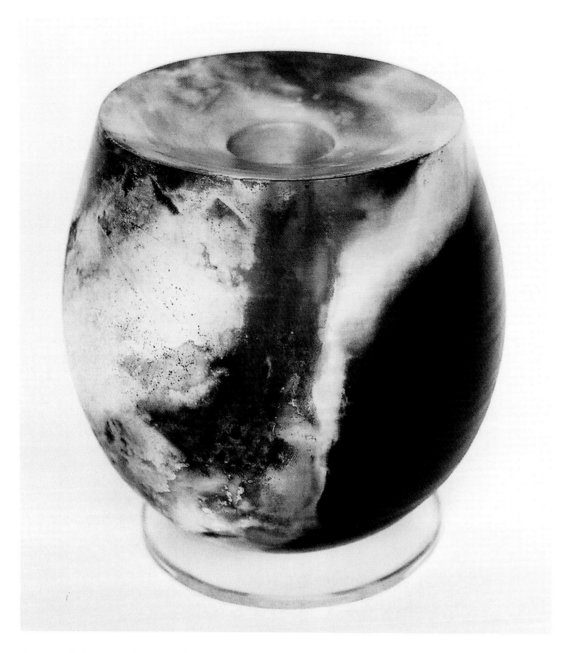

Double Walled Bowl. Height: 16 cm (6¼ in). *Photo: Gudrun Kainz.*

Firings are carried out in the evenings and unpacking completed on the third day. The pile is covered with wood shavings, then some small pieces of wood. Solid metal bars are lain across the inner part of the pit around 30 cm (12 in) apart, which will protect the work from the weight of the wood above. Next the pit is filled with pinewood and almost covered with metal sheets, which can be moved to control the airflow and the speed of fir-ing. The wood is lit from one end, and as it burns down the pit is completely covered to slow the cooling process.

Kainz is working with unpredictable basic elements and thus has to be aware of weather conditions such as humidity and wind, which can affect the colour and the marking results. But she does not let the weather deter her, being able, for instance, to pack and fire the pit in the rain by using the metal sheets as a 'roof'.

SIGNE LASSEN

My work is mainly about the transformation of energy and the stream of life.

For almost a decade, the Danish ceramicist Signe Lassen has lived in Bornholm, a small granite island in the Baltic Sea whose brilliant light and landscape of rolling hills and forests, together with its coastline of rocks and sand, has inspired generations of artists. Its rich history has been revealed through archaeological excavation, and its Neolithic burial mounds represent a reminder of ancient cultures. The mysterious symbols and geometric forms engraved into the rocks are attributed to its Bronze Age inhabitants. Lassen's open vessels, which she calls 'crucibles', spring up from narrow bases and have the appearance of ancient bronzes dug from the earth. The surfaces are broken up by subtly defined lines which criss-cross the form, containing areas of mottled texture and subdued colours of grey, ochre and blue reminiscent of weathered rock or metal. This experience of living on Bornholm and its influence on her work is something she has reflected upon:

> I cannot say that I am especially inspired by anything – at least I am not aware of it. Images – ideas of forms – simply appear in front of my 'inner eye'. I have never felt a need to do any initial sketching, and I work directly and intuitively when experimenting with new forms. I do believe, however, that you will be influenced by whatever surrounds you whether you are conscious about it or not. Living here has probably somehow 'rubbed off' on me. My work is mainly about the transformation of energy and the stream of life. When working with clay I get a feeling of having borrowed a small lump of the Earth, and of being in a magic process of changing it into something visually beautiful, which can be given back to the Earth, and hopefully much more easily understood by its inhabitants in its changed form. It is my hope that the energy I feel present when working with clay and fire will somehow affect the audience and bring them peace – even if only for a little while.

Lassen studied ceramics at the School of Glass and Ceramics on Bornholm in the mid-to-late 1990s, where she was introduced to low-temperature smoke firing techniques. Whilst training on a student programme with the English raku potter John Wheeldon, she was further inspired by contact with a wide range of British ceramicists working in this tradition; her final examination project combined both raku and smoke firing using refractory slip and glaze to produce smoke markings. Since that time she has narrowed her working processes further:

> During the last couple of years I have left the raku techniques completely, finding the act of glazing and

Crucible. Height: 23 cm (9 in). *Photo: Signe Lassen.*

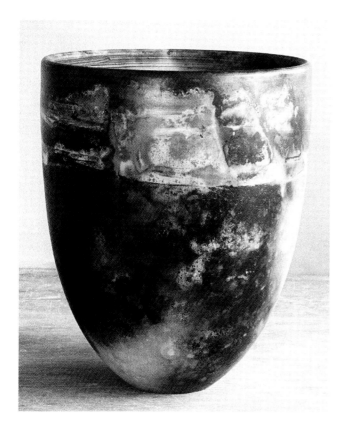

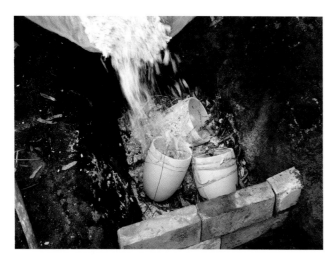

Pots have been wrapped with salt-sarurated string and copper wire; mosses, leaves and seaweed are also tied to the surface for special markings.
Photo: Signe Lassen

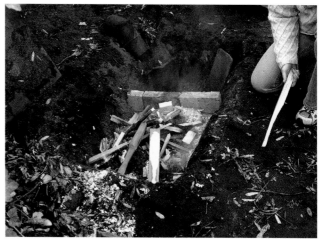

The pieces are covered with a thick layer of shavings, then twigs, woodchips and wood.
Photo: Signe Lassen

The pit has been covered with metal sheets and soil.
Photo: Signe Lassen.

the glazes themselves increasingly tedious. Also it is getting more and more important to me to find the warmth and softness that the clay itself offers, and to try to bring a message of the value and importance of simplicity. I have within me a deep longing for simplicity in life and quietness of mind. I believe this to be the main reason why I have become so strongly attracted to the smoke-firing techniques.

Lassen throws the forms with an industrial white stoneware clay from Germany, mixed with fine grog. The outer surface is polished in a wet state at the wheel with a wooden and rubber kidney; insides are left so as to retain throwing marks. After turning and fine-tuning the form, the surface is repolished with a wooden kidney before receiving an application of terra sigillata slip. It is usually white but sometimes mixed with varying amounts of local iron-bearing clays. If additional shine is desired, the surface is polished between the leatherhard and bone-dry stages with a sheet of polythene wrapped around a finger. A bisque firing to 960°C (1760°F) follows. Lassen has recently moved into Ronne, Bornholm's major town, and needed to adapt her smoke firing (which had been carried out above ground) to the social demands of a residential area. She decided it was safer and more considerate to dig a pit in a corner of the small garden, so as to reduce the smoke. This she has designed so that she can reduce the size of the firing chamber according to the number and size of pieces to be fired by building a loose wall of bricks inside.

Being a new experience to me, firing in the ground is a challenge which I believe I will overcome by trial and error. Results so far have been quite all right, though I still need to figure out how to obtain clearer colouring.

Pots are prepared by wrapping with wet string saturated with salt and copper wire, which both give a linear design; sometimes mosses, leaves, shavings or seaweeds are tied to the surface for special markings. Pieces are then placed leaning against one another in the pit – sometimes separated by crumpled newspapers or garden trimmings to ensure air pockets and clearer flames. Fine sawdust is used to give blacker areas. Copper sulphate and/or salt is

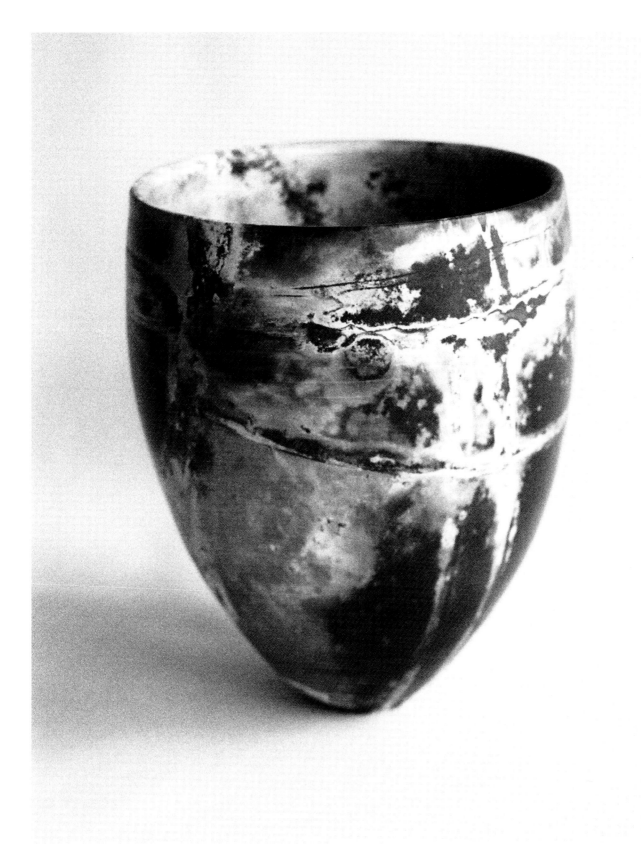

Crucible. Height: 23 cm (9 in). *Photo: Signe Lassen*

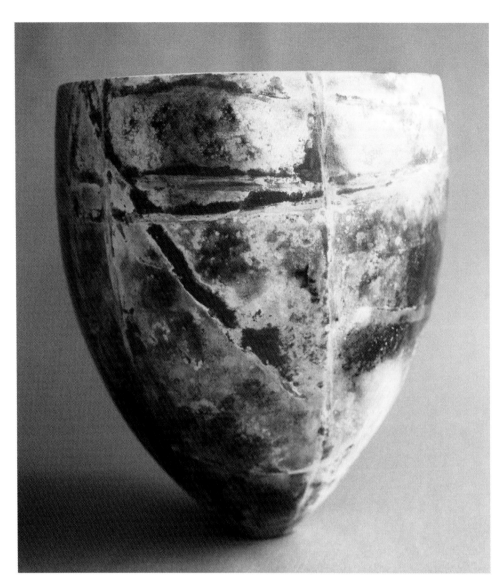

sprinkled directly on and around the pieces, attaching it-self to the surfaces where the wet string is tied. The pieces are covered with a thick layer of shavings, followed by a layer of twigs and woodchips to slow down the combustion at the beginning of the firing. A fire is built on top and set alight, then stoked repeatedly until a suitable amount of charcoal can be spread out evenly just before the pit is closed. The pit is covered with iron sheets followed by a layer of soil; certain parts are left uncovered to ensure a draught.

The amount of oxygen is controlled either by closing the air holes completely with soil, or by lifting corners of the iron sheet covers, which encourages clear flame and creates movement in the fumes from the salt and copper. For darker, smokier results she keeps the pit almost com-pletely sealed, allowing only sufficient oxygen for the combustion to happen. After the firing the pit is left for 24 hours until the fire dies out completely. Finally, the pieces are polished with furniture wax, signifying the end of a process she finds very enriching.

Lighting up a pit fire leaves me in a state of mind that resembles that of meditation. It is the point of the creating process where I can let go of control and leave my work to the elemental forces and the vagaries of chance. This forces me to look at them as a part of a greater whole; as something outside the range of my ego. In the constant striving for bigger, better and faster results in our world today, the process leaves me relaxed and deeply satisfied.

II
Smoke firing
with a kiln

- Smoke firing in a saggar
- Smoke firing in a kiln
- Smoke firing post raku

Detail from work by Jane Perryman.

6

SMOKE FIRING IN A SAGGAR

Saggars were originally developed for industry to protect pottery from the effects of impure fuel such as coal. The ceramic artists in this section have turned the tradition inside out by packing their work with combustible and volatile materials inside saggars to trap the drama and effects of fire. The saggars are placed and fired inside modern kilns. Traditional clay saggars have been adapted into a variety of alternatives including building the saggar with bricks directly inside the kiln, using found metal containers (such as paint tins or stainless-steel sinks) and the construction of purpose-built saggars with paper and clay slip. The temperature and atmosphere of the firing can be controlled easily because the heat source comes from the kiln, not from the burning combustibles. The saggar can be completely or partially sealed to give a heavy or marginal reducing atmosphere.

The variables and versatility of saggar firing can be used in a controlled way to achieve surface consistency such as the black work of Eva Marie Kothe and Magdalene Odundo, or in the linear designs of Duncan Ross. Pao Fei Yang and Alison Tinker work more freely using salts and oxides to achieve dramatic colour variations in their work and I layer the saggar with sand and sawdust to achieve tonal and textural contrast. The high temperatures used by Sebastian Blackie and Nattinee Satawatthamrong result in near vitrification of the clay, which develops rock-like surfaces and deep colours. Saggar firing can be approached as an urban solution to fire and smoke restrictions or lack of access to rural space.

Eva Marie Kothe, **Smoke-fired Vase** (detail). *Photo: Nisse Peterson.*

MAGDALENE ODUNDO

I am interested in the form – the firing is incidental and exists to enhance the pieces

Magdalene Odundo referred to the intensive pottery tuition she received whilst on a student trip to the Abuja pottery in Nigeria as having taught her 'humility for clay'.[1] Could it be that this humility, which has remained with her from those early days, represents the core strength of her achievement as a leading ceramic artist? Odundo's work is contemporary and sophisticated, but its power to arouse emotion stems as much from its feeling of tenderness as its sense of potency. These enigmatic qualities are rarely expressed together in any art form, but in ceramics they arise from a profound empathy with the clay as material – as something to respect and nurture rather than to control. Today, 30 years later, she is in a very

Carbonised Vessel, 1997–8. Height: 61 cm (24 in).
Photo: Abbas Nazari.

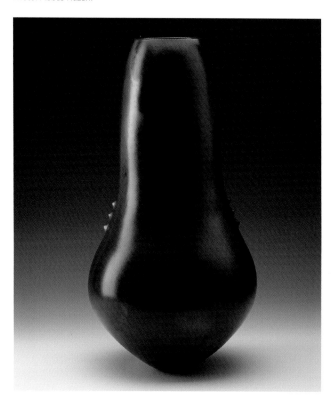

different place, which she describes as being 'free of technique'. Having established her voice it is as if she and the clay are one. She has said,

> *In Nigeria, I learned to look and listen. By listening to people who made art, it became apparent that ambition wasn't enough to make you a potter. Patience was the vital ingredient, and you had to learn to observe, to participate in pot-making, carving, weaving; the act of knowing wasn't just thinking, it was a totality. It was more than apprenticeship, it was a form of engagement and adoption.*

During a recent visit to her studio I asked her how her perception of the world has been moulded through ceramic activity, in her roles as maker, professor, curator and international traveller.

> *Objects speak. Making objects is a human condition, it gives you a ticket to humanity and allows a dialogue with others. Ceramics has an edge because it is so universal, and I feel it's a privilege to have this international perspective.*

Odundo came to England in 1971 from Nairobi in Kenya, where she had been working as a graphic artist. She was given a scholarship to study on the foundation course at Cambridge College of Arts and Technology, where she discovered the ceramics collection at the Fitzwilliam Museum and the pre-Columbian collection of pots at the Museum of Archaeology and Anthropology. From there she was encouraged to take the ceramics course at Farnham College of Art for three years, studying under Henry Hammond. During a college trip to Cornwall in her first year she met Bernard Leach and later Michael Cardew, which connected her to Abuja

Carbonised Vessel, 1987.
Photo: Duncan Ross.

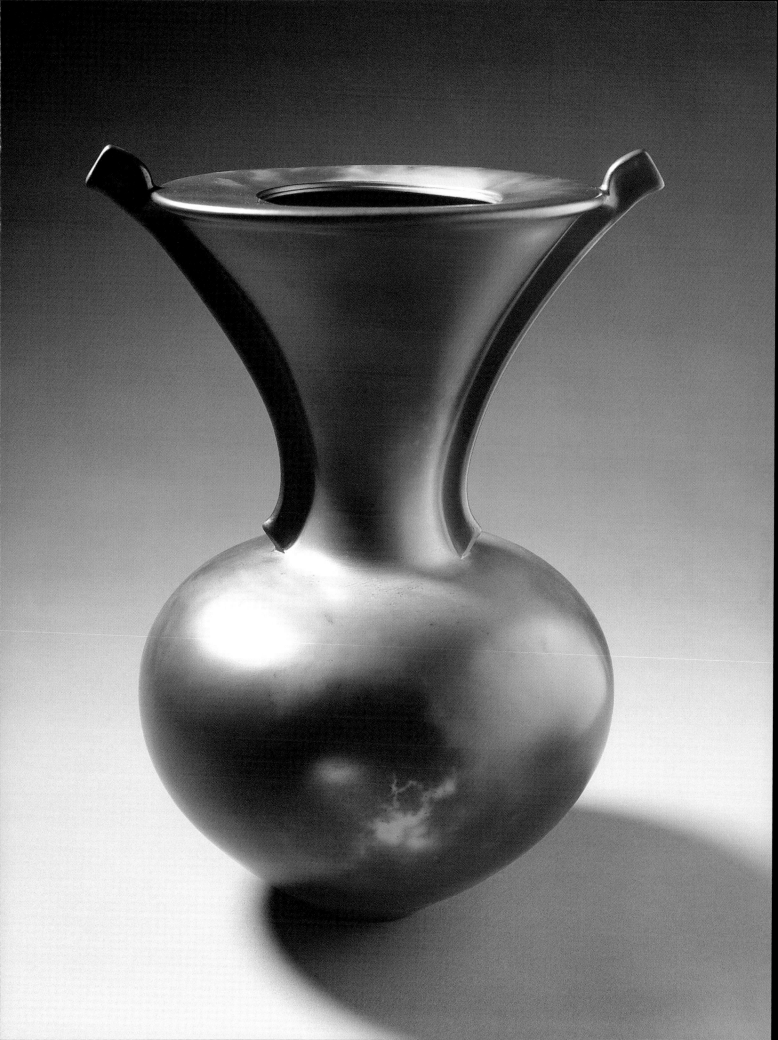

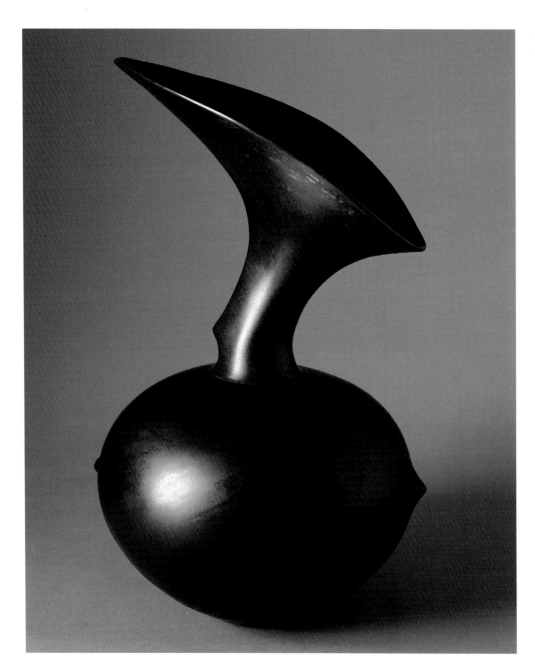

Pottery, the training centre Cardew had set up in Nigeria. She worked there for three months, learning throwing, handbuilding, kiln-building and firing, and received tuition from Ladi Kwali in the traditional Gwari techniques. She began handbuilding during her final year, and describes her work at that time:

> *I found it physically satisfying to make large handbuilt pieces, but there was nothing personal in the work; it was derivative. I was using high-temperature glazes.*

Travels in Southern California and New Mexico led her to visit Maria Martinez, where she remembers,

> *The Blackware blew my mind. I had seen that black in Nigeria, and began to realise how universal ceramics are.*

Thus, during a relatively short period Odundo had managed to rub shoulders with some of the giants of ceramics from different parts of the world. The experiences sparked a lifelong interest in studying ceramics on a global level and helped to lay the foundations for her own ceramic

identity. From 1976 to 1979, she was in charge of African Studies at the Commonwealth Institute in London, and used their collection of artefacts to teach children. From here she went to the Royal College of Art, initially for an MA by thesis, researching into raw materials and low-cost firings with the aim of gaining the knowledge to set up a workshop in Kenya along the same lines as Abuja Pottery. She was persuaded by her tutors to combine this research with her own pot-making, and began burnishing and experimenting with carbonising and saggar firing. Everything came together in the pots she presented for her final degree show in 1982: her connection with handbuilt African pots, the influence of burnished black-fired Pueblo pottery, and her investigations into low-firing techniques.

The American writer Susan Peterson has described Odundo's work: 'Each pot is made to have the stillness of a dancer frozen at a particular moment in the dance, with balance secure yet full of tension'. Emmanuel Cooper[2] has described her fascination with the dance performances taking place at the Commonwealth Institute – the stance, movement and posture expressed through the human body. Odundo's forms are imbued with a host of multicultural and historical associations, but what grabs the immediate attention are qualities of movement and stillness expressed together. She has talked of being

> attracted to something that is almost a kind of electricity in how pliable the body can be. Thus with plastic clay, which, while it is capable of being shaped to capture that mesmerising, hypnotic achievement, the pot ends up in a motionless state. That is what I try to capture.[3]

Over the years Odundo has explored a repertoire of forms through repetition. The archetypal shape is enclosed, containing something of secrecy and mystery. It swells out from a narrow base, then curves back inwards before rising up again through a neck and flaring out into an opening whose angle can still the eye or emphasise movement depending on its horizontal or diagonal plane. Her variations on this theme are primarily interpreted through either a symmetrical or an asymmetrical profile. Symmetrical forms express energy about to be released through the tension of internal volume, whereas the asymmetrical forms contain strong anthropomorphic

qualities, mainly female, and a sense of more dramatic movement. Raised nipples, seams and nodules of clay added to the surface make further allusions to the human body: an erect nipple on a breast, a pregnant woman's navel or the hungry belly of a child.

Since the late 1990s, Odundo has worked with another, simpler form, larger in scale (77 cm/30 in high), cylindrical, with less-defined curves, whose gender definition could be male or neutral.

> I have become obsessed with form. What was once an embellishment has now become an engagement ... I always want to go a bit further. I want to surprise myself ... When I begin to build a structure, I do a lot of drawing in-between refining, revising, reworking, abstracting ideas from what is there. I work on a lot of pieces at the same time. I do a lot of drawing in-between, to alter, to change. Even when I start off with a specific idea within a series, it never ends up like

Carbonised Vessel, 1997/8. Height: 46 cm (18 in).
Photo: Abbas Nazari.

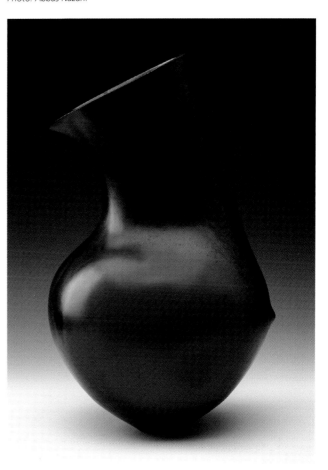

Work in progress in the studio.
Photo: Jane Perryman.

that. For all the amount of drawing, planning and saying that I am going to create a certain shape, they never get realised. They always metamorphose from what they were intended to be. You add, you subtract, you extract information – it is an ongoing dialogue. Then I get up and look at the pieces, get angry with them, like them or dislike them, and sometimes towards the end I get surprised, especially with those that gave me a hard time … My work is like a child, you have hopes for them when they are born, then, when they reach the age of fifteen, you want to throttle them. I start and hope that work will develop as a union of several pieces, but the relationship of several parallel pieces that are being created at the same [time] is very complicated. You have to give the work space.

Magdalene uses a mixture of marl clay and brick clay which is slaked, then mixed and sieved. The pots are handbuilt using the traditional techniques Odundo learnt from the female Gwari potters of hollowing out a lump of clay, then pulling up the walls until the shape is created, and finally forming the shape with short coils of clay. The surface is burnished with spoons and pebbles, then covered with a terra sigillata slip and polished. Once fired this smooth, shiny surface will enhance the pot's tactility and seductive power. After the bisque firing of around 960°C (1760°F), the pots are placed in a saggar containing wood shavings or woodchips, and fired to between 900-1060°C (1652-1940°F) depending on the colour required. Results vary from velvet matt black to metallic; some are left partially carbonised with patches of red clay and some completely red from an oxidised firing. She has said,

> *I am not enamoured of the firings; I am interested in the form – the firing is incidental and exists to enhance the pieces; it is not there as some magical thing. After months of investment, the firing is such a final moment, you want to prolong it – it's like life. You want it to go on and on. I enjoy making, much more than finalising the work. I hate making those final decisions, but it is an essential and inevitable part of ceramics that you can't do away with.*

Notes

1, 2, 3 Emmanuel Cooper, 'The Clay of Life: The Ceramic Vessels of Magdalene Odundo' in *Magdalene Odundo*, edited by Anthony Slayter – Ralph (Aldershot: Lund Humphries, 2004).

RICHARD NOTKIN

I am asking questions in my art that I intend to be directed at everyone

The American ceramicist Richard Notkin has said,

> *The responsibility of each artist is to place himself or herself at the mercy of inspiration, and to be productive. The results of the best of this work, in all its diversity, will write the history of ceramics, whatever its nature.*

Notkin has already won a place in the history of ceramics as a leading figure in the postmodern ceramic movement with his overtly political work based on the traditional Yixing teapots of China. More recently, large-scale sculptural installations have given expression to his grave concerns with the social and political dilemmas of our world. His work has been collected and exhibited by museums and galleries throughout the world; he has also won prestigious awards and fellowships, and has shared his knowledge as an educationalist in many colleges and international workshops. He is represented by the Garth Clark Gallery in New York and lives in Helena, Montana.

Notkin's father was an immigration lawyer who represented Chinese clients and was regularly given gifts of Chinese ceramics, scrolls, wood and ivory carvings, which were displayed in the family home. From an early age Notkin developed a fascination with the fine craftsmanship and intricacies of these objects, which he recognises were a major influence on his work. At high school his art skills were encouraged by mentor and teacher Robert Erickson, who steered him away from near juvenile delinquency towards a life with purpose through art. Growing up in Chicago he was able to visit the city's museums and art galleries, where he discovered the surrealist painters, and was particularly impressed by Salvador Dalí, René Magritte, Yves Tanguy and Max Ernst. Their devices of metamorphosis, scale manipulations and unusual juxtapositions of imagery to create a narrative would later be adopted by Notkin in his own ceramic art. His formal art education was at the Kansas City Art Institute, where

All Nations Have Their Moments of Foolishness (detail).
Individual tiles: 7 x 7 cm (2¾ x 2¾ in).
Photo: Richard Notkin.

The Gift, 1999. Earthenware tiles fired in sawdust-filled saggars, 204 x 284 x 7.5 cm (6 ft 8 in x 9 ft 4 in x 3 in).
Photo: Richard Notkin, courtesy of the Portland Art Museum, Portland, Oregon, USA.

he studied painting and sculpture, discovering clay by accident during his third year.

> *I borrowed a small piece of clay from a fellow sculpture student, began manipulating it, and enjoyed the feel and immediacy of the material. I've been modelling and manipulating clay ever since, nearly 38 years now.*

A master's degree followed in 1973 at the University of California, Davis.

For over 30 years, Notkin adopted the precise making techniques from the potters of Yixing, using the teapot format to express a narrative through the juxtaposition of various objects, images and symbols. His symbols were designed to communicate clear messages about the USA's questionable nuclear-energy programmes, foreign policy and military imperialism. For instance, the depic-

tion of dice meant gambling with lives; mushroom-cloud finials on top of teapots shaped like nuclear cooling towers explain the dangers of the energy programme. During the last few years Notkin has been exploring large-scale sculpture entailing the investigation of new clays, and firing and post-firing techniques.

> *I find myself in a transitional phase that is quite challenging and often difficult, but necessary to the evolution and growth of my art. I feel that to remain viable, an artist must remain forever inquisitive, eternally a student – technically, aesthetically and conceptually.*

His installation *The Passages* (1999) is a plea for sanity. It is about lessons heard but not heeded during the 20th century, and how these ignored lessons will affect

our survival in the future. It is in two parts: *The Gift* is a 3 x 2 m (9 ft 8 in x 6 ft 6 in) mural made up of tiles displaying the image of a mushroom cloud from a nuclear weapon. The saggar-fired tiles (1,106 in total) are arranged according to their shades of white through to black to form a near-photographic image, but as the viewer approaches, the reliefs on individual tiles come into focus. Notkin uses the tiles to illustrate the literal fallout from a nuclear explosion in the form of human skulls, brains, hearts, ears, crates, demolished buildings and dice. The second part, *Legacy*, is presented on a low floor plinth spanning almost 7 sq. m (75 sq. ft) in front of the mural and comprises a thousand human ears, ranging in scale from 3 to 60 cm (1½ to 23¾ in), in a seemingly random pile. Through additions to the stoneware clay (such as vermiculite and grog) together with post-firing sandblasting techniques, the ears give an illusion of natural rocks. On closer inspection the rocks become recognisable as ears. They represent his concerns with a wide range of issues – of the ear as both receiver and listener to the outside world, of an exterior tunnel into the human mind, as well as references to fossils and piles of shoes from the Holocaust era.

In 2006, Notkin completed another large-scale mural (1.5 x 1.2 m/4 ft 11 in x 3 ft 11 in), *All Nations Have Their Moment of Foolishness*, in response to the invasion of Iraq. Like *The Passages* it also operates on two different but interconnected levels. One is the composite image from afar; the other is the close-up imagery dealing with the individual implications of the whole picture. Notkin describes his ideas as follows:

All Nations Have Their Moment of Foolishness *depicts the closely cropped face of George W. Bush. The image was chosen not to ridicule, but to capture some essence of the man. This particular image of Mr Bush impressed me for its lack of expression or emotion, and the visually prominent dark irises. (I have tried to imagine, in vain, what is occurring behind them.) As the viewer approaches the piece for a closer examination, the highly detailed, individual tiles dominate. Relief images impressed on the tiles include buildings and cities demolished by aerial bombardment, the rubble of bricks and charred beams with occasional skeletal remains, nuclear mushroom clouds, the infamous hooded prisoner in Abu Ghraib*

The Gift (detail).

prison, barbed wire, bombs falling, and additional images of war and destruction, including the iconic screaming horse from Picasso's painting Guernica, *which has become one of the great antiwar icons in the history of art. I have also included some of the more recognisable images from my past works which also pertain to our many human follies, such as the 'cube skull' icon, dice, brain and heart tissue, wooden crates, ears, etc. As a final ironic twist, I have added a few tiles which depict the feet of Christ, a relief I carved based on a detailed view of Michelangelo's* Pietà. *The image is intended to reflect on the self-proclaimed 'War President' as an equally self-proclaimed follower of the 'Prince of Peace'.*

Notkin works methodically, spending long periods of time researching, drawing and planning his images, which are carved as relief prototype tiles, then made into press moulds. His installations can take a whole year to complete.

Fortunately, I am a very patient person, some might even categorise me as obsessive. One of the joys of being an artist is that obsessions are not considered handicaps, but are often celebrated – obsession as tool!

All Nations Have Their Moment of Foolishness is made from 344 white earthenware tiles, each slightly smaller than 7.5 cm (3 in) square. The tiles were fired raw in sawdust-filled saggars to about 1100°C (2012°F), giving a wide range of grey shades, from pure white to jet-black. Their positioning within the saggar determined their colour: tiles which faced the outer, slightly porous wall of the

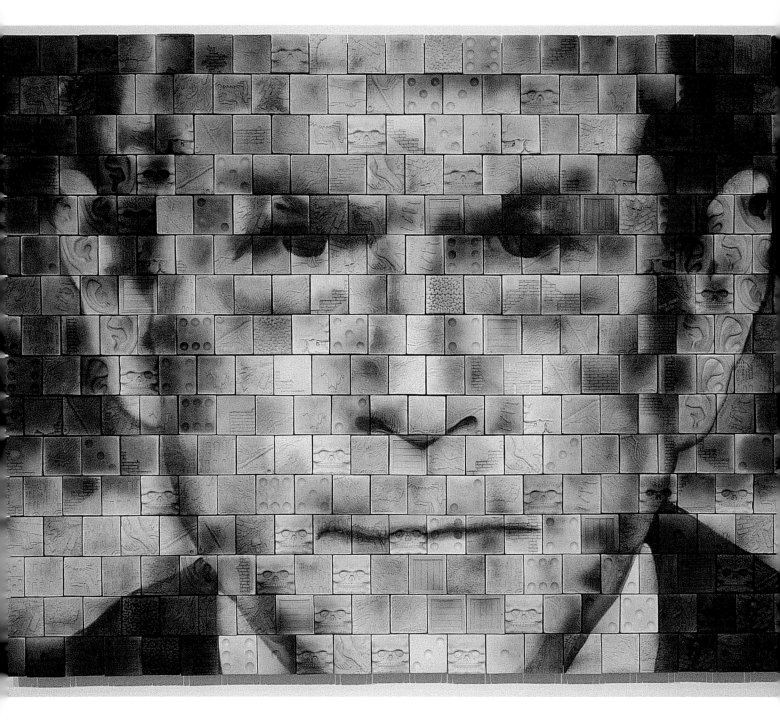

All Nations Have Their Moments of Foolishness, 2006. 117 x 154 x 11.5 cm (46 x 59½ x 4½ in).
Photo: Richard Notkin, courtesy of the Elizabeth Leach Gallery, Portland, Oregon, USA.

All Nations Have Their Moments of Foolishness (detail). Individual tiles 7 x 7 cm (2¾ x 2¾ in).
Photo: Richard Notkin.

saggar received ample oxygen and fired almost bright white, whereas tiles positioned near the centre received little oxygen and emerged nearly jet-black. Where one part faced towards the saggar wall and the other part towards the interior, a gradation of light to dark tones occurred. The depth of the carved reliefs also affected the modulation of surface tone, as the tiles are fired face to face with sawdust compressed between them, resulting in random mottled variations.

After firing the tiles were sorted according to the intensity of their shading. The photographic image to be enlarged was overlaid with a transparency, upon which was printed a grid in a staggered, bricklike pattern of tiny numbered squares. The wooden backing for the mural was cut into multiple sections, each of which contained eight horizontal rows of tiles. The front of the wooden panel was then prepared by drawing a grid to match the gridded photograph. Each square in the gridded photograph was evaluated for its shading modulation, so that the tile which corresponded most exactly to the square in the photographic image was selected and glued to the board. As more tiles were added, the image of the photograph began to emerge, especially from a distance. Finally, Notkin added detailed highlights such as the sharper lines around the suit jacket, and facial features such as ears, jaw, lips, nose and eyes, with brushed-on layers of watercolour stain.

Notkin says of his work,

I am asking questions in my art that I intend to be directed at everyone, not only those who are practitioners and followers of the contemporary arts scene. Many of these 'every persons' may disagree with my sentiments, but few will misinterpret my intended message. If the piece only provokes a spirited and meaningful dialogue then it has accomplished its function. Art's greatest value is to touch people in profound ways, in ways that can even, on occasion, change lives. As André Malraux observed, 'Art is a revolt against man's fate.'

Notes

1 *The Gift* is in the permanent collection of the Portland Art Museum, Portland, Oregon.

Technical notes

Saggars are made from assembled clay slabs 2 cm (¾ in) thick using the clay recipe below. They are bisque-fired two cones higher than their highest temperatures will be during their later function as saggars.

Saggar clay

Fire clay	50
Ball clay	20
Coarse grog	10
Medium grog	10
Fine grog	10
Add bentonite	(2 parts per 100)

PAO FEI YANG

I had also discovered clay as a comforting medium through which I could express myself.

Pao Fei Yang is a Taiwanese ceramic artist living in the Boston area of Massachusetts. She makes two-dimensional wall hangings from saggar-fired tiles assembled to describe a mysterious, mystical world. When placed together the individual tiles form pictures containing symbolic imagery together with geometric shapes of urban structures and soft images from nature. Yang originally attended National Taiwan University, where she studied plant pathology, before moving to the United States to study painting at the University of Connecticut in the early 1970s. A serious car accident in 1983 left Yang unable to concentrate for any length of time or focus her eyes, and she was forced to give up painting.

Horse in the Moonlit Woods, 32 x 24 cm (12$\frac{1}{2}$ x 9$\frac{1}{2}$ in). *Photo: Susan Byrne*

Blazing Sun, 48 x 25 cm (19 x 10 in). *Photo: Susan Byrne*

However, an opportunity to work with the Japanese potter Makoto Yabe at the DeCordova Museum School in Lincoln, Massachusetts opened up a new world for Yang:

While I could no longer draw or paint, I could manipulate clay, and found it to be highly relaxing and just what I needed. The drawn-out steps in the process, the time between concept and completion, allowed me to rest my eyes and my mind.

In 1995 Yang saw saggar-fired works for the first time, and was instantly drawn to their qualities of warmth and intimacy. The following year she joined the Radcliffe College Ceramics Studio in Boston, where she learnt about saggar-firing techniques from Shawn Panopinto. It was the beginning of a gradual development towards finding her own voice. Yang's account of personal healing through working with clay and fire is a moving one:

Clay and nature have played major roles in my life and personal healing. About twenty years ago I was involved in a traumatic automobile accident which compelled me to give up painting. It was during that

period that I discovered the shrine in my heart. It was here that I slowly recovered from my painful memories and learned how to endure physical discomfort. I had also discovered clay as a comforting medium through which I could express myself.

I was very moved by a show I had attended which explored the process of healing through art. When we feel pain or hurt we retreat to an inner space seeking comfort. The triangles in my work represent my sacred space, my heart's shrine. The larger ones symbolise the strength my soul seeks from turbulence. In my early saggar work, these triangle images would always appear black and grey. Black crows are another healing metaphor. When I encountered a wounded crow flying, I knew I could also heal. The trailing lines that I often used represent the floating, caressing movements that allow me to reach a transcendental state. Different weather conditions are used to depict my various emotional states.

Strength is also gained through nature, which is always inspiring. Walking my dog through the woodland trail,

Copper wire, steel wire, brass wire, copper tape, copper mesh and copper nails are used, wound around or placed against the tile surface prior to bisque firing.
Photo: Pao Fei Yang.

Fine sawdust has been laid around the edge of the horse design. Coarse sawdust saturated in copper carbonate is packed around the top part of the saggar, and will give the impression of sky. The sawdust packed against the bottom half is saturated with yellow ochre and red iron oxide, and will represent the ground.
Photo: Pao Fei Yang.

Removing the design after the firing.
Photo: Pao Fei Yang.

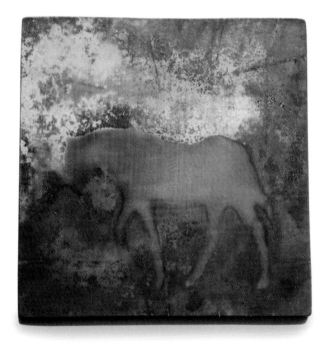

The finished tile.
Photo: Pao Fei Yang.

I experience a healing in its tranquillity, and know the true meaning of life. Each year we participate in this renewed cycle of life as the solitude and peace of winter meld into the rebirth of spring; then the lush growth of summer melds into the flamboyant colours of autumn. My later work changed from the monochromatic tones to a more colourful palette as a reflection of these woodland images that my heart embodied. I regain my strength through the knowledge that struggle is also part of the life cycle.

Having travelled in Europe, Morocco and New Zealand, Yang has discovered new inspiration in architecture that she has transformed into a new vocabulary of symbols. The geometry of wrought-iron designs on windows, and of structures such as bridges and tear-shaped arches, has found expression in her art. Tiles are formed, with the aid of a slab roller, from a low-fire white clay and cut into shape when leatherhard. After drying them carefully between two drywall boards weighted with bricks, the terra sigillata slip is applied with a flat brush and the tiles polished with soft rags. The graphic images, symbols and linear designs are applied to the raw surface before bisque firing; Yang regards her tiles as one would a sketch pad or canvas for a painting. Metal wire (copper, brass or steel) is wrapped around the tiles or cut and carefully placed on the surface to create a line drawing. The closer the wire is to the piece, the sharper the image will be. For solid images, copper tape or sheeting can be cut into forms and combined with flat clay shapes that are laid onto the tile surface and secured with tape or wire. By applying oxides such as yellow ochre or red iron to the clay cut-out, Yang can print the image onto the tile during the firing, opening up many creative possibilities.

A bisque firing to around 970°C (1778°F) will transform the linear designs from the copper wire to purple, the brass wire to black and the steel wire to brown, yellow or red. The copper tape or sheeting cut-out forms will turn purple (and if later fired in sawdust will produce a halo effect around the purple shape). Yang uses a variety of combustible materials during the saggar firing, such as salt-marsh hay, straw, sawdust and seaweed. These are

Wonder Through the Woods in the Late Evening. 30.5 x 25.5 cm (12 x 10 in). *Photo: Susan Byrne*

saturated with solutions of copper carbonate, cobalt carbonate, red iron oxide and yellow ochre in the ratio of one gallon of water to half a cup (American measure) of oxide, and also solutions of salt. The materials are soaked for half an hour and then dried out completely. The tiles are stacked inside the saggar with the materials placed in between and around them to create a soft, smoke-vapour effect. For an exact image the tiles are fired flat with the materials laid on top, and for a sharp white edge one tile is partly blocked by another. Precise edges are achieved by sprinkling fine sawdust mixed with oxides to outline the image, and loose sawdust in other areas. The saggar firing takes place in a raku kiln, with the temperature built up slowly over a period of six hours to about 900°C (1652°F). When the temperature has matured the kiln is reduced for 12 minutes, then re-oxidised for two minutes before being shut down.

Never satisfied to let the flames do all the work, I found that I could best express myself through creating images hand in hand with the elements. It was as if I were painting with fire and minerals! It is a challenging, mysterious and intangible experience to try and understand the various materials and their

relationship to the fire. Since it can never be totally controlled, the results must simply be accepted as a gift bestowed by the elements.

Technical notes
Terra sigillata (Val Cushing's formula)
 Clay 1500gm
 Water 14cups (US measure)
 Calgon 7.5gm
 Tennessee no. 9 Ball Clay (US) will produce a matt surface.
 Jackson Ball Clay (US) will produce a shiny surface.
 Red Art Clay (US) when fired with sawdust will produce red to
 rusty-red or grey to silver colours.

Colours from oxides after saggar firing
 Copper carbonate: green or red
 Cobalt carbonate: blue
 Red iron oxide: orange, red, brown
 Yellow ochre: yellow, orange, brown
 Salt: pink, orange
 Seaweed: pink, purple

EVA MARIE KOTHE

My work is to do with identity, as if saying 'Here I am'.

The Swedish ceramicist Eva Marie Kothe lives near the coast on the island of Gotland, one of the larger islands in the Baltic Sea. It is a magical place, steeped in Viking history and bathed in the kind of unpolluted light experienced at high altitudes rather than low sea levels. Her strong black vessels with their studded and organic textures are grounded in contemporary Scandinavian design, but they also resonate with ancient firing and metalwork techniques. There is a dynamic between the static vertical forms and the exterior relief work which moves the eye around the surface. She says,

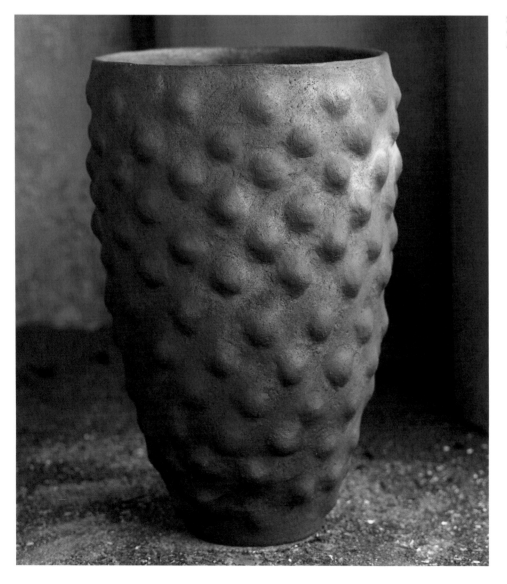

Smoke-fired Vase. Height: 32 cm (12½ in).
Photo: Nisse Peterson

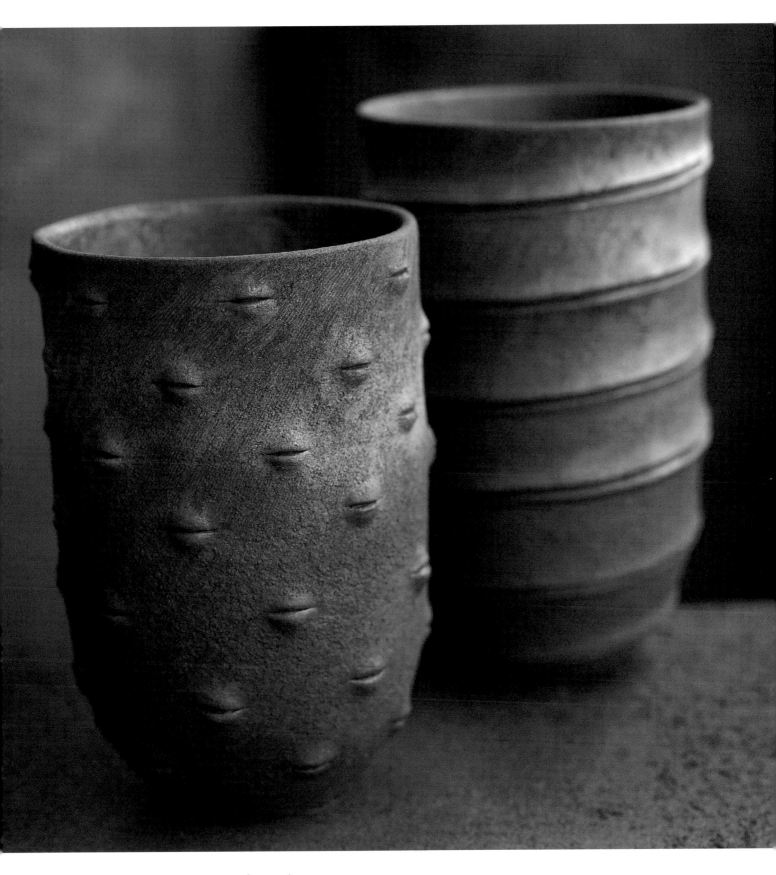

Smoke-fired Vases, height: 27 and 29 cm (10³/₄ and 11¹/₂ in). *Photo: Nisse Peterson*

Building the form with extruded coils.
Photo: Jane Perryman

Pushing the raised surface shape against the template.
Photo: Jane Perryman

Slicing through the clay wall with a razor blade.
Photo: Jane Perryman

My work is inspired by the word 'stele', meaning a standing stone or marker – it is to do with identity, as if saying 'Here I am'. I have researched into many cultures which use this stele and I want my pots to express something of that quality.

Kothe remembers first touching clay at the age of 15, and it was an instant love affair – she recalls it as a life-changing experience. Later she attended Capellagarden, a school for crafts on the island of Oland, where she studied ceramics, wood and textiles. From there she moved to Gotland in 1979 to apprentice with a production potter. She set up as a studio potter making blue-and-white thrown tableware in stoneware – supplementing her income by teaching in a school specialising in Viking history.

When I moved here from the mainland I was hit by the impact of the wild landscape and the standing stones representing a constant reminder of history. Gotland is full of Viking treasure.

During a digging project, her pupils discovered some silver treasure from the Viking Age which aroused interest from the government. The hoard subsequently funded the setting-up of a Viking school called Stavgard, whose ethos was to learn about Viking culture through hands-on living experience: the children would dress, live, cook and sleep like Vikings. Kothe became interested in teaching black-fired Viking pottery techniques, and went to the Archaeological Research Centre at Lejre near Copenhagen in Denmark to study the traditions of a type of 18th-century Danish black pottery called Jydepotter. Through her research she gained the confidence to start experimenting.

As many teachers do, Kothe began the process of teaching and learning black firing alongside her students. Raw pots were placed in a dug-out hole lined with straw, covered with wood, then straw, and finally with turf. The pots emerged black and the wood became charcoal. In 1985 she was commissioned by the Museum of Gotland to make handbuilt, black-fired 'Viking' pots for the gift shop, which were instantly a commercial success. Since then Kothe has gradually developed her own distinctive voice, exhibiting regularly in Sweden and abroad as well as continuing her bread-and-butter production work.

Kothe's way of making is systematic and highly controlled. Small oval pots made to fit into the hand are thrown and altered, and larger forms are built up by coiling. She uses a heavily grogged German modelling clay, with extruded coils which will later be scraped down to form an even surface. She describes the language of coiling as being intimate, and enjoys the natural rhythm of working in batches of several pots, gradually building them up in rotation. The hard-edged studs are cut and applied, the organic ones pushed out from the moistened interior clay wall against a plastic template. Some are slit with a razor blade and pushed out further. The insides are burnished and then covered with terra sigillata slip, which will contrast with the rough mat exterior surface. Occasionally, the projecting studs are also covered with terra sigillata and polished to give a further contrast. A bisque firing to 1000°C (1832°F) is followed by a black firing with sawdust in a saggar to 750°C (1382°F).

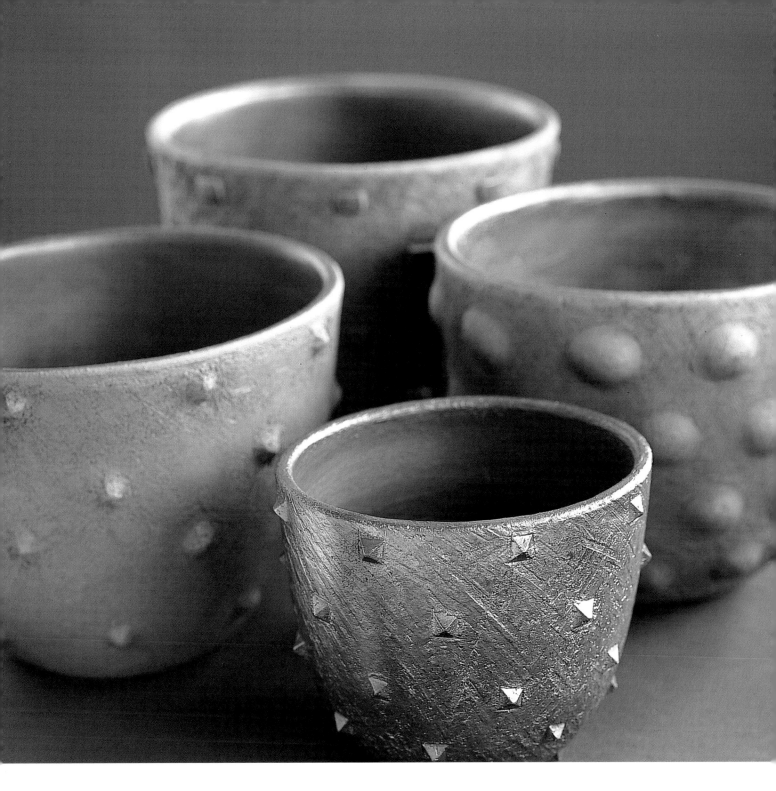

Group of Smoke-fired Vases, height (smallest): 20 cm (8 in). *Photo: Nisse Peterson*

Kothe says of her work,

First you see one thing – all black. Then you come nearer and see the surface texture. Then you touch, lift up and see something else – you feel the rough outside and the smooth inside. You can't look quickly – you'd only see a black pot – you have to come close to see its qualities. If you are a busy person you miss it.

JANE PERRYMAN

Making, travelling, writing and teaching are all expressions of my work and have become mutually symbiotic

One of my favourite quotes is by the late French ceramicist Pierre Bayle, who said, 'Minerals leave me cold. For that reason I never make glazes. Glass cuts, it is rigid. It lacks life. I never manage to be moved by it despite its icy beauty.' These words resonated with the way I felt about glaze and my constant struggles with its alchemy. I finally discovered my way in the mid-1980s through exposure to the work of Siddig El'Nigoumi and Elspeth Owen. I was attracted to the immediate qualities of burnishing and smoke firing and also by the many associations these techniques trigger through the senses and memory. The penetration of smoke marks right into the ceramic surface gives a feel-

ing of integration with the form, and when combined with burnishing expresses a rich, tactile surface. Naked clay, not covered by glaze, has the chance to breathe, feels soft and warm to the touch, and can both absorb and reflect light. There is also the connection with ancient pottery, together with a sense of unbroken traditions being brought into a contemporary context. I had originally studied with little enthusiasm for a degree in industrial ceramics (slipcasting and mould making) at Hornsey College of Art in London, resigning myself to a career of designing for industry or entering the teaching profession. I chose the latter and spent the following ten years investigating many ceramic directions and

Saggar-fired Vessel. Diameter: 25 cm (10 in). *Photo: Graham Murrell.*

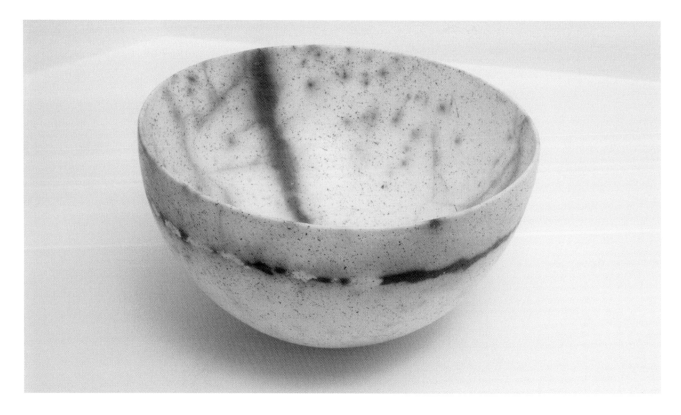

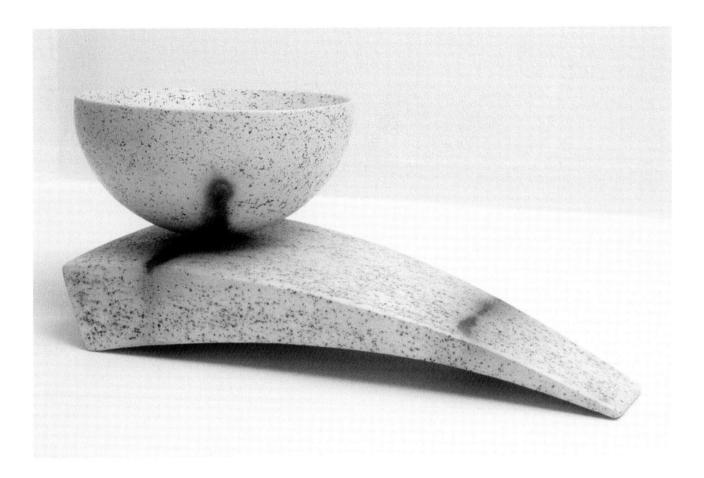

Touching Balance. Length: 24 cm (9½ in). *Photo: Graham Murrell.*

searching for something which would grab me – rather like searching for a soulmate. When it happened, I knew.

I needed to simplify my whole approach and began investigating the low-tech approach of handbuilding and smoke firing. Clearing the studio of glazing and slipcasting paraphernalia was liberating. I realised that I could simplify my equipment and materials, no longer relying on commercial pottery suppliers for all my needs; I also could recycle combustibles, and find smoking containers in rubbish dumps. At that time there were no specialist books to learn from, but I loved the exhilarations and disappointments of learning through trial and error, and became captivated with the endless possibilities of playing with fire and smoke. I began looking at unglazed ceramics in the archaeological and anthropological sections of museums in London and Cambridge, especially pots from ancient Cyprus and early European Celtic pottery.

The work developed slowly due to my choice of techniques, together with the limitations of materials and studio space. Working for fourteen years in a shed within a small Cambridge city garden gave me the kind of physical boundaries which are frustrating but can also release creativity. These constraints focused my attention on developing smoke firing in an urban environment. Growing up in the climate of pre-consumer, postwar Britain during the 1950s and '60s, I had learnt to improvise with found materials and came to believe in the philosophy of 'less is more'. This new way of working felt as familiar and natural as going home. Gradually, I discovered various ways to produce minimum smoke by using coarse wood shavings (which burn quickly) in a brick-built container or newspaper in a metal bin. I was able to achieve a whole range of smoke resists using paper, clay slip, aluminium foil and liquid wax in different combinations. I enjoyed working with coloured slips and building up surface layers of linear decoration inspired by African

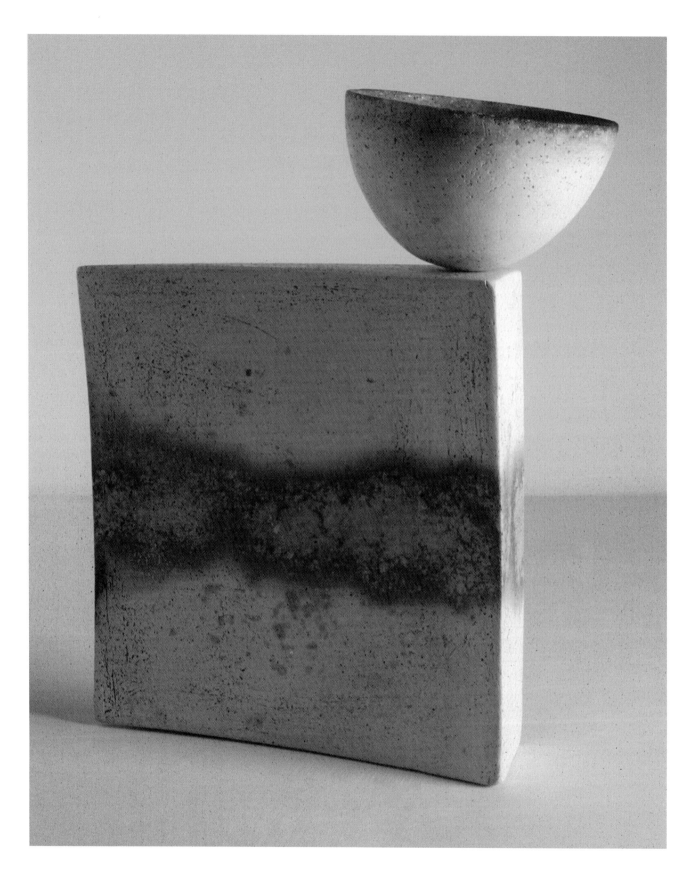

Touching Balance. Height: 28 cm (11 in). *Photo: Graham Murrell.*

A bowl is partly filled with sand inside the metal saggar.
Photo: Jane Perryman

The saggar is filled with sawdust and sealed with a lid.
Photo: Jane Perryman

Removing the bowl from the saggar after the firing.
Photo: Jane Perryman

and South American textiles. As so many potters who smoke fire have commented to me, the attraction of this kind of firing lies in the unpredictability and hopeful anticipation. Nothing can be repeated exactly, and there is a strong element of the 'given'.

During the last 18 years I have used the vessel as my basic form, exploring its nuances so that one idea develops organically from another. There are many physical and metaphysical analogies between a vessel and a human body – common words such as 'foot', 'belly', 'shoulder' and 'neck', as well as concepts of offering and receiving. As a committed yoga practitioner and teacher, I believe the development of yoga practice and understanding has mirrored my ceramic work. The Sanskrit word Yoga means 'union of body and mind', which could be interpreted in ceramic terms as the balance of weight and volume, the unity of form and surface, or the dynamic between inside and outside.

Working within the limitations of body and mind is the same journey I make with ceramic materials of clay and fire, striving for a state of 'effortless effort' which is instantly felt and recognised whatever the medium. The clay vessel, just like the human body, can express openness, closure, softness, tautness, tension, dynamism, potency, vulnerability or tenderness, these qualities developing from its beginnings as plastic clay. In this way, ceramic form expresses emotion. For many years I explored narrow-based bulbous and flaring forms, which for me represented uplifting feelings of optimism. Through extensive travels in India for my book *Traditional Pottery of India*, I became familiar with the shape of the ubiquitous round-bottomed cooking pot. Later, I adapted this

form, and its qualities of security and of being well grounded became the antithesis of the narrow-based form. Its rounded base meant that it retained an upward, springing movement from its balance on a tiny point. It combined strength with fragility, having the tendency to rock but never to fall over.

I learnt a form of saggar firing from the traditional potters in the Kangra valley of Himachal Pradesh, where a metal oil drum is filled with pots and pinewood, sealed and placed in a horseshoe-shaped open kiln during the oxidised firing. I began using metal saggars (old paint tins or stainless-steel sinks), gradually becoming interested in cultivating the bands of black through to grey fire marks produced by firing with sawdust and sand. An exploration of outward – and then inward-turning rims developed into a way of working with double walls. There was an element of ambiguity in the perceived weight and internal volume of the piece compared with its outward appearance. During the last few years I have been exploring sculptural concerns, with tension and balance expressed through the juxtaposition of two forms, one balanced upon the other. One is a timeless bowl and the other an extended horizontal form with shallow curves making reference to contemporary urban structures such as buildings, walls and bridges. These composite pieces contain ceremonial allusions and invite interaction through being handled and repositioned into new compositions.

I find that making, travelling, writing and teaching are all expressions of my work and have become mutually symbiotic, each one feeding and nurturing the other. It has become a way of life rather than a profession. I

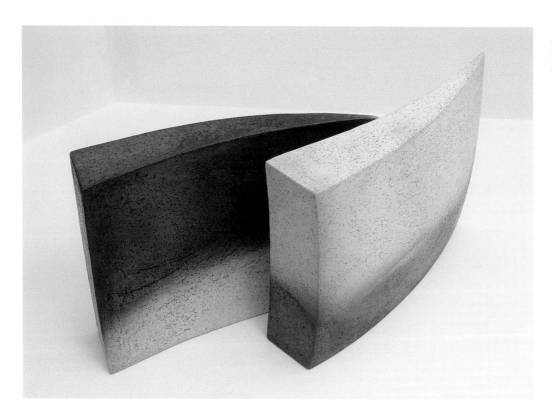

Shifting Walls.
Length: 32 cm (12 ½ in).
Photo: Graham Murrell

began looking at high-fired unglazed porcelain during my research for *Naked Clay: Ceramics without Glaze*, finding its whiteness and the effects of light upon its surface exciting and seductive. I wanted to integrate these white qualities into my own work while retaining a link with smoke firing and burning. I began mixing organic materials with the clay, such as straw, couscous, lentils, rice, tea and coffee grouts, which would burn out, leaving a pitted surface. At the time I was lime-washing the exposed oak timbers in our house, and because the lime putty happened to be in the studio, I tried mixing it with oxide pigment, and inlaying the texture before refiring. It worked well, and it was interesting that later the same year, during a visit to the Metropolitan Museum in New York, I gravitated towards a showcase containing pots from ancient Cyprus, which were incised and inlaid with white lime.

The smoke-fired pieces are handbuilt using combinations of coiling, press-moulding and slabbing techniques from a mixture of T-Material and porcelain clays (in the ratio of 2:1). A porcelain slip is applied before burnishing and fired to 1000°C (1832°F). Some pieces are treated with resists (paper, wax and clay slip) then saggar-fired with sawdust to around 700°C (1292°F).

Other pieces are smoke fired in oil drums or brick containers outside so that the firing is partly oxidised, giving greater tonal contrast than is achievable through saggar firing. The white work is built and burnished in the same way, but the clay body consists of equal amounts of porcelain and T-Material mixed with combinations of coffee and tea grouts and vermiculite. After an initial firing of 800°C (1472°F) the pieces are refined with sandpaper, then refired to 1100°C (2012°F). A lime/oxide solution is brushed into the pitted surface texture and then fired once more in a saggar with sawdust and sand to 700°C (1292°F). Finally, the pieces are waxed.

I live with a musician whose main concerns are with improvisation, whether applied to performance or composition. The dictionary defines improvisation as 'to perform or make quickly from materials and sources available, without previous planning'. Hans Coper has compared the art of ceramics, in its constant improvisation on a theme, to the playing of jazz. This improvisation with the elements of earth, fire and water is what motivates me to continue searching for new ways.

DUNCAN ROSS

I look for an organic quality in the shape and good proportions between rim and base.

I only use earthenware clay and smoke. Everything comes from that.

These words, chosen by Duncan Ross to describe his work, have been reduced to the bare essentials and represent a metaphor for his ceramic art. Ross's concept and working practice are expressions of a minimalist approach borne of simple but highly skilled techniques. His distinctive style is achieved by exercising restraint to explore limited forms, and a limited colour palette to express formal surface decoration. There is no short cut to this level of expertise; it comes from years of discipline

Flared Bowl. Height: 17 cm (6³⁄₄ in). *Photo: Duncan Ross.*

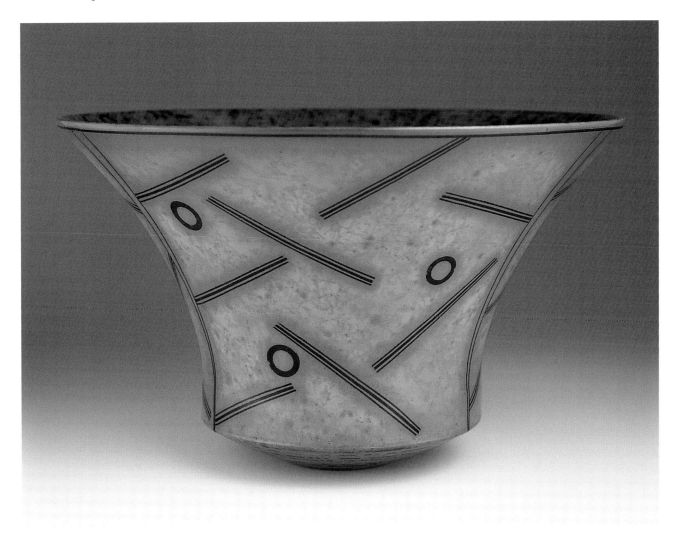

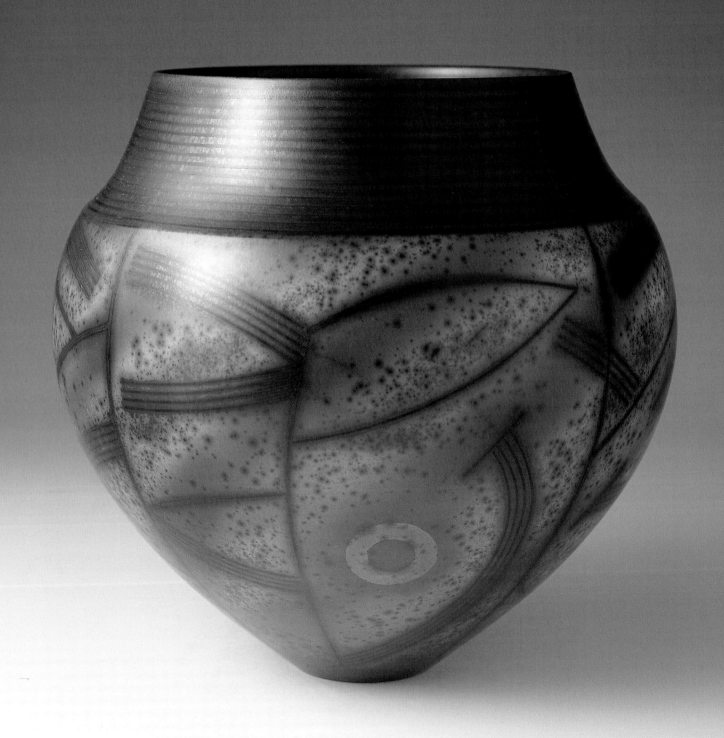

and repetition, in the same way that a musician achieves fluidity by practising scales. While Ross's open vessels have strong associations with ancient pottery and ritual containers, they are also sophisticated and contemporary. He counterbalances the stillness of classical form with an investigation of dynamic surface movement enhanced by the rich surface of polished terra sigillata.

Ross attended Farnham School of Art in the 1960s (he still lives in the same area), and was taught, among others, by Gwyn Hanssen Pigott and Henry Hammond. Research for his thesis into the firing and decorating techniques of the black and red vases made by the potters of Classical Greece would inspire his chosen way of working 20 years later. After graduating he spent many years working in education as well as making reduction-fired stoneware and later raku, which introduced him to the excitement of low-temperature firing. In the late 1980s he took the plunge to become a full-time ceramicist and spent a year visiting other potters, carrying out glaze and slip tests and developing his personal style. He made the decision to concentrate on one-off pieces rather than repetition domestic pots, and to simplify his working methods. The work of Pierre Bayle, which he saw featured in a magazine article, acted as a catalyst to link together several ideas he had been investigating.

I wanted to simplify my work and began by using coloured slips, building up surface character using layers and burnishing them, but the effects were rather harsh. Recalling my thesis as a student on Greek red-and-black figure ware I made a number of trials using a fine colloidal slip – terra sigillata, applying it very thinly to see what colours I could get just using clays. I added a smoke firing to penetrate and break up the colours, giving me a wider range. Among the results was a particularly interesting small bowl, and immediately I could see the possibilities of the qualities of colour and the way the smoke entered the layers. It had a translucency and depth of colour I wanted, and where there was a line the smoke entered the body and created a shadow around it, which I found very exciting.

Terra Sigillata Dark Bowl. Height: 19 cm (7½ in).
Photo: Duncan Ross.

My earliest burnished pots were simple, with less use of different thicknesses of slip, controlled to give different tones of colour, and as time has gone on I have developed that, using it as a palette. It has allowed me to concentrate on form and decoration and see how I can develop the slips to give added richness to what I do.

Ross describes himself as a repetition maker, searching for the development that arises naturally from working with groups of pots which are the same. He keeps a sketchbook to record ideas and also to rework earlier forms with a slightly different emphasis, such as a broader belly or a changed rim.

I look for an organic quality in the shape and good proportions between rim and base; inside to outside form. I sometimes put the form back on the wheel as it dries, and throw through again to push the shape further than the wet clay would allow. Turning is an important process as it allows me to create the uninterrupted surfaces and small base profile that I want. I turn and lightly polish inside and out.

The throwing clay is a low-firing red earthenware with added molochite; the terra sigillata is a clay Ross has sourced locally and digs himself – the area around Farnham in Hampshire has an abundance of naturally forming brick clays. Ross's dominant interest lies in his surface treatment, using repetitive linear patterns which vibrate with movement, leading the eye around the form. He plays with themes of motifs that he refers to as pictograms, as well as formal designs which float with graphic clarity above a mottled, multilayered background. Inspiration comes from a variety of sources: ranging from Indian Ikat textiles to the industrially made printed textiles of Collier-Campbell from the 1980s; from Polynesian bark cloth to the Mimbres ceramics of New Mexico; and from the linear painting of Klee and Miró.

The surface is built up with layers of terra sigillata slip applied very thinly by brushing, spraying or pouring; the slips are so thin that great care has to be taken in handling at this stage. The decoration is built up in-between the layers of slip using paper resist, taped lines and sometimes latex resist that can be added and pulled away as the sigillata layers are added. It is this very thin use of the terra sigillata which gives the final, almost translucent effect.

There is a quality from etching I enjoy – a hard line with a burr around it – and I get that from the shadow effect of the smoking. It has a mysterious quality, where the smoking enters the clay and is also resisted by it. It gives a richness that comes out of and contrasts with the translucency of the surface. I like the surface not to be too clear – the main thing about using slips, especially terra sigillata, is that there is no difference between the body and the surface. It all belongs to the clay. It is not like a layer of glaze on the surface.

Finally, the surface is given a gentle burnish with a pad of polythene or chamois leather, and after being dried slowly, the pots are bisque-fired to 1000°C (1832°F). The smoke firing takes place in saggars – pots are packed individually and surrounded with sawdust and wood shavings, and fired in his gas kiln to 700°C (1292°F). As the heat increases, the sawdust smoulders and subjects the terra sigillata surfaces to an intense carbonising atmosphere – where the slip is dense it resists the smoke and where applied thinly it becomes black. Finally, the pieces are cleaned of ash and given a light coating of clear wax. Like a composer, Ross is in full control of orchestrating these elemental processes; he is not after chance encounters with the kiln but uses the firing to make permanent what has already been decided. The results produce a subtle variation of colours from chestnut through dark oranges and browns, sometimes light yellow, grey and gold. The blacks can lighten to grey and sometimes to a pale blue.

Terra Sigillata Bowl. Height: 15 cm (6 in). *Photo: Duncan Ross.*

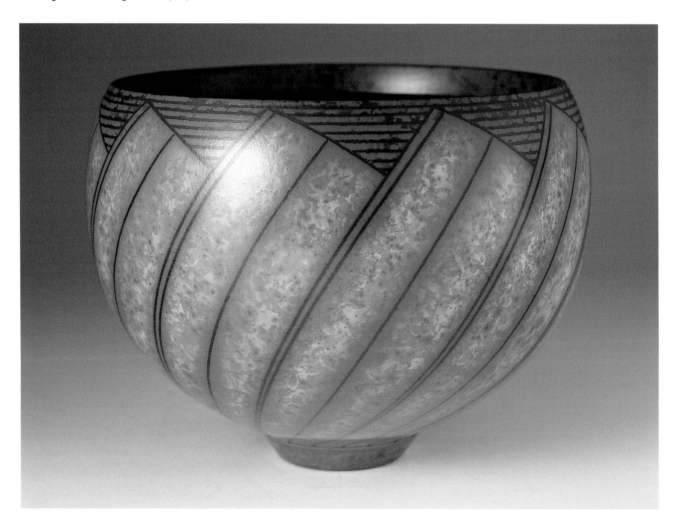

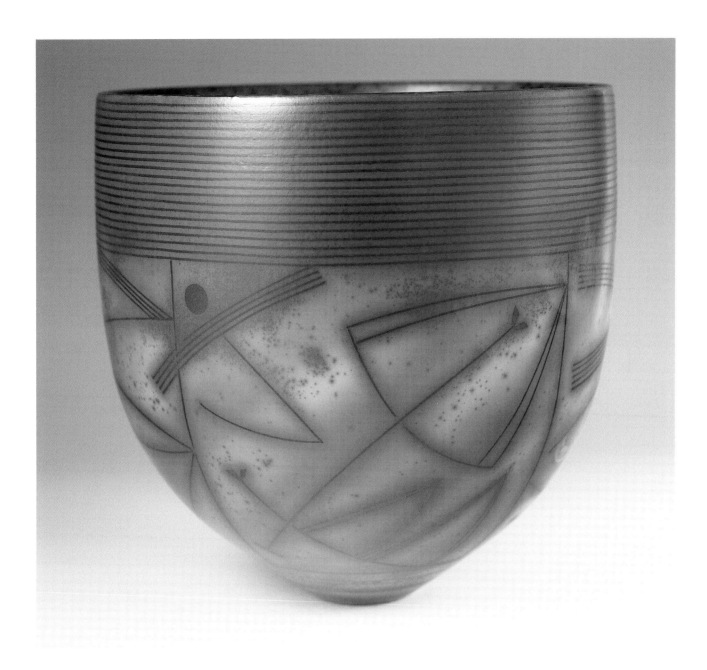

Terra Sigillata Bowl. Height: 22 cm (8¾ in). *Photo: Duncan Ross.*

It is interesting that although Ross closely controls his work at every stage he also acknowledges that the most successful pieces seem to have evolved from a more unconscious part of him.

My best pieces are slightly outside myself: the ones that haven't worked so well seem closer to me; the best ones seem to have been made by someone else.

Technical notes

Terra sigillata slip preparation

Clay 1.5kg
Water 8litres

Soak for 24 hours. After slaking, the slip is mixed well and if a coarse clay is being used, it is sieved through a 60s mesh. An amount of 7.5g of sodium hexametaphosphate is ground up and added to the slip, mixed thoroughly and left to settle undisturbed for 48 hours. Surface water is then removed and the top layer of particles syphoned off. This will form the sigillata.

ALISON TINKER

I think of making ceramics as a playful, hands-on, free sort of activity

Clay is such a basic, dirty, squadgy, nice thing to work with and enjoy – how can you keep that feeling throughout the drying/firing process?

Alison Tinker has developed a personal language by manipulating soft clay to explore emotional experiences through the themes of vessels and containers such as bowls, spoons and lidded forms. Her free handling of form and surface gives the qualities of spontaneous energy she wishes to capture, and represents a kind of iconography of her day-to-day life. The Spanish art historian Dolors Giral has said, 'Alison Tinker's ceramics form a part of a trend we could call naturalistic in which the material, the personal contribution and the final role of the firing combine to give us, in the end, a piece of work which seems incredibly simple but extremely sophisticated in its profound creativity.'

Tinker is an English ceramicist who has lived on the outskirts of Barcelona since 1987. She trained at Farnham School of Art in the early 1980s, primarily as a thrower, but was introduced to saggar firing and low-firing techniques by her tutor Sebastian Blackie and visiting lecturer Paul Soldner.

I found glazes uninspiring and slightly frightening – all that chemistry and molecular weights for a start – and I found the glazing process like an afterthought to the shapes I wanted to make. I think of making ceramics as a playful, hands-on, free sort of activity – clay is so cheap and anyway you can recycle it, so there's a sense of freedom in the material. Smoke firing

Canopic Jars. Height: 16 cm (6½ in). *Photo: Sergio Hernandez*

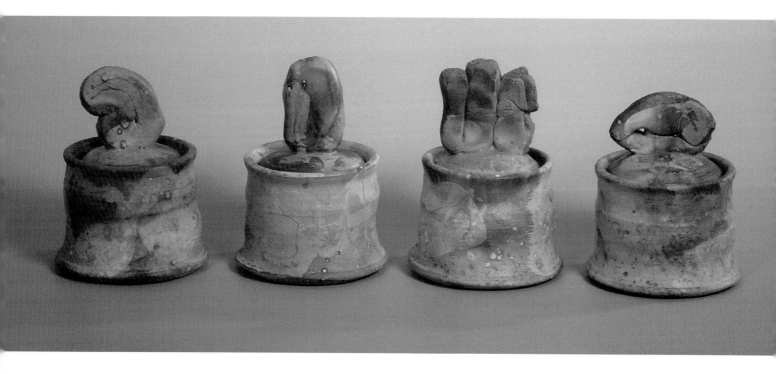

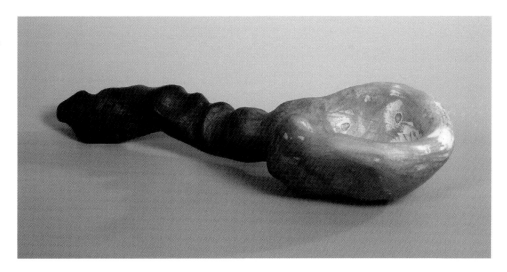

Spoon. Length: 26 cm (10¼ in).
Photo: Sergio Hernandez

seemed to fit in much more with my making process – it's not very controlled, you are playing around; some pieces will be lost, others will be a wonderful surprise.'

Since living in Spain Tinker has combined earning a living through producing a line of stoneware tableware and teaching English, while at the same time evolving her more individual pieces. Sources of inspiration can be linked to the roughness and ritualism of Japanese tea bowls, to the work of Tàpies and Miró, and to the making processes of Paul Soldner and Peter Voulkos.

Although Tinker's concern to express clay as material lends itself to sculptural form, she has always worked within the parameters of the vessel. Some of her work is deliberately whimsical and humorous, which is partly due to her self-effacing character but is also a deliberate statement against the pretensions of the art world.

> *I felt more comfortable making a bowl than a piece of art though I have always loved Peter Voulkos's idea of a bowl with big holes in it for keeping your old socks in. The story of Winnie the Pooh comes to mind, where he is taking Eeyore a jar of honey for his birthday but he eats all the honey on his way there, so ends up just giving Eeyore a pot to put things in.*

Sometimes she has a preconceived idea for her subject matter, but the approach of playing with clay to see what comes up best preserves the sense of fluidity and freedom she desires. The significance of references and memories which find their way into the pieces only develops later, similar to the way a dream becomes interpreted and understood after the event. Her series of Canopic Jars refer

to Egyptian burial urns used to hold the entrails of mummies, which she saw during the time she spent working in the bookshop of the British Museum. Tinker's Canopic Jars are for containing the eyes, hands, heart and soul, which she feels would need to accompany her in her own afterlife.

Spoon and Nut Bowls represent other themes explored by Tinker which conform loosely to the idea of a container metamorphosed into a strange, heavy, lopsided object. These small, dense, hand-sized forms retain evidence of the clay's journey from amorphous lump through initial pressing, pushing, pinching and squeezing with fingers and the heel of the elbow. The bumps, lumps and dents invite tactile exploration across their burnished surfaces, and the marks and colours describe the movement of flame during the firing. *The Tear Bottles* are based on lachrymatories found in ancient tombs, small bottles which held the tears of mourners. Tinker found the reference in a cheap American bestseller which described the act of collecting one's tears in a bottle, then giving the bottle as a present to someone as a symbol of a profoundly shared experience.

Influenced by some ceramic work marked with script by the British ceramicist Elspeth Owen, Tinker began to use text scratched through resist slip onto the ceramic surface. An avid and eclectic reader, she selects words or phrases from novels, poetry, jokes or songs which have a personal resonance rather than a particular message.

> *I often wanted to find ways to incorporate words into my paintings or pots but never before did it successfully. Smoke firing is great for this. Some parts of the*

Saggar constructed from fire bricks inside the gas kiln.
Photo: Sergio Hernandez

Scratching through the clay slip before fast-firing with newspaper.
Photo: Sergio Hernandez

Washing off the resist slip after the smoke firing.
Photo: Sergio Hernandez

text come out clearly, some can't be understood – my writing is really scrawly and it was just right.

Tinker works with both saggar firing and fast-newspaper firing, using different clays and firing temperatures. All her work is handbuilt using a wide variety of slabbing, pinching and any hand-manipulating process (though not coiling, as this is too slow). It is important to work fast to capture the vitality of the plastic clay. Pieces for the saggar firing are made from a 50/50 mixture of white stoneware and grogged clay, then bisque fired to 900°C (1652°F). A saggar with two chambers, one stacked above the other, is constructed from fire bricks inside the gas kiln. This avoids crowding too many pieces into one saggar, resulting in the pieces at the bottom becoming too black. Pieces are often dipped in a saltwater solution to encourage some pink or orange colour, and packed with a mixture of coarse sawdust (fine sawdust is too black), coffee grounds and wet sand collected from the water's edge on the beach. She recollects,

Once after a huge summer storm where the rain poured through the town and out of the drains onto the beach, I collected sand from around the drain outlets – the results were extraordinary rainbow effects! I think there were a lot of chemicals in there from the agricultural areas around the town.

Any gaps between the bricks are filled with grogged clay, but the saggar is not airtight. The slow firing to 1000°C (1832°F) (followed by a soaking temperature of an hour) takes about a further 24 hours to cool.

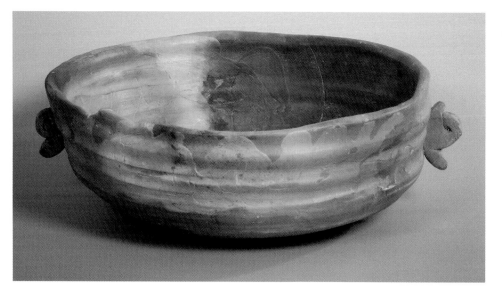

Flat Bowl. Height: 32 cm (12 ½ in).
Photo: Sergio Hernandez.

Three Lachrymatories. Height: 13 cm (5 in). *Photo: Sergio Hernandez.*

Work for the fast firing is made from fine porcelain, then burnished carefully with a pebble at least three times before a bisque firing of 900°C (1652°F). The surface is then painted with a thick clay slip and scratched through with a wooden tool to define words, symbols or patterns. A basic brick construction acts as a container, and the pieces are fired with newspaper – some tightly rolled into balls to burn slowly and some slightly scrunched to burn fast. After five minutes the container is covered with a kiln shelf and left – more paper can be added and burnt if the pieces are required to be blacker. Later the slip is cleaned off with water and finally, after drying, a thin coat of beeswax is applied. Tinker says of the firing,

> *There is something far more exciting for me in digging around in a pile of ashes to see what I can find than opening the kiln and thinking, 'Ah, yes, that's exactly as I planned'.*

SEBASTIAN BLACKIE

For me, how something is made is fundamentally part of its meaning

Sebastian Blackie's pioneering work with saggar firing and paper kilns has spanned three decades and inspired an international ceramic audience through his making, teaching and writing. Daily aspects of life have been integrated into Blackie's work to express an ongoing ceramic discourse where his basic tools of earth, fire and found materials are continually investigated and reinterpreted – he has alluded to it as a 'clay diary'. His mission is to provoke the practice of comfortable suburban ceramics into a place of gentle radicalism where values are questioned and perceptions altered. To experience life by doing things makes the journey as important as the destination; it was also Blackie's childhood solution to undiagnosed dyslexia. For him, the ceramic process has always been as significant as the work he withdrew from the kiln in its final form.

> *For me, how something is made is fundamentally part of its meaning … this includes, amongst other things, the vocabulary of making.*

Saggar fired Pot.
Photo: Sebastian Blackie

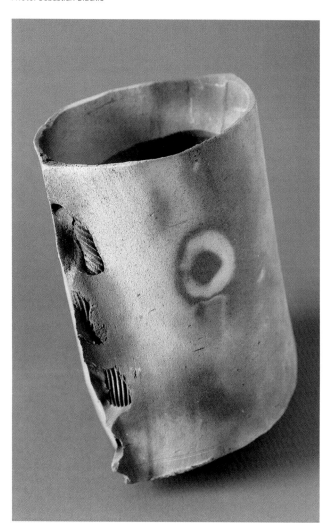

As a young man Blackie wrote to Bernard Leach to ask for guidance about studying ceramics, and it was suggested he attend Farnham School of Art (now West Surrey College of Art and Design). There he developed basic pottery skills, became proficient at throwing, and after graduation stayed on as a lecturer – slowly working his way up to head of department. Today he runs the MA course at Derby University called Art and Design: Advanced Practice and Theories. The first years teaching at Farnham in the early to mid-1970s brought Blackie into contact with an international group of ceramicists who introduced him to alternative approaches to making, firing and thinking. Michael O'Brien (Michael Cardew's assistant at Abuja Pottery in Nigeria), who was conducting some research at Farnham, introduced Blackie to wood firing; Magdalene Odundo was a student of Blackie and together they went to assist a wood firing at Cardew's pottery in Wenford Bridge. She also taught him the African way of coiling, where the pot remains stationary and the maker applies the coils whilst moving around the pot like a dancer. The Japanese ceramicist Takeshi Yasuda was a teaching colleague of Blackie's during that time and introduced a method of firing where charcoal is burnt in a small brick-built bottle kiln and fired up to stoneware temperatures. Blackie was interested in the resulting

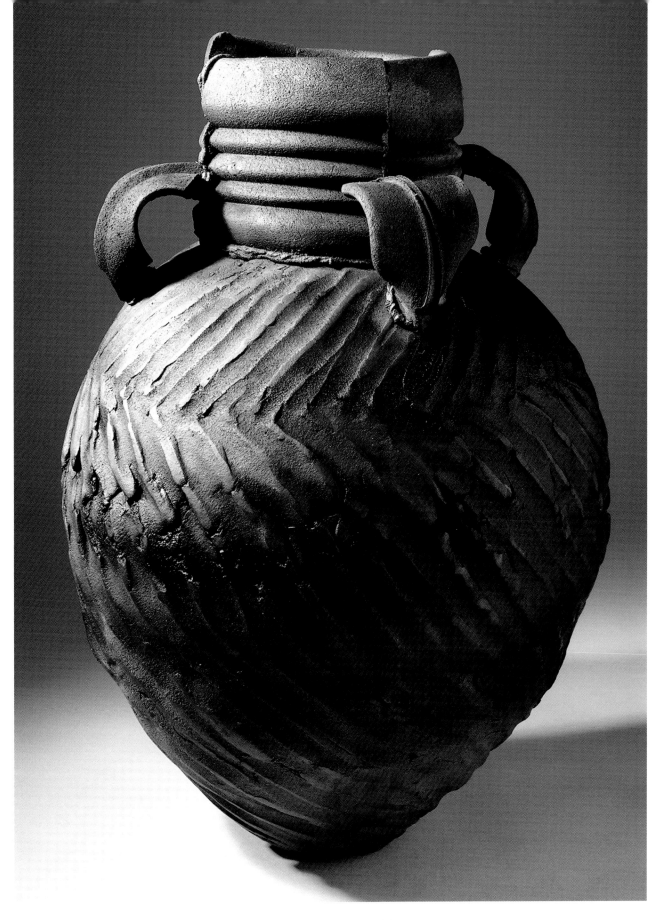

Saggar-fired Vase, 1997. Coiled and wire-cut, height: 44 cm (17 ¼ in). *Photo: Sebastian Blackie*

effects of heavy carbon trapping but found the charcoal an expensive fuel to burn.

He discovered he could produce some of the rich qualities of wood firing and charcoal firing by firing in a saggar:

It is ironic that the technique uses saggars, not to protect work from the effects of impure fuel as Wedgwood did, but to synthesise qualities otherwise impossible in gas or electric kilns; nevertheless, while it may evoke the drama of untamed fire it is wholly

Pot Fired in a Cardboard Kiln. *Photo: Sebastian Blackie*

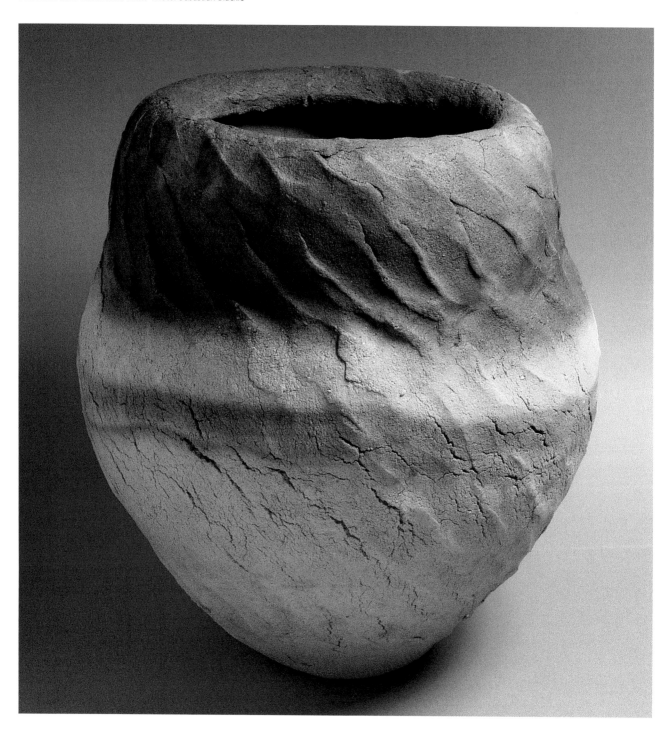

dependent on the temperature and control of the modern kiln.

Initially burning charcoal, Blackie soon realised that he could use sawdust as a cheaper alternative, and that if he sealed the saggar completely the fuel would turn to charcoal. Inspired by the work of Aline Favre, the Swiss potter who invented the paper kiln in the early 1980s, Blackie began making paper saggars by using a cardboard cylinder as a former and coating it with about 15 layers of newspaper and slip. It was suddenly possible to tailor-make the saggar to fit the work; the low thermal mass meant huge fuel savings, and by simple modification he could pierce the saggar wall to allow air to burn the sawdust selectively with decorative effect. By firing to high temperatures (up to 1300°C/2372°F) Blackie could achieve the kind of gutsy extreme firing qualities he admired in the work of abstract expressionist ceramicist Peter Voulkos.

Each stage of the making history is evident in Blackie's work and celebrated as a journey from its original state as formless material to becoming a ceramic vessel. He expresses a sense of fluidity in these processes akin to a series of choreographed dance movements – digging, wedging, shaping the soft clay with fingers and then the intense dramatic activity of white heat and flame. The clay is often unrefined dug clay (he uses both earthenware and stoneware), and Blackie employs a repertoire of forming methods, singly or in combination, to give him the kind of versatility he needs – coiling (Nigerian method), press-moulding into paper and muslin moulds, pulling (like pulling handles), and cutting through a solid block of clay with wire. I have watched him forming a cone of clay by walking around it backwards whilst shaping it with his hands, a technique he invented whilst working at Ryoji Koie's studio in Japan. The thick slurry he uses for joining is not cleaned away where compression causes it to squelch out, but remains as a visible statement. Unless the piece has been constructed (where joins are vulnerable to temperature differentials because the sawdust has an insulating effect) it is fired raw to encourage deeper colour. Presently, Blackie is firing in a gas kiln, but since the saggar provides a micro-atmosphere and can be sealed, he has also used electric kilns. The pots are packed into the saggar and covered with sawdust – either fired unlidded if he wants the horizontal white line to appear, or covered with a lid if he wants the colour to be blacker.

I usually soak the kiln at about 500°C (932°F) until the sawdust has fully carbonised and to allow the heat to penetrate the pack. At 1300°C (2372°F) I soak [for] anything between 30 minutes and three hours then crash-cool to 800°C (1472°F) by opening the door. This kind of firing leaves a distinctive whitish line across the work. Above the line the variation of colour results from different degrees of reduction and re-oxidisation, fly-ash glazing, etc. Below the line the colour is [the] soft, sometimes lustrous, blue-black of impregnated carbon. The line, I believe, is the result of sawdust continuing to burn as the kiln cools, exposing the impregnated carbon to air.

In the late 1980s Blackie began experimenting with paper kilns (detailed descriptions are in Chapter 9), partly as a natural development from the paper saggars and also influenced by the impact of watching a Nigerian bushfiring at Aberystwyth Ceramics Festival in 1989. This bush firing, conducted by women who had never left their village, caused a sensation and must have been inspirational to many potters – it is still talked about in ceramic circles today. (Similar open firings are described in detail in Chapter 2). Blackie says,

The bush kiln makes me think that, in many cases, the simpler the technology the greater is the skill required, which in turn develops observation and a deep understanding of materials. I believe one firing with a paper kiln will teach more than 100 firings in an electric kiln.

His original article 'A Paper Kiln', published in *Ceramic Review*, was followed two years later by 'More Paper Kilns', where he introduced a kiln structure built from tightly rolled-up newspapers joined together with tape and placed in rings, one on top of another, to form a cylindrical structure.

I became curious to know if the paper would provide both insulation and fuel as the corn stalks, straw, hay and wood had done in the Nigerian firing. What seemed particularly important in the bush firing was not just generating heat but also accumulating it long

Covering sheets of newspaper with slip to make a paper saggar.
Photo: Sebastian Blackie

Building the paper saggar.
Photo: Sebastian Blackie

Packing the kiln with paper saggars.
Photo: Sebastian Blackie

A paper saggar firing in progress. If they survive the first firing, they can be reused for up to 20 firings.
Photo: Sebastian Blackie.

enough for it to do its work. It seemed that the tightly rolled newspaper might allow this to happen.

A further variation was the use of cardboard kilns using packaging material from shops, where the principles were much the same as with newspaper kilns.

When lit, the cardboard, compacted under its own weight, will initially carbonise. Once this charring phase is complete, drawing air through this mass of glowing carbon generates the heat. Some of the heat accumulates in the chamber and is insulated by the layer of ash which forms on the outer wall of the kiln.

Blackie's Zen approach, one of working with or becoming the clay and fire rather than dominating it, is at the root of his success as a master of improvisation. During our conversations he has compared saggar firing to gardening in a window box: they both provide urban solutions to constraints on space, expenditure and time in contemporary society. They both also feed the soul.

NATTINEE SATAWATTHAMRONG

As the kiln is opened the infinite natural miracles are discovered, inspiring me to work further.

The ceramics of Nattinee Satawatthamrong are informed by her practice of Wabi Sabi, the Japanese Zen philosophy committed to living in the present moment and seeing beauty in simplicity. It acknowledges three simple realities: nothing lasts, nothing is finished and nothing is perfect. To accept these realities is to find contentment. She says,

> *Buddhism teaches us to take a neutral path … not too sensual and not too ascetic, to love solitude and peace, to be satisfied with what one has or is, to understand*

Wabi Sabi Teapot. Height: 16 cm (6¼ in).
Photo: Aroon Peampoonsopon

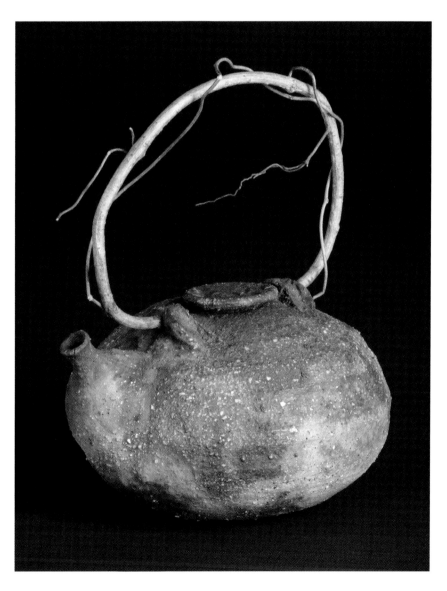

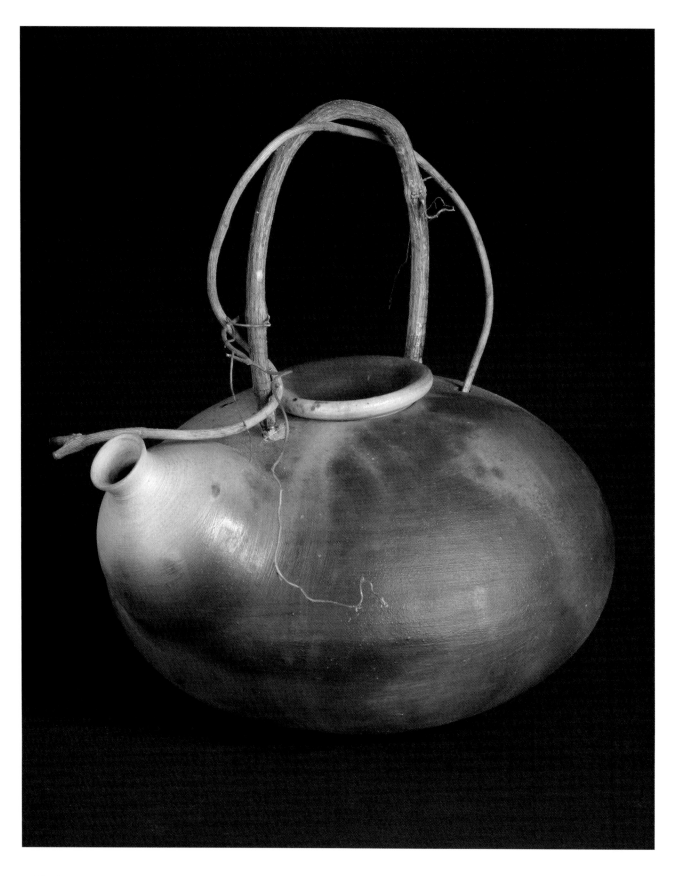

Wabi Sabi Teapot. Height: 17.5 cm (7 in). *Photo: Aroon Peampoonsopon.*

Packing the saggar with rice husks, copper carbonate, iron oxide and charcoal.
Photo: Nattinee Satawatthamrong.

One saggar has been packed and closed with a kiln shelf; more layers can be constructed and stacked above.
Photo: Nattinee Satawatthamrong.

nature and appreciate natural beauty which is often overlooked.

Satawatthamrong makes functional vessels such as traditional teapots, cups and lidded containers, as well as sculptural pieces. The forms are organic, inspired by nature; their surfaces are rough and rocky or smooth like pebbles. Surface fire marks resulting from high-temperature saggar firing emphasise Satawatthamrong's commitment to celebrating material and process. Her work expresses a sense of fluidity and immediacy achieved by capturing the journey and natural transformation of raw clay during firing.

Smoke firing has no specific pattern. There is no right or wrong but it's an experiment to find natural miracles. The output from smoke firing may be perceived differently according to each person's taste, satisfaction, designs, atmosphere and experience.

Nattinee Satawatthamrong was born in Bangkok, Thailand into a family of doctors. She displayed an early talent for art during her childhood and later studied ceramics at Silpakorn University in Bangkok, where she graduated in 1996. This was followed by travel to England, where she completed an MA at the Kent Institute of Art and Design, exploring the ideas of Funk ceramics. She became influenced by American ceramicists from the Bay Area of San Francisco such as Rudio Audio, Robert Arneson and Peter Voulkos, and produced sculptural

work based on casting and juxtaposing found household objects.

I chose ceramics because it is something three-dimensional that we can touch and use in our everyday life. I like the words 'Art of Living' as it is my philosophy to making art. Ceramic is just a mundane material from the earth but it is extremely exciting and challenging to explore. When we use a little different percentage of mineral or firing temperature it can make a big change to our work.

After returning to Bangkok, Satawatthamrong decided that she wanted to become a serious potter making functional ware and was offered an artist residency at the Shigarake Ceramic Cultural Park in Shiga, Japan. It was here that her interest in smoke firing began. She was able to experience for the first time the ancient Japanese wood-firing techniques of noborigama and anagama, as well as pit smoke firing, and was instantly captivated.

The smoke-firing process became my artistic focus. The firing atmosphere drives the beauty of the clay to the surface; no matter how we try to control it, we have to allow natural forces to create the object d'art.

Satawatthamrong's primary concern is to produce art work which can function as part of daily life. By saggar-firing her pieces to high temperatures she ensures that the clay will vitrify and become watertight. The pieces are thrown or coiled using either stoneware or porcelain

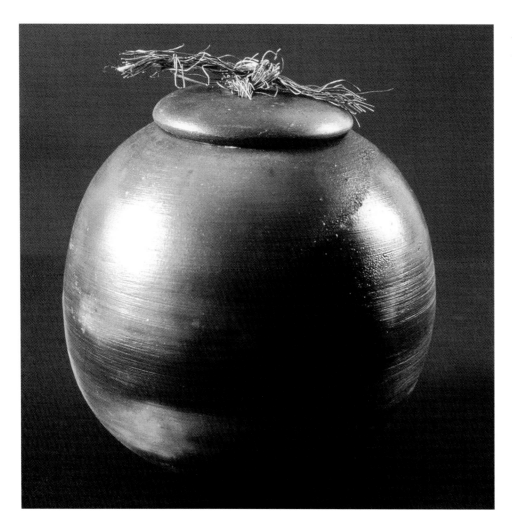

Tea Caddy. Height: 13 cm (5 in).
Photo: Nattinee Satawatthamrong

clays, chosen for their distinct and different qualities. The white porcelain will give clear colour variations after the saggar-firing; whereas the stoneware, which is often mixed with gravel, results in a rustic, rocklike surface. The saggar is built up with fire bricks and kiln shelves inside a gas kiln. This approach of purpose-building a saggar rather than using a fixed size has the obvious advantage of flexibility. A series of these saggars can be stacked up, holding different combustibles and colouring agents as well as accommodating pieces of various sizes.

The base of the saggar (a kiln shelf laid directly onto the floor of the kiln) is covered with a layer of straw followed by a layer of sawdust, and the bisque-fired pots (fired to 800°C/1472°F) are carefully arranged on top. Next comes a sprinkling of rice husks around the pots and then pieces of charcoal are lain directly against the clay surfaces. The straw will leave stripes on the pieces, the rice and sawdust will give marks of black through to grey, and the charcoal very dark, glossy marks. Copper carbonate is sprinkled around the pieces (giving pink, red and burgundy colours) and sometimes iron oxide is added, producing a yellow ochre. Everything is then covered with sawdust; any parts left uncovered, touching the saggar walls or touching other pots, will remain unsmoked (white). The saggar is closed with a kiln shelf and, if desired, another saggar can be built above it, and so on. The firing takes 9-10 hours. At 950°C (1742°C) the firing atmosphere is changed to reduction until the temperature reaches 1250°C (2282°F). After firing the pieces are waxed several times, and where appropriate a handle made from natural materials such as twigs and rope is added.

As the kiln is opened the infinite natural miracles are discovered, inspiring me to work further. The fire produces different nuances of poetry on the surface.

PAMELA GORGONE

I want the work to be direct, elemental and quiet.

Pamela Gorgone lives in Watertown, in the American state of Massachusetts. Her black-and-white installation work is concerned with simplicity of shape and the calm of repeated forms.

> *I always seek elemental simplicity. My search has been motivated by an interest in formal clarity – aided by the mystery and timeless power of numbers, sets and series. This work is the result of retreating from any decorative impulse, and a drive towards a more reductive purity – exploiting just the thinness and plasticity of the clay, the possibilities of basic shapes,*

and effects of the fire itself. I want the work to be direct, elemental and quiet.

Gorgone uses a low-firing white clay, and forms the pieces by slab-rolling and hand-cutting. The bisque-firing is around 1050°C (1922°F), followed by a saggar-firing (of the black pieces) using fine sawdust to 850°C (1562°F) for 4-6 hours.

Grey Area. Length: 28 cm (11 in). *Photo: David Caras.*

7 SMOKE FIRING INSIDE A KILN

The ceramicists in this section smoke fire directly inside their kilns, which avoids the need for separate equipment. Wood, gas and electric kilns have been chosen to suit either rural or urban working environments and the combustible fuel for smoking has been selected from what is locally available. The late Pierre Bayle's approach grew out of an economical necessity to reduce expenditure, resulting in a simple wood-fired brick and mud built kiln (resembling a bread oven) for both oxidised and reduced firings. By shutting off the air he was able to produce a reduction atmosphere causing smoke to penetrate the crackled terra sigillata surface. After reaching the bisque temperature, Munemi Yorigami cools his kiln to 600°C (1112°F), then stokes the fire mouth with damp pine needles and seals it completely. The steam increases pressure inside the kiln and forces the carbon deep into the ceramic surface. Ellen Schopf, a city dweller, has developed an unusual and effective low-temperature smoke firing inside her electric kiln. She uses everyday organic materials, such as oats made into an aqueous solution with milk and poured onto the ceramic surface. Localised carbonisation takes place at 400°C (752°F), the smoke produced is minimal and the elements will remain unaffected because of the low temperature.

Pierre Bayle, Lidded Columns (detail).

PIERRE BAYLE

The search for beauty remains my continual preoccupation.

In 2002 Pierre Bayle won the prestigious Liliane Betten-court prize 'pour l'intelligence de la main' (for the intelligence of the hand), one of many prizes and honours awarded to him during his lifetime. Sadly, he died in 2004, but through his dedicated, uncompromising personal quest for beauty he developed a unique voice which inspired and captivated a broad audience. He said,

> *The search for beauty remains my continual preoccupation. I have an inner certainty that I can recognise it and detect it. However, I am always asking myself about its true nature. In fact, I know exactly what my own beauty ought to be, and I try to protect it, but I can't vouch for everyone. Beauty is like a language that most people can hear, even if total understanding is often arduous.*

Bayle's vessel and sculptural work combines qualities of pure form and linear fluidity with rich earth-coloured surfaces broken up by crackle smoke marks. His repertoire of enclosed vessels and sculptural forms, sometimes incorporating figurative imagery, embraces his passions of entomology, ancient antiquity and mythology.

Bayle lived in the countryside near Narbonne in south-western France, close to the place where he was born. His stone farmhouse was surrounded by vineyards, olive and almond trees, and shaded by huge pines; his studio looked out towards the snow-covered peaks of the Pyrenees. The surrounding Mediterranean area, steeped in the history of Roman and Greek culture, helped to inform his choice of terra sigillata and the influence of classical ceramic forms. Bayle studied pottery from the age of 14 at the technical college at Castelnaudary, and followed this with an apprenticeship in throwing at the workshop of Jean Vergnes in Languedoc. Later he went to a factory in Paris, making large rococo lampshades which were sold in expensive shops; but a yearning to return to his roots sent him back to the south.

It is ironic that the economic hardships he experienced in order to set up a workshop were the catalyst to develop his art.

> *It is interesting to note, looking back, how the direction that one takes is linked to the precise constraints of one's circumstances. Without money it is out of the question to buy a kiln; trying for high temperatures is practically impossible and besides you have to use unprepared clay which is loaded with iron. So, when you arrive with your wife and a bundle of belongings at some place or another – and this could happen in Europe or in Africa - you start off with nothing; just with clay and water. Then you have to cook. With any means you have. In Mexico the potters cook using cow pats …*

Bayle built a wood-burning kiln with old bricks from a baker's oven, dug the local earthenware clay and then set

Broken pots built into a retaining wall outside Pierre Bayle's house.
Photo: Nesrin During

Canaupe aux Scarabées.

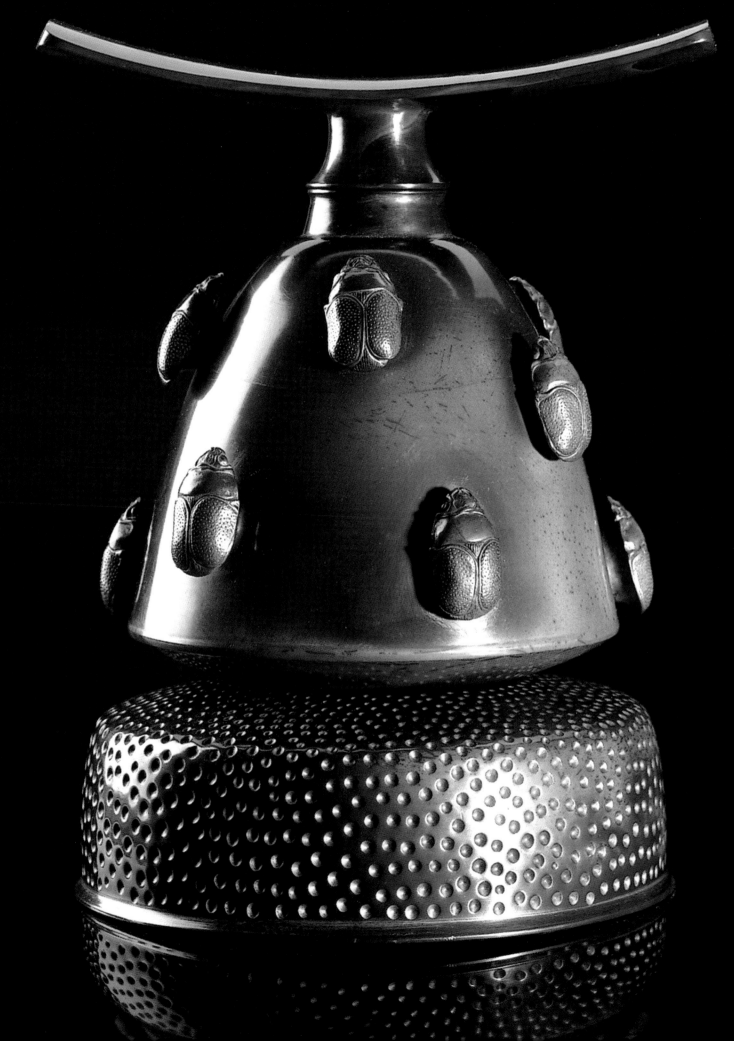

Pierre Bayle's studio. *Photo: Nesrin During*

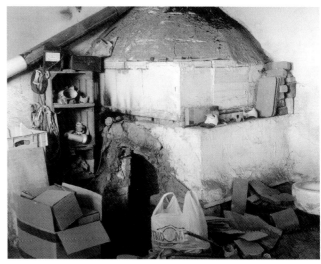

Wood-fired kiln used by Pierre Bayle. *Photo: Nesrin During*

Two Gaea forms in progress; once coated with terra sigillata slip, they were polished with the palms of Bayle's hands.
Photo: Nesrin During

about the task of earning a living. His range of humorous anthropomorphic pots were popular with the tourists, but once immersed in the activity of production he realised he needed to find a more personal direction. At the time, during the 1970s, most other potters were producing stoneware, but he never felt inspired by the 'drab' colours or by the 'coldness' of the glaze. He did, however, feel moved by pots he saw in museums, pots of modest appearance but which he felt aspired to be true works of art. During a stay in Paris he had spent many hours in the Louvre studying the red-and-black pottery of ancient Greece and later said that he 'longed to get

near this perfection of form which so moved me'. By adopting the Roman technique of terra sigillata and experimenting with the firings, his work began to come alive and gave him the personal voice he was searching for. During the 1980s he began exhibiting this new work, initially in France and then internationally; it was received favourably and was soon sought after by museums and private collectors. Historically, Bayle's work was an important contributor to the resurgence of interest in the ancient and traditional techniques of low-temperature smoke firing. It influenced several other ceramicists featured in this book, incuding Duncan Ross and Giovanni Cimatti.

Bayle investigated form by adapting classical artefacts such as canopic jars and alabaster vases through a lengthy process of reinterpretation. He was able to absorb and reinvent them to express his own experience. He worked systematically, starting with a rough sketch which slowly developed into a form through many pages of minor adjustments and annotated variations. Here he describes how column forms provided him with a fertile source of inspiration:

Several years ago I worked for about a year and a half on the theme of the column. On top I wanted to put a shape – something – but it just didn't come, absolutely nothing at all! I was no good. I didn't fire anything. I even destroyed it all. Then one fine day the idea came to me simply put a lid on top of the columns. It became a pot, it was a return to authenticity, to my own story. For I am, first of all, a potter. I felt the urge

*to place a horizontal on my column and my cups
evolved, then I worked on the development of the
capital. For a time the column itself had more
importance than the shape on top. I can thus recognise
easily the chronology of my work, all the more so since
I draw everything first in exercise books. The next step
was to upend the process; the column quite simply
became the foot. I think that Hans Coper worked in
the same way.*

Other works are linked to his interest in mythology, and
during the 1990s he developed an elegant full-bodied
bell-shaped form rising up into a narrow bottleneck,
which he called *Gaea* (the Greek goddess of the earth).
The potency of Bayle's *Gaea* is an example of his ability
to express opposing dynamic qualities within a form at the
same time. The wide base lifts up from its resting point so
that it seems to hover above the ground; its contained

Erigone à Ecailles. 45 x 25 cm (17¼ x 10 in).

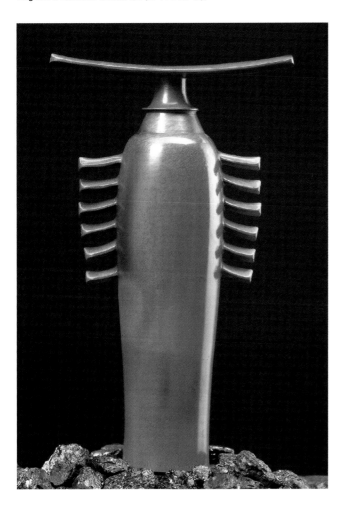

space is full of tension as if about to burst, yet the outside
of the form remains still. The flowing curves of its silhou-
ette draw the eye back onto the polished surface, which
is divided into three horizontal incised bands and a sin-
gle vertical one. They give a sense of symmetry and
classical proportion. Within the widest band the surface is
broken up by sparsely spaced rows of raised spots resem-
bling the shell of a beetle and alluding to his fascination
with the natural world. *Gaea* took seven years to mature
and symbolised for Bayle the peak of his achievement as
a ceramic artist searching for the perfect form.

Bayle loved to take long walks into the countryside,
observing the microcosm of life in the fields and vine-
yards surrounding his house. He spent many hours
crawling on all fours to observe and contemplate the in-
sects, foliage and fruits which inspired the literal imagery
in his work. For instance, there is a cube-shaped pedestal
topped with a group of modelled poppy heads; and a
gourd-shaped form with attached relief scarab beetles
entitled *Bitter Apple with Scarab Beetles*. He once said,

*I love to watch the potter wasps, great craftsmen who
produce fantastic work. Around the house I know all
the birds' nests, and at my front door I can gather pine
cones. One day an idea takes shape. I go back to my
pot and find a place where I can model scales like
those on pine cones. I am always looking for a motif to
use – like, for example, stylised vine tendrils. Often
the reference is deliberately direct, like the shells I have
recreated from scarab beetles. I have also copied the
perfect symmetry of black olives.*

Most of the forms were thrown from a white faience
earthenware and when leatherhard, burnished with self-
made plastic ribs. After drying, a terra sigillata was applied,
made either from red clay dug from a local dry lake bed,
or from Vallauris brick clay. Bayle believed the high soda
content fluxed the slip and contributed to the density of
the crackle pattern. The wood-burning kiln was a sim-
ple brick-and-mud structure resembling a bread oven
with a long fire mouth. The temperature of the first ox-
idised firing was increased very slowly, taking twelve
hours to reach between 900-1000°C (1652-1832°F). The
second smoke firing was taken to between 400-500°C
(752-932°F), and then heavily reduced so that carbon
penetrated into the crackled parts of the slip which had
not been vitrified during the first firing. From these

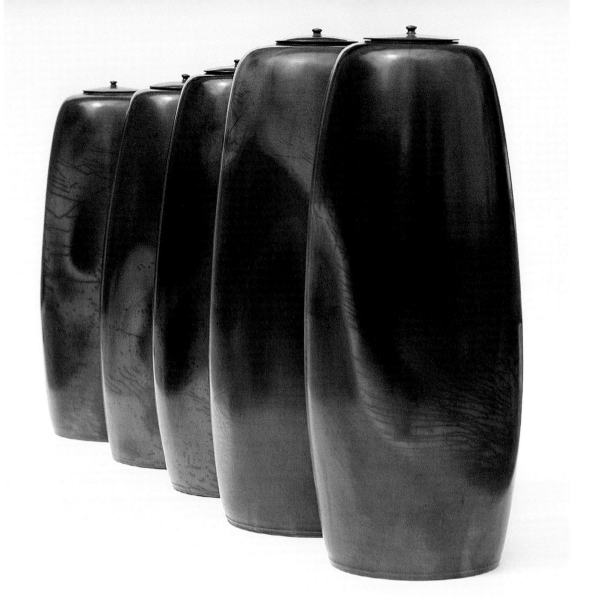

Lidded Columns.

deceptively simple materials and firing techniques
Bayle was able to achieve a rich variety of colours:
jet-black, grey, red, pink, yellow, ochre, gold and many
nuances in-between.

Bayle was a perfectionist, breaking anything which
did not satisfy his high standards; there is a wall outside
his studio built from discarded and smashed pots. The
Dutch potter and writer Nesrin During visited Bayle in
2001 at the time of his illness, and describes her impres-
sions: 'Pierre Bayle was very ill when I first went to see
him … at first he was very subdued and silent … he was
judging us for what we were worth … apparently he
liked us, then he opened up miraculously … he became
so alive, you wouldn't believe it. Then about a year later
we went back; he was half his size but once again we

could hardly leave; he was so talkative. I wanted to buy a
piece from him, he had no new work. The wall that you
see in the picture (see p.132) goes on and on; and they
are not broken or cracked pieces; just not up to his stan-
dards. I said 'can't I buy one of these?' He replied 'no way'
… he asked me to come back next year. There was no next
year. He was a very special person.'

Technical notes
Terra sigillata
1 kg red iron clay
7 /1000 soda for deflocculation
This makes 7g of slip.

ELLEN SCHOPF

My pottery is a remote echo of forgotten cultures.

The ceramicist Ellen Schopf lives in Freiburg, near Germany's Swiss border. She creates open vessels of classic proportion which give the impression of floating as they balance motionless on their narrow bases above the ground. Her repertoire of cylinders, vases and bowls refers to ancient pottery, as well as expressing a sense of elegance through their thin walls and graceful forms. The surface treatment of random smoke marks, with its subdued colour palette of greys, browns and blacks, helps to emphasise the restrained serenity of her work.

> *While I have not looked for something new, but rather have used the old for guidance, I have found my own evolving path. My pottery is a remote echo of forgotten cultures.*

It is interesting when people find their way into ceramics having received formal training in another discipline.

Large Bowl. Height: 13 cm (5 in). *Photo: Frank Schindler*

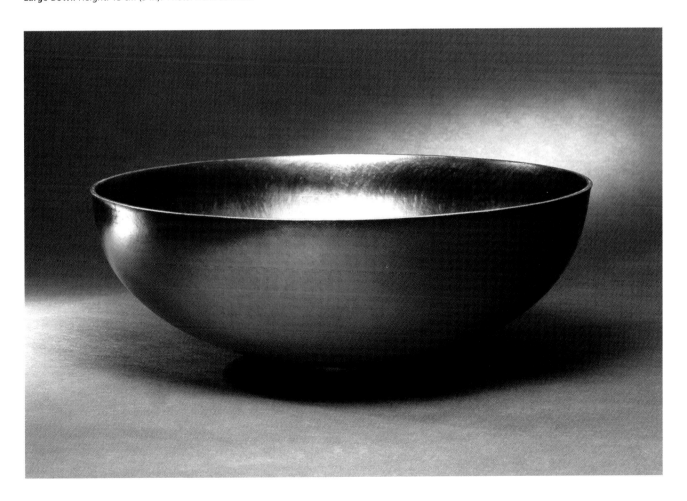

Preparing the combustibles: (left to right) water mixed with milk, coffee grouts, poppy seeds and baked oat flakes.
Photo: Ellen Schopf

Pouring the liquid over the bowl.
Photo: Ellen Schopf

The bowl has been placed upside down in the kiln on top of a plate and covered by a second bisque-fired bowl which acts as a saggar. Smoke firing is to 390°C (554°F).
Photo: Ellen Schopf

Schopf began her career in medicine and, like many others in this book, discovered ceramics by chance. As a young doctor, she came across the work of Edouard Chapallaz, a famous Swiss master of pottery, and was instantly captivated. She became an avid collector of ceramics, visiting galleries and museums and learning to appreciate the cultures of ancient and contemporary ceramics. During a visit to the museum of modern ceramics in Deidesheim she discovered some work by the German ceramicist Lotte Reimers, a self-taught potter who later became a role model. Reimers encouraged Schopf to follow her ceramic aspirations and take the first tentative

steps towards working with clay as a second career. The Potter's Book by Bernard Leach became an important resource as she embarked upon many years of trial and error underpinned by her rigorous work ethic and meticulous attention to detail.

Schopf initially worked with glazed stoneware, but an extensive study in the late 1970s for a Ph.D. thesis on the history of medicine led her to the Pre-Columbian art of Mesoamerica. Her research involved studying the enormous number of effigies representing death in those cultures in order to understand their significance in relation to medicine. During a subsequent visit to Mexico

After the smoke firing – the saggar has been removed.
Photo: Ellen Schopf.

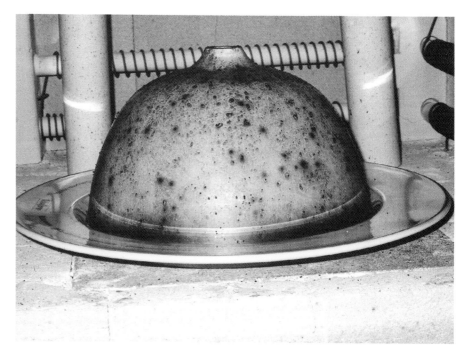

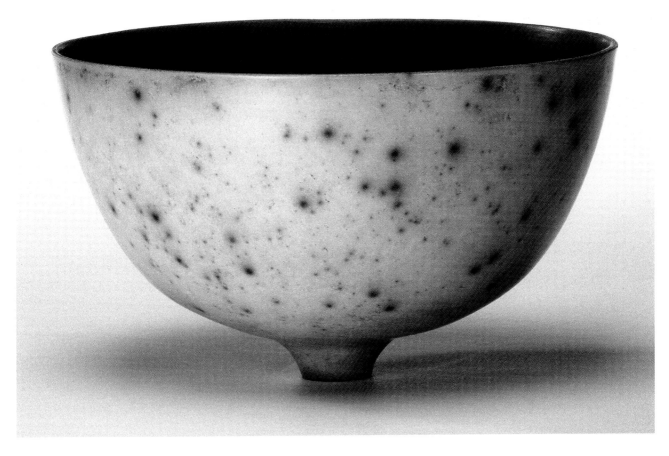

Speckled Grey Footed Bowl. Height: 11.5 cm (4 1/2 in). *Photo: Frank Schindler*

and Guatemala she came across burnished low-fired vessels and sculptures.

> *I was deeply touched by the restrained beauty of burnished vessels and objects and I began burnishing myself.*

Schopf started to work with polished surfaces and developed her own individual method of smoke firing within an electric kiln.

> *I found inspiration for my work not just in the world of pottery, but also in the artistic legacy of different cultures, for example, patterns of ancient tapestry and fabrics, engravings of Islamic metal vessels, gold shimmering backgrounds of paintings from the Middle Ages, wood carvings and stone sculptures.*

Schopf works with Westerwald red and white clays (from western Germany) mixed with 25-40% grog depending on the size of the piece. Cylindrical forms are built by slabbing, and the round bowls press-moulded by pushing the wall of the vessel outwards against the mould with a damp sponge.

> *The Korean potters of the Yi period (16th century) have taught me that perfection is not absolutely essential to beauty. A pot can be imperfect and can still be beautiful, emanating life and grace. You can find highly acclaimed and admired pieces of pottery in Korean and Japanese museums that can display obvious irregularities, cracks and flaws. This encouraged me to accept and embrace technical flaws.*

The leatherhard surface is covered with a porcelain or clay slip and burnished several times with pebbles before a final burnish with polished agate. Some surfaces are engraved into patterns and painted with coloured slips. A bisque firing is carried out to

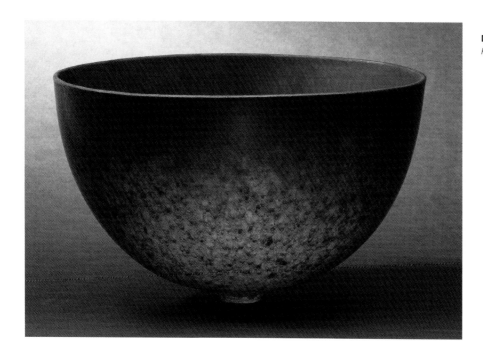

between 900 and 970°C (1652 and 1778°F), followed by smoke firing.

Through working in isolation, Schopf has developed an unusual approach to firing combustibles around her pots.

> *The first results in my electric kiln were disappointing. As I used to work for several years with stoneware glazes, it was natural for me to think of a glaze-like application of combustibles. First I made experiments with many different organic substances from the garden, like dandelion and euphorbia and various seeds. Little by little I developed the methods I use today. I developed a number of aqueous solutions consisting of a variety of organic materials. I apply these just like a glaze by using either a spoon or a sponge.*

The organic materials consist of coffee grouts, baked oats and poppy seeds which are either mixed with water or a mixture of water and milk.

Vessels are usually placed upside down in the kiln; their interiors filled with newspapers and coffee grounds, carefully avoiding direct contact of the fuel with the vessel wall. The smoke firing is completed at between 380 and 400°C (716-752°F), with reduced air supply to enhance the carbonisation process. At this low temperature, the elements of the kiln are not affected. Schopf often repeats the smoke-firing process several times until a satisfactory effect is reached, before finally applying beeswax and polishing.

> *Many factors play a role in what the surface eventually looks like. The physical and chemical properties of the organic substances, the amount of material applied, the depth of penetration into the shard, the firing temperature (at 400°C/752°F nearly all the material is completely burnt) and finally a bit of luck all play their part in the creation of the vivid surface.*

MUNEMI YORIGAMI

By breaking the form Yorigami believes he is reaching the very 'heart and soul' of the clay

The sculptural work of the Japanese ceramic artist Munemi Yorigami is an exploration of the opposing forces of control and unpredictability to create a 'whole'. The resulting pieces, which he calls 're-creations', are deliberately broken at the raw stage then treated to different firing techniques and reconstructed into a dramatic patchwork of white, black and orange or ochre. By breaking the form Yorigami believes he is reaching the very 'heart and soul' of the clay and expressing something of its intrinsic nature. He emphasises the hazards of transforming clay during its journey through fire; the risky nature of firing and the ever-present vulnerability to breakage. Yorigami exploits the chance of risks and unexpected results by his choice of multiple firing with its inevitably different shrinkage rates. He gives significance to those elements of ceramics that are beyond his control and puts them in a new context, which he describes as 'transforming memory'. His work embraces a range of scale, from domestic-sized, tabletop sculpture to monu-

mental pieces of 2 m (6 ft 6 in) high, as well as installations within the landscape.

Yorigami grew up in Kyoto where his father was a potter. After studying landscape gardening and agriculture at the university, he studied ceramics at a vocational college and then became apprenticed to the late Kazuo Yagi, who has been a major influence. Yagi formed the famous Sodeisha group in the late 1940s (of which Yorigami is now a member), which represented avant-garde ideas that looked beyond established Japanese traditions. Yagi was well known for his use of black fire, or kokuto, which underwent a revival after the Second World War and later became firmly established in Japan as a sculptural technique.

Yorigami uses a fine clay to facilitate the highly polished surface qualities he requires, building his pieces with slabbing, coiling and press-moulding techniques. The construction of large sculptures is controlled by a technique he employs of hanging a string from the ceiling,

Stoking damp pine needles into the kiln before sealing it with clay to trap the smoke.

Sealing the kiln with clay to trap the smoke.
Photo: Munemi Yorigami.

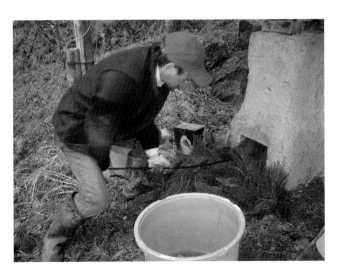

Munemi Yorigami with re-creation **Humpty Dumpty Falling Down**. Height: 80 cm (31$\frac{1}{2}$ in).

Re-creation Cubes. Height: 60 cm (23½ in). *Photo: Munemi Yorigami.*

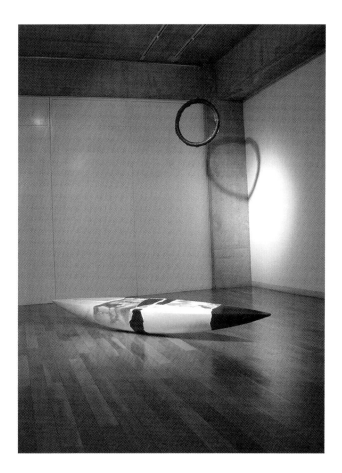

Re-creation **The Mooring has Parted.** Length: 23 m (7 ft 6 in). *Photo: Munemi Yorigami.*

which acts as a guide to gauge the central axis of the form as he coils it up from the base. After the shape of the piece has been scraped down and refined, the surface is slightly dampened and burnished with a pebble. Next the piece is turned onto its side and broken by hitting a wooden hammer against the clay wall. This act, like the firing, is also unpredictable, as the shapes and sizes of the broken pieces cannot be entirely controlled. With luck the breakages will occur naturally, but if some pieces are too big they are broken further. The irony of deliberately smashing his work is a graphic illustration of Yorigami's message to present ideas of strength and vulnerability, but it also draws on his practice of Zen.

The broken pieces are fired in three different ways to 900°C (1652°F): a black firing, an oxidised firing, and a firing to encourage the flashing of orange colour. The black firing takes place in a kiln cooled to 600°C (1112°C) after reaching the optimum temperature. The kiln is then stoked with wet pine needles and sealed. The water content of the pine needles expands into steam, increasing the pressure inside the kiln, and forcing the carbon deep into the surface of the clay. The fired pieces are assembled and stuck together with glue, to emphasise the joining lines. As shards, the pieces have no value but once reconstructed they metamorphose into a new creation with different meanings that challenge our perceptions.

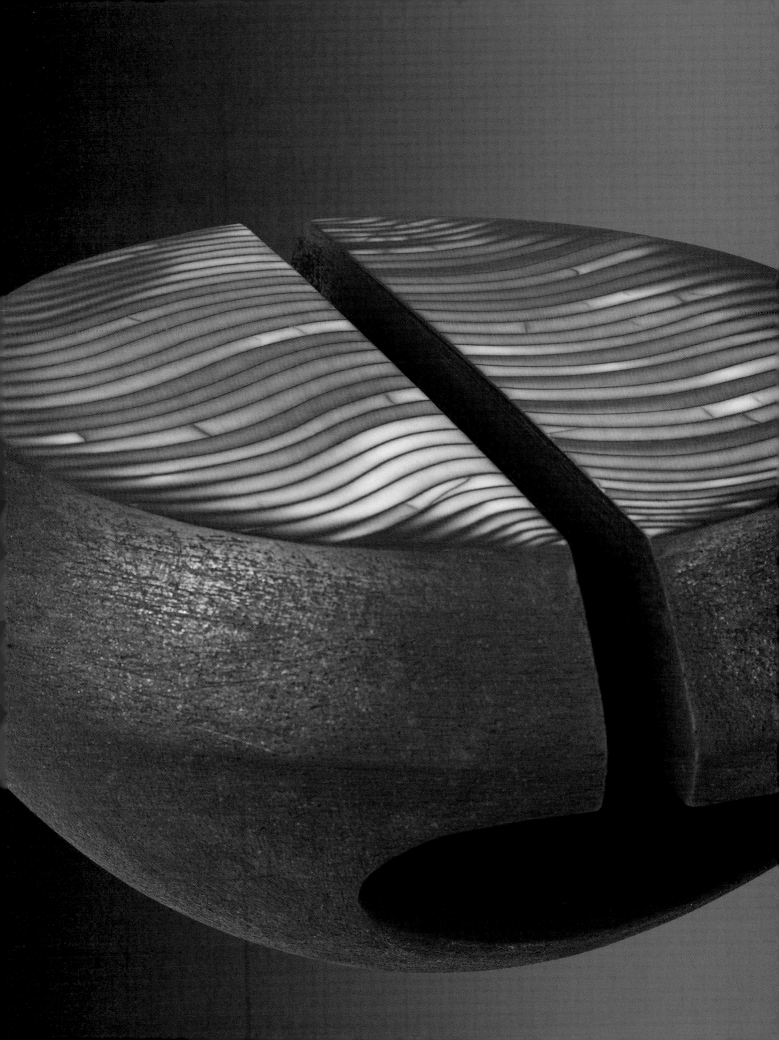

8 POST RAKU SMOKE FIRING

Inspired by Bernard Leach's introduction of Japanese raku in *A Potters Book* in the 1970's, American potters became intrigued with the technique and began to develop it into the postfiring reduction process familiar to us today. The ceramicists in this section smoke fire their work in sawdust after extracting it whilst still hot from a raku or electric kiln. By using a range of firing temperatures and resists to create designs they are able to achieve both plain and highly decorated surfaces. Anne James obtains her rich surfaces by combining lustre and smoke firing. Pieces are withdrawn from an electric kiln when the lustre temperature matures at 800°C (1472°F), then placed directly onto a bed of sawdust. The carbon speckling appears as saw-dust is sprinkled directly onto the surface, igniting upon contact with the hot ceramic. Joy Bosworth extracts her pieces from a high temperature raku firing (1000°C/1832°F) and reduces them in sawdust to achieve a rich gunmetal black effect whereas Giovanni Cimatti works with much lower raku temperatures of around 600°C (1112°F). This allows him to reduce thermal shock during firing and work with finer clay to produce a wide range of vibrant terra sigillata colours. Ashraf Hannah draws through slip and glaze resists to create linear smoke designs which will be cleaned away after the raku firing and reduction in sawdust.

Split-top Sculptural Form by Ashraf Hanna. Height: 20 cm (8 in).
Photo: Adrian Hawke

GIOVANNI CIMATTI

Aesthetically, I find myself drawn to surfaces that recall ancient Attic and Roman production

Visiting an artist in their studio brings new insights and new levels of understanding of their work. I was privileged to spend a couple of days with the Italian ceramicist Giovanni Cimatti, who lives in Faenza, a north-eastern Italian city traditionally associated with majolica ware. Standing in a darkened corner of his living room is a large fish tank lit so that the water appears almost black but the tropical fish and plants are brilliantly highlighted. Their tails are exaggerated fan shapes, constantly moving and flashing colours of luminous orange and gold. For many years Cimatti's work has been inspired by the sea – both by the aquatic life of fish and plants, and by the maritime mythology of ancient Greece. Stories of mermaids and sirens such as Parthenope, who drowned herself when Odysseus evaded the lure of the singing sirens, are an important part of his ceramic narrative.

His sculptural forms, with their curving silhouettes, summon obvious associations with female torsos and sea creatures, as well as with the dynamic movement of flames. Their shapes naturally lead the eye up towards the tip (which for Cimatti represents the visual exit), emphasising the space above and around the form. Cimatti's palette of glowing terra sigillata colours is drawn from local clays – oranges, yellows and ochres created by the unique blend of Mediterranean climate and geology. He uses a technique he calls 'raku dolce' (soft raku), which breaks up the colour with black crackle marks, following the shape of the forms and giving them a sense of drama.

Ciotilona. Diameter: 30 cm (12 in). *Photo: Enrico Liverani.*

(Right) **Elfi.** *Photo: Enrico Liverani.*

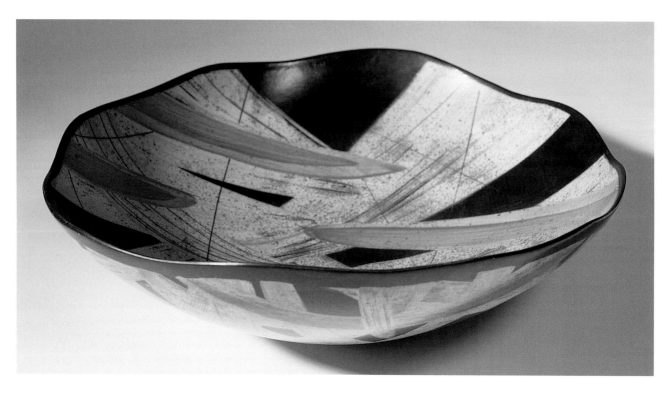

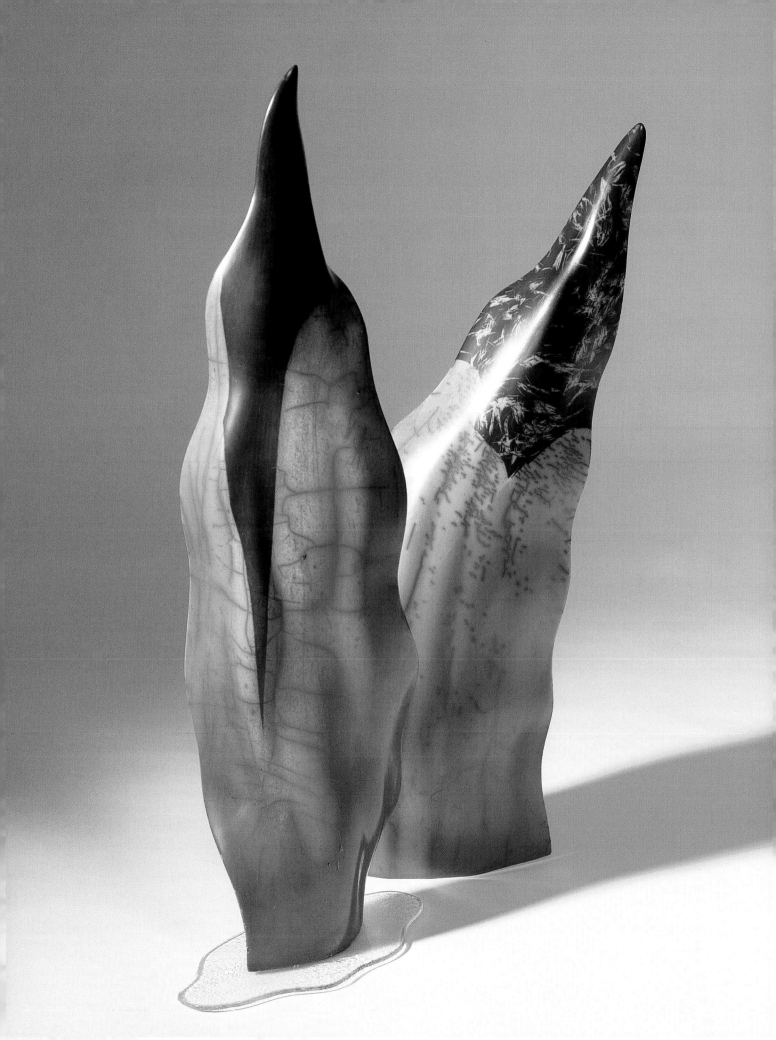

Scratching through the terra sigillata slip will allow the smoke to penetrate the fine lines during the reduction.
Photo: Jane Perryman.

Packing the raku kiln.
Photo: Jane Perryman.

The bowl has been withdrawn from the raku kiln and placed in a bed of sawdust.
Photo: Jane Perryman.

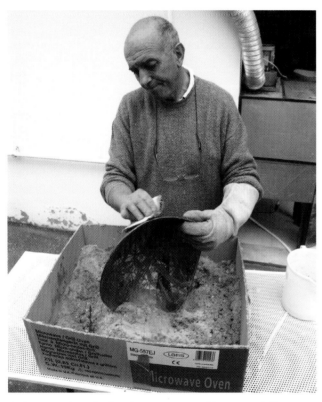

During post-raku reduction, the porous areas without terra sigillata quickly absorb the smoke and the bowl is cleaned.
Photo: Jane Perryman.

The forms are often literally broken and rejoined, allowing him to emphasise a small area by giving it a contrasting treatment such as complete blackening or a different kind of pattern. The art historian and critic Maria Grazia Morganti has said of his work investigating the theme of sirens, 'Perhaps the fragmentation of their bodies corresponds to technical needs, but it is certain that it gives us back a sense of myth that has layered over time, creating a complicated literary puzzle. It is as if these figures with their variegated 'skin' were formed by shreds of the stories, always different, of sailors from all times.' As well as exploring sculptural and mythological ideas, Cimatti makes open bowls whose surfaces serve as a medium for his highly expressive designs.

Cimatti grew up with an awareness of the significance of materials – his father was a self-employed artisan who worked with wooden furniture. An introduction to ceramics at school laid the foundation of his passion for clay, and led him to studies at the National Institute of Ceramics in Faenza, where he also trained to become a teacher. Teaching has paralleled his career as a ceramicist; in the 1970s he became Director of the School of Design in Faenza, and then through the '80s and '90s he taught at the School of Ceramics in Faenza. His ceramic development has undergone several stages or 'seasons', as he describes them. For ten years he worked with transfer printing on factory tiles, followed by ten years exploring architectural ceramics, then a period in the 1990s investigating the Korean technique of sanggam[1], before developing 'raku dolce'. He says,

I began to experiment with raku and high-fired ware for teaching purposes. By the end of the nineties I found myself holding a brand new creature, 'raku dolce', conceived from the union of sanggam and raku. This creation was the result of my desire to achieve a polished surface using engobes and patinas obtained by decanting clay slip. During this project I was also influenced by the work of contemporary artists Duncan Ross, Pierre Bayle and Tjok Dessauvage.

Cimatti is an alchemist with a passion and innate curiosity for all things ceramic. His studio is crammed with hundreds of bottles, chemicals, test tiles – a lifetime's collection of ceramic paraphernalia – all stored systematically and representing investigations into many diverse techniques. He discovered that, like the ancient Greeks and Romans, he could improve his terra sigillata by using rainwater (which is free of dissolved salts), and began collecting it in a garden cistern.

When I began to apply the terra sigillata-type engobe to pieces destined for raku firing, I was surprised to see that when dry some of the applications became automatically shiny without burnishing, and were blackened by the absorption of smoke at much lower temperatures. The possibility of obtaining a deep, intense black from smoke at much lower temperatures (570–600°C/1058–1112°F) than the usual raku kiln temperatures (700–950°C/1292–1742°F) allowed me to adopt a grogless clay. I could use this smooth clay

without any serious danger of thermal shock when the piece was taken from the hot kiln. The possibility of working with a smooth clay for raku was very liberating for me, and opened up vast new horizons. Aesthetically, I find myself drawn to surfaces that recall ancient Attic and Roman production, and enjoy the excitement of uniting their Mediterranean tactile and chromatic characteristics with the ancient and modern firing methods of Japan.

Forms are coiled from red terracotta clay; the bowls are press-moulded using a fine grogless stoneware clay (containing 0.2% sand), then force-dried with a gas burner. The dry surface is covered with a slip made from the white clay body (with the sand removed) and then the designs are built up with various terra sigillata slips. These are all produced from clays collected locally by Cimatti from the mountains around Faenza. The slips are applied with various brushes, a spray gun and wax resist to separate the colours, then finally polished. A bisque

Ciotilona. Diameter: 30 cm (12 in). *Photo: Enrico Liverani.*

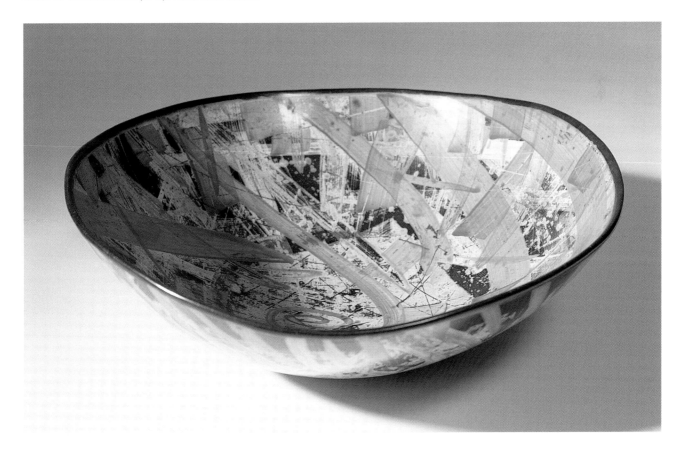

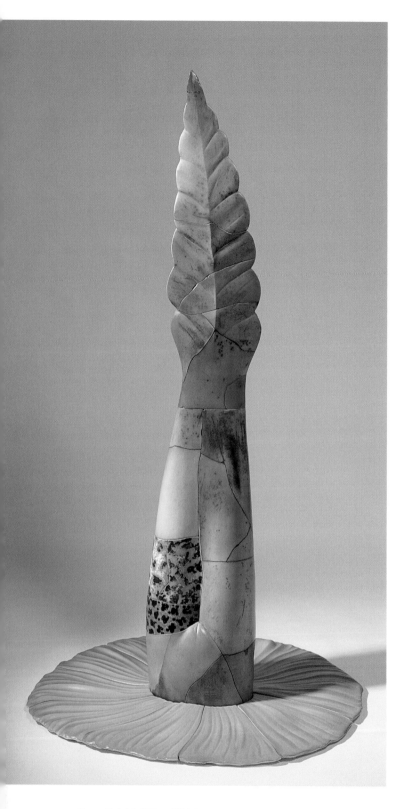

firing to 960°C (1760°F) will leave the base white slip porous but the terra sigillata areas non-porous. A raku firing follows to a temperature of between 570 and 600°C (1058 and 1112°F). The pieces are withdrawn and immersed in a cardboard box filled with damp pine sawdust, which produces vapour rather than smoke (Cimatti lives and works in a residential area). A second, less risky possibility (as illustrated) is to apply the terra sigillata slips after the bisque firing and fire the raku kiln to 970°C (1778°F). This vitrifies the terra sigillata, and once the temperature drops to 600°C (1112°F) the pieces are withdrawn and carbonised in the same way.

Notes

1 The original Sanggam method involves incising the design into leather-hard clay and covering the piece with an engobe. The engobe is then scraped from the surface, remaining only in the incised parts. Cimatti took this technique further by engraving into the engobes themselves, which had been applied to bisque ware.

Ligea. Height: 170 cm (67 in).
Photo: Enrico Liverani.

ANNE JAMES

When I can get into play mode, when I'm not worrying about the outcome, is when things can happen.

Anne James is well known for her highly decorated smoked lustre work. The first time we talked about her ideas for *Smoke-fired Pottery* 13 years ago, she spoke of an ongoing search to bring a sense of freedom into the skill of a disciplined ceramic process. One of the dictionary definitions of freedom in this context is 'ease; lack of effort'. These are elusive qualities to capture in fired ceramic, but over the years an exploration of different techniques and approaches has enabled her to express something of their characteristics. James has recently expanded her repertoire of vessel forms and formal surface patterns to investigate wider themes related to abstract and figurative ceramic sculpture.

James was raised in Dublin, and after studying ceramics and printed textiles in Belfast during the early 1960s completed a teacher-training course. She later moved to Gloucestershire, where she started her first workshop and still lives today. She originally made domestic stoneware but changed clays when she discovered an immediate rapport with porcelain. This change of clay

Slabbed Torsos. Heights: 22 cm (8¹⁄₂ in). *Photo: Anne James.*

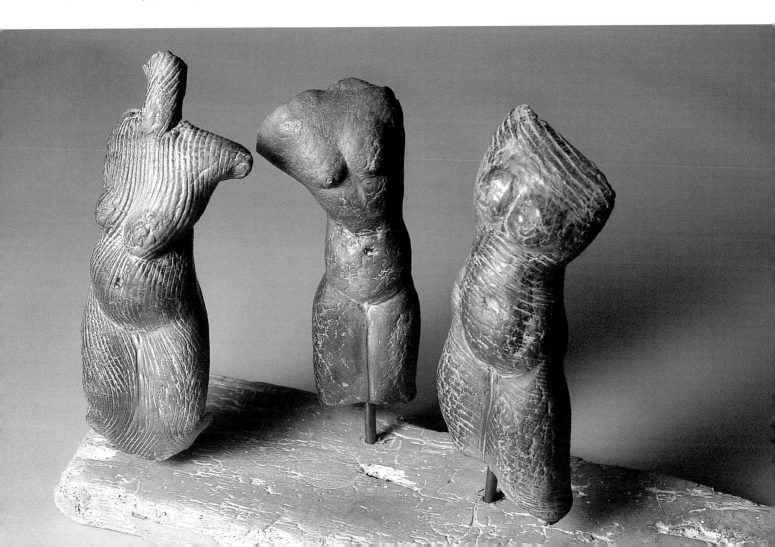

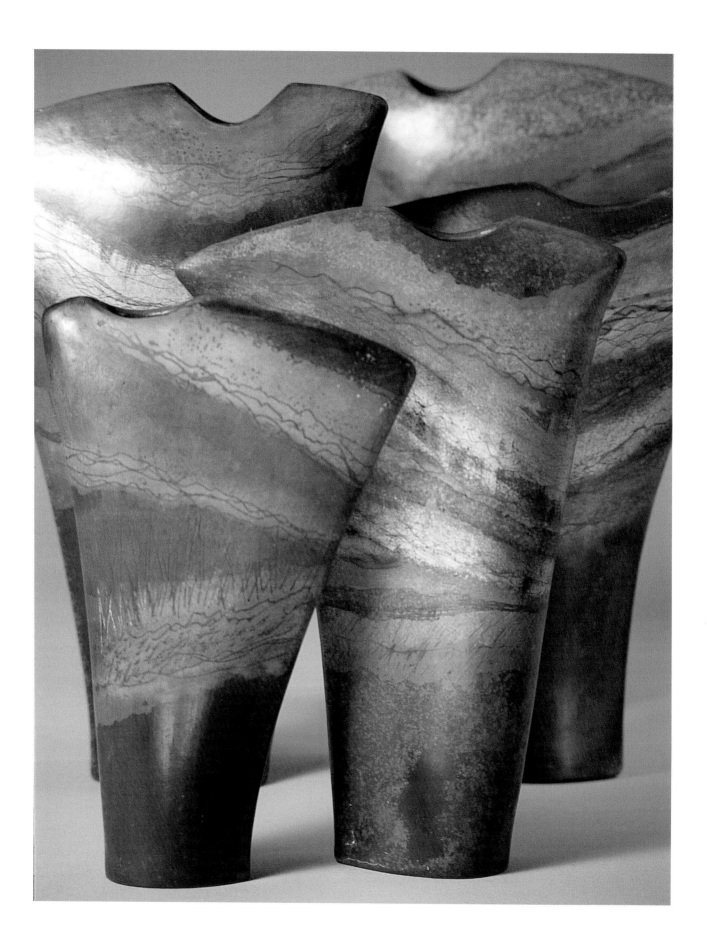

directed her away from functional ware towards small, organically inspired forms which were thrown, then beaten and squashed. In 1983 an important turning point was reached, inspired partly by David Roberts demonstrating raku and partly by an exhibition of Sutton Taylor's lustred ceramics. She realised the potential of working with lower temperatures and began to experiment with smoked lustre-glazed raku. A chance visit to an exhibition of Indian textiles had a further major impact and marked the beginning of a long investigation into textiles from India, Japan and Africa which inspire her surface designs.

Throughout her career, James has continually kept sketchbooks, and these are an important part of her art. They represent a visual diary of visits to museums, exhibitions and travel to her favoured landscapes of sea and desert. She does not use them literally, but their significance is pivotal to her ceramic work and her sense of place in the world. During the last ten years a change of basic making technique from throwing to slabbing has given her work some of the qualities of vitality and expressiveness she desired. Influenced by watching a demonstration given by the American ceramicist Mark Pharis, she began to use cutting and joining processes to construct an open dish. By exploring an infinite range of possibilities of the positioning and length of cuts she found she could change the form, in much the same way as a dart will change the shape of a garment. James wanted to find a sculptural solution to the traditional bottle form she had used for many years and developed a series of abstract vertical forms from a single slab of clay. These new pieces had an immediate affinity with both ancient artefacts and contemporary architecture (such as the Guggenheim Museum in Bilbao). They expressed a sense of movement through their formation from soft clay into asymmetrical forms.

I had always been fascinated by Neolithic and Bronze Age axe-heads and flints, and had been drawing them for years. These slabbed pieces are process-based – to do with processes and seeing what happens, playing with it. What can I do with a single slab? I started to

preform the shape by hanging it over a wooden roller suspended over a plastic box.

Recently, James made a shift from the routine of studio practice and exhibition deadlines by joining the Access to Art course at Stroud College of Further Education.

I felt the processes I used were becoming repetitive and it would be useful to step back from ceramic work for a while to widen my horizons and expose myself to new ideas and ways of working. If you can get into that thoroughly then different things can happen which are unexpected. I was giving myself permission to play, which you don't do when you work alone making things to sell. When I can get into play mode, when I'm not worrying about the outcome, is when things can happen.

The course was a challenge to her observational and drawing skills and involved a wide spectrum of disciplines. The vertical slabbed forms gradually evolved into figurative torsos, and by marking the surface with linear ridges and textures she was able to emphasise the dynamic energy of the form. This work is bisque fired, then smoke fired in sawdust which, in contrast to her lustre work, leaves a restrained monochromatic palette of greys through to black. Lastly, it is polished with white liming wax to highlight the texture. Further improvisations around the theme of a single clay sheet have developed into an installation of ambiguous press-moulded forms with reference to natural shoreline objects such as crabs, shells, driftwood or stones.

James uses a David Leach porcelain clay to which she adds molochite, and forms her pieces almost entirely from slabbing and joining. Slips consisting of the sieved porcelain body mixed with oxides and body stains are applied by spraying thinly in bands, patches or stripes before burnishing and bisque firing to 1000°C (1832°F). A combination of techniques is used to apply the layers of lustres. These include direct painting, printing with sponges cut into simple shapes, and the use of resists such as latex so that there are several layers of lustre colour, with spaces of exposed slip in between. Next follows a lustre firing to 800°C (1472°C) in a small electric kiln, before the piece is withdrawn red-hot from the kiln and smoked in a nest of sawdust contained in an open metal box. Sawdust is also sprinkled onto the

Axe Forms. Heights: 26 – 20 cm (10¼ x 8 in).
Photo: Anne James.

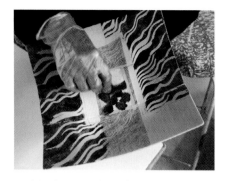

Applying lustres to the surface using latex resist to form the designs.
Photo: Jane Perryman.

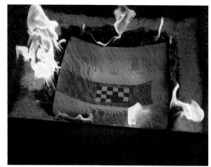

After the lustre firing the dish is withdrawn at 800°C (1472°F) and placed into a bed of sawdust.
Photo: Jane Perryman.

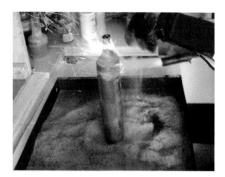

Burning sawdust directly onto the surface of tall bottle forms with a blow lamp.
Photo: Jane Perryman.

surface until the desired effect is achieved. The upright forms require a different approach; as well as the sprinkling technique, pieces are rolled across a bed of sawdust contained in tinfoil.

Removing the pot at the right moment is crucial, as too much smoking can mean a loss of the subtle lustre markings. The build-up of lustres established during these multi-firings allows the play of light to transform

Slabbed Dishes, Lengths: 35cm, 26cm, 22 cm (13 ³/₄ x 10¹/₄ x 8¹/₂ in). *Photo: Anne James*

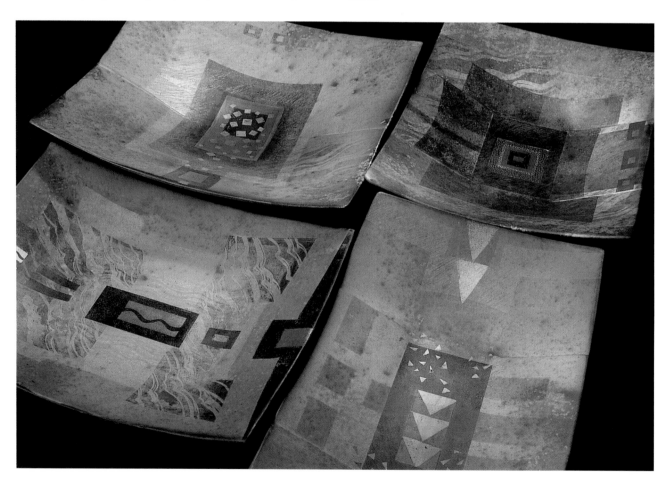

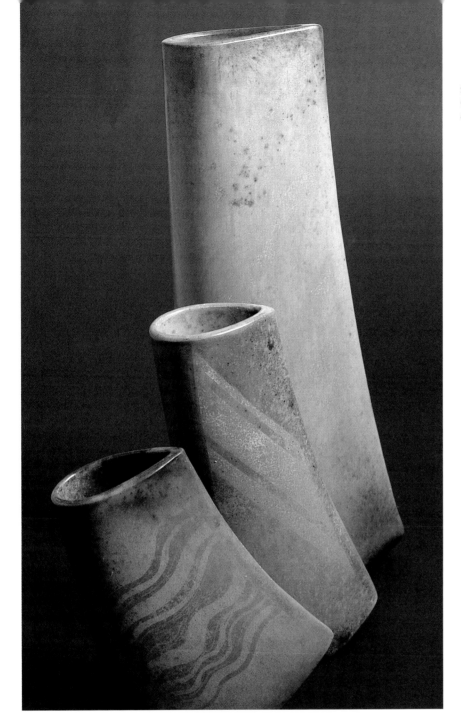

Slabbed Vessels. Heights: 28 cm, 18 cm, 14 cm (11 in, 7 in, 5½ in).
Photo: Anne James.

the surface so that different patterns emerge and disappear as the piece is handled and tilted. All ceramicists play with fire, and James has developed a particularly dramatic technique to overcome the cracking problems of tall bottle forms. She has found that she is able to achieve a similar effect to that of post-raku firing, but without the risks. By burning sawdust directly onto the surface with a blowtorch, she can avoid the uneven effects of thermal shock that can happen during cooling. I watched her do this in front of an extractor fan in her studio, though she did emphasise that the process would be safer if pursued on a calm day outdoors! James describes the importance of smoke firing in her work:

The smoke seems to transform the whole surface; it draws all the elements underneath together and unifies them. It modifies and softens the colour – even to the areas which are very slightly smoked.

JOY BOSWORTH

I wanted to respond to the artefacts from my own urban environment.

Joy Bosworth's black-fired ceramics have evolved from her life's experience as a city dweller living on the outskirts of Birmingham. She is inspired by found and discarded detritus from urban environments, such as wet cardboard boxes, fast-food packaging, exhaust pipes, burnt circuit boards and rusty buckets. These are the kinds of obsolete items whose destination is a dump or landfill site in Western societies. It is intriguing how through the weathering and ageing processes such mass-produced objects can metamorphose back into something resembling their original state. Wet cardboard can begin to take on the appearance of a rotting tree trunk; weathered metal can over time look like rock.

Vessel with Formed Silver Lid. Diameter: 28 cm (11 in). *Photo: Dan Bosworth.*

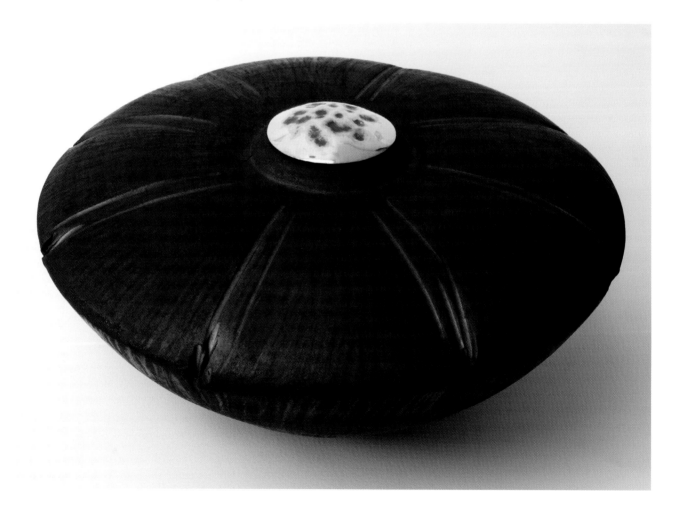

Three Split Vases. Height: 17 cm (6 ¾ in). *Photo: Dan Bosworth*

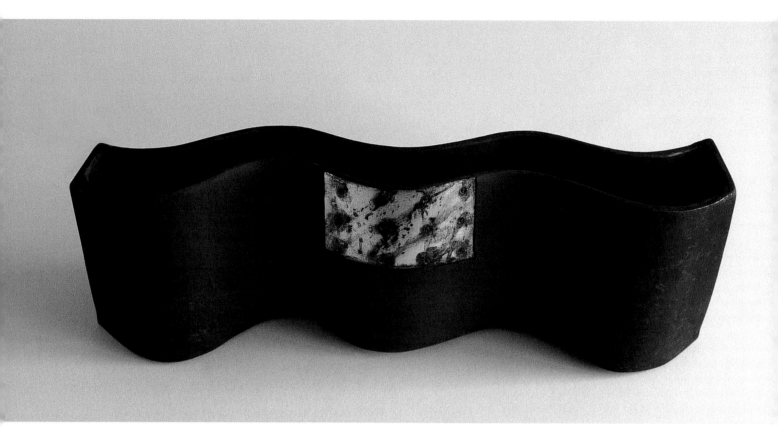

Corrugated Vessel. Width: 27 cm (10½ in). *Photo: Dan Bosworth.*

Artefacts speak of the humanity of the people who made them – that's why I love the Pitt Rivers Museum (The museum of anthropology and archaeology in Oxford). I didn't want to make copies of artefacts from other cultures – I wanted to respond to the artefacts from my own urban environment. Often precisely made, these objects when discarded become distorted and altered by their use and misuse.

Bosworth's interest in contemporary urban artefacts was further enhanced by the historical tradition of clay's ability to mimic other materials. Since ancient times, copies of objects made from valuable substances such as pewter, bronze and silver have been copied in clay, a far less labour-intensive and more readily available material whose status value is much lower. Bosworth's application of gold and silver leaf onto the ceramic surface is a deliberate gesture of ambiguity about the value of throwaway artefacts and also about the value of clay itself. She works with vessel-based forms, exploring open

dishes, vases, cylinders and more recently enclosed spheres. Much of the work is based on sheet metal and constructed by slabbing.

I'm not motivated by technique – the technique came from the original object.

The elastic, seductive qualities of plastic clay are celebrated by retaining the manipulating processes of the soft slabs. Folds, bumps, dents, overlaps, piercings and slashings all become part of the final form, capturing the fluidity of movement and speed of making. Recently she has been exploring thrown and burnished spherical forms with formed silver lids, which possess qualities more associated with stillness and containment than with the dynamic movement of her slabbed work.

Bosworth came to ceramics late in life. Her initial career was secretarial, and it was not until her children were growing up that she took an initial City and Guilds course in ceramics which prepared her for both graduate and finally postgraduate degrees at Wolverhampton

Polytechnic. It was here that her investigations into discarded urban waste (she was collecting exhaust pipes) were made significant by her tutor Dennis Farrell. He pointed out that by photographing and drawing value-less objects they are made valuable. Since then, Bosworth has combined studio work with teaching ceramics part-time at the University of Central England.

Bosworth's work is handbuilt using slabbing, assembling and throwing techniques from a 50/50 mixture of porcelain and white stoneware crank clays. She works quickly with the thinly rolled-out slabs, without measuring, and often overlays the edges with thinner strips to give a defined frame. In order to retain the spontaneity of process she minimises the actual touching of the clay; and patterns are made by pressing found objects (such as the tip of a biro pen) against or through the clay. Burnishing the thrown pieces, however, requires a very different, much slower approach of repeatedly touching and polishing the surface. A bisque firing to 1060°C (1940°F)

is followed by a secondary firing in a small gas-fired ceramic-fibre raku kiln that Bosworth built herself. At 1000°C (1832°F) the pieces are withdrawn, plunged into a metal reduction chamber containing wood shavings and covered completely with a metal lid. After 10–15 minutes the work is withdrawn, still hot, and protected with a ceramic fibre blanket to allow slow cooling. The surface is then scrubbed and rubbed down with wet-and-dry sandpaper to give a smooth finish until the subtle shades of dark grey, gunmetal and black are revealed. Lastly, patinated silver leaf (lacquered to protect and maintain the quality of the finish) or 23ct gold leaf is applied to the surface.

Applying patinated silver leaf to the black-fired surface.
Photo: Dan Bosworth.

ASHRAF HANNAH

*I found that once an intimate understanding of form is acquired,
one is free to improvise on its endless variations.*

During the ten years Egyptian ceramicist Ashraf Hannah
has worked with clay he has developed a distinctive style
through his classical vessel and sculptural forms marked
with highly defined linear and carved designs.

> *My appreciation of the vessel form goes way back to
> my early art training, where a considerable time was
> spent on still-life studies. Invariably, the composition
> would include at least one piece of pottery and so the
> proportions of the classic ancient forms were
> programmed into my mind from early on. I found that
> once an intimate understanding of form is acquired,
> one is free to improvise on its endless variations.*

Hannah's slow, methodical handbuilding technique lends
itself naturally to his exploration of closely related forms.

Carved Angular Vessel. Height: 32 cm (12½ in).
Photo: Adrian Hawke

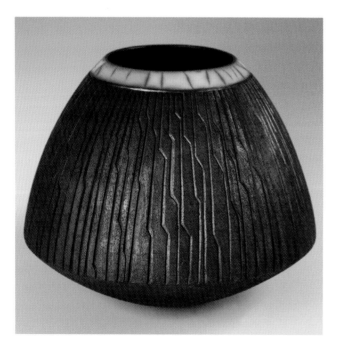

They typically rise up from a narrow base and culminate
in a small opening, giving emphasis to the profile and
providing a large surface area for design possibilities. The
improvisations he talks of have produced bulbous and
full-bodied vessels, vase forms with an elongated vertical
emphasis, wide round-bottomed vessels, and completely
enclosed scupltural vessels.

> *Since it is the space within that defines the form, I am
> interested in how concealment or exposure of such
> space can alter the character of the piece.*

Early studies at the El Minya College of Fine Art in Egypt
were followed by a course in Theatre Design at St Mar-
tin's College in London, and his introduction to ceramics
came through adult-education classes. Inspired by at-
tending Alan Bain's handbuilding and pit-firing workshop
on the Greek island of Evia, Hannah realised that this
kind of firing was not conducive to living in an urban
centre such as London. Researching the wide selection
of ceramic books available during the 1990s acquainted
him with Tim Andrews's book *Raku*, and my earlier
Smoke-fired Pottery, which equipped him with the infor-
mation he needed to begin experimenting. In 1999, he
took the leap of faith to become a full-time ceramicist,
and the following year he moved to west Wales, where he
began investigating slip-resist techniques combined with
smoke firing. A desire to work on a larger scale and to
juxtapose different tonal qualities with linear design has
led him to experiment with the technique of naked
raku. By restricting the designs to smaller areas such as the
rim, he can contrast the rich qualities of smoke decora-
tion on a polished surface with the natural black reduced
clay. Some pieces are treated with straight-edged incised

Large Vessel, Burnished Panel. Height: 55 cm (21½ in).
Photo: Adrian Hawke

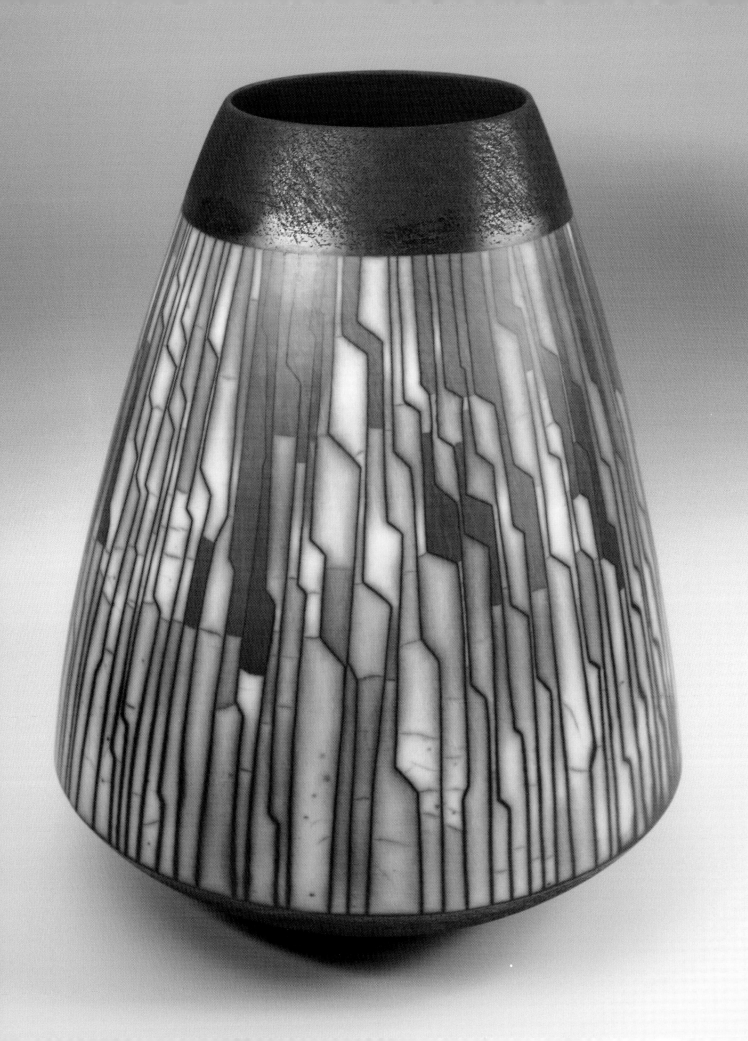

Incising through the layers of slip and glaze with a wooden skewer.
Photo: Adrian Hawke.

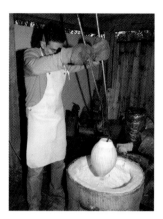

Removing the pot from the raku firing.
Photo: Adrian Hawke.

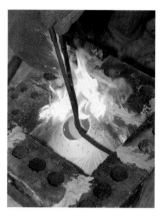

Plunging the pot into sawdust before sealing the container.
Photo: Adrian Hawke.

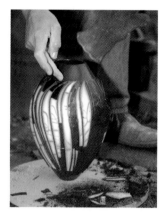

The resist shell is cleaned away.
Photo: Adrian Hawke.

patterns which are carved into the surface, creating dark lines and shadows.

Hannah works with his own brand of commercial clay and begins the forms from a pinch pot, to which he adds flattened coils of clay. Refining the form at leather-hard stage involves scraping with metal kidneys followed by the application of slip made from the sieved clay body (to remove the grog). He burnishes the surface with pebbles and builds up several further layers of slip, burnishing in-between until the desired high sheen is achieved. Some pieces are carved straight into the coarse clay surface using sharp knives; later, after raku firing, these will be reduced in sawdust to achieve a completely black surface. In the meantime, bisque firing to 985°C (1805°F) is followed by applying the surface design with masking tape, which is covered with a layer of slip (made from the clay body with the addition of gum arabic) and then a layer of glaze. The design is drawn onto the surface with a pencil and then incised through the layers of slip and glaze with a sharpened skewer stick. After the raku-firing in a gas kiln to a temperature of 850°C (1562°F), the piece is withdrawn and plunged into sawdust (hardwood produces less resin), sealed and left to cool. When removed, the resist shell is cleaned away and finally the surface is waxed. Hannah says of the firing,

The technique of smoke-fired ceramics poses many challenges; it is seemingly simple yet one that is quite laborious and often fraught with difficulties. One can never take the results for granted since a successful piece is essentially the result of a collaboration between design and chance, precision and spontaneity, artist and elements; for it is the flames which ultimately breathe life into the work.

Technical notes
Naked raku
Resist slip: made from the clay body (Ashraf Hannah Clay) mixed with gum arabic.

Resist glaze:
85 per cent alkaline frit
15 per cent china clay.

Ashraf Hannah Clay (professional range)
Available from Scarva Pottery Supplies

MARC VERBRUGGEN

I want to express the way people react to or disregard signals which surround us in the real world.

Marc Verbruggen is a Belgian ceramic artist whose work is concerned with the exploration of human emotion through the theme of self-portraiture. This piece, *Inside Outside*, is a mixed-media installation of nine ceramic tiles mounted on the top of an iron box, each of which can be arranged with the others to form a square or a line. One of the tiles contains a photographic silk-screened image of Verbruggen himself; the others show mysterious symbols based on an 'O' and an 'X' which represent an abstract language of the paths we choose or are forced to take in life.

> *They represent a kind of filter in my mind … I want to express the way people react to or disregard signals which surround us in the real world. Signals like personal situations, world news, human behaviour.*

The 'O' symbol represents acceptance and the 'X' represents rejection of the continual choices which confront us.

He alludes to the symbols as being a 'game', and there is an obvious reference to the grid of nine spaces which form the basis of the game of noughts and crosses which we all played as children.

The tiles are made from white grogged stoneware clay which is pressed into wooden moulds, then covered with terra sigillata slip and bisque fired to 980°C (1796°F). A grogged manganese slip mixed with sawdust or fibre wax (to stop it peeling off) is applied to the dampened tiles. Marks are formed either from applying wax to the bisque to resist the thick slip, or by scratching through the slip after application. The pieces are fired in a raku kiln to between 900 and 950°C (1652 and 1742°F), then removed and smoked inside a closed chamber with sawdust and leaves for five minutes. Finally, the manganese slip is washed away.

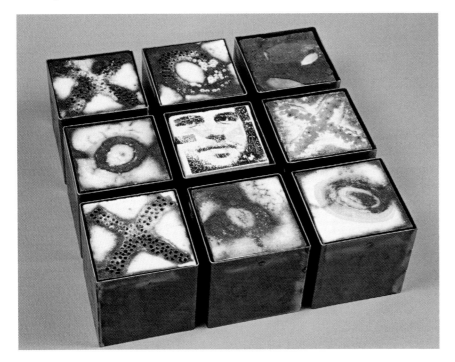

Inside Outside.
50 x 50 x 15 cm (20 x 20 x 6 in).

9 SMOKE FIRING IN GROUPS

When the American ceramicist Hal Riegger was asked why he found the 'primitive' approach to firing so pertinent to teaching he replied, 'Justification is found in the effect upon people as well as in the effect upon the resulting pots. In its simplicity and therefore its demands upon the skills of the potter (which are greater because of the technical simplicity), a manner of clear, logical thinking is brought about. We are, in a sense, taken back to the uncluttered thinking of children. Not only is this refreshing in so complex an existence, it is good training for the mental processes.' Riegger wrote these words in 1972, and since then, industrialised Western society has become much more consumerist and computerised, resulting in the alienation of people from many elemental processes. Constant exposure to sophisticated technology can lead to an assumption that technology is merely about pressing a button on a computer.

The kilns which use computerised technology to control temperature can separate the potter from much of the joy that the fire can give. In urban areas, where modern housing is heated by fossil fuels, smokeless zoning denies people the simple pleasure of a garden bonfire. Some of the drama and magic of traditional wood firing, which requires a spacious rural environment and a ready

LEFT: Special-needs students (15–16 years old) from Heltwate School, Peterborough, building brick kilns to be fired with sawdust and newspaper, c.1993.
Photo: Jane Perryman.

BELOW: David Ruddock from Hills Road Sixth Form College, Cambridge, smoke firing inside his sculpture with newspaper, c.1993.
Photo: Jane Perryman.

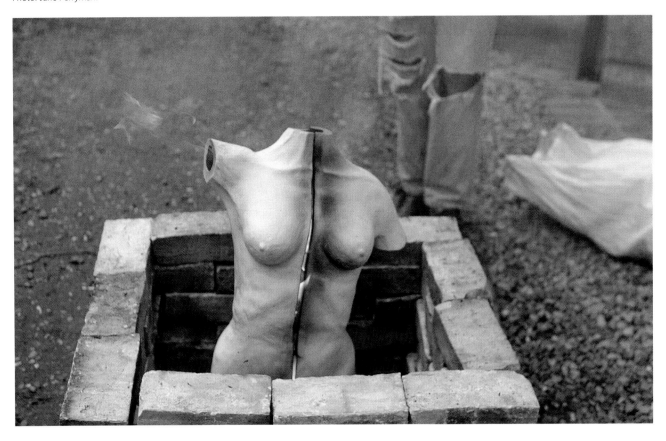

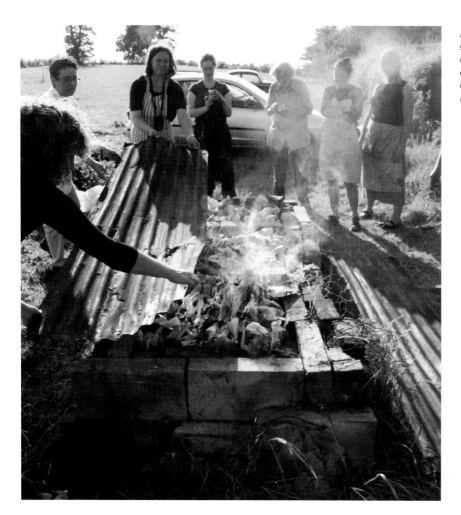

A sawdust firing covered with corrugated-iron sheeting. Because the brick container is constructed on a slope, the firing can be carried out in rain and storms as the rain drains down the lid. Jane Perryman Workshops, 2005.
Photo: Jane Perryman

supply of wood, can be captured through simple smoke firing techniques. Smoke firing is manageable on a domestic scale within an urban environment, and the techniques are versatile and open to improvisation depending on the location and available fuel. Equipment is minimal and inexpensive, and can often be found at recycling centres, at the local dump or in a skip. Firing can be carried out in the open or in an improvised container constructed from bricks or metal. During a workshop I gave in Switzerland, for instance, we devised an efficient chamber for sawdust firing from a sheet of corrugated iron bent into a tube with wire. Fuel can be any found combustible, and one of my ongoing interests has been to source the fuel locally. Whilst living in the city I used newspaper and sawdust; since moving to the countryside I have also used wood, dried cow and horse dung, and straw. At Harvard University in Boston the concrete environment was devoid of anything legally combustible, but the piles of cigarette butts discarded by

office workers were mixed with flammable liquid for a fast firing demonstration.

The various activities associated with smoke firing particularly lend themselves to groups, and are suitable for any age or level. I have worked with a wide range of ages and abilities including children, students with learning difficulties, college students, adult potters and professional artists. In schools, by taking an interdisciplinary approach, smoke firing can be experienced within a wider context through other subjects and disciplines. It requires the student to take risks, to learn by trial and error, to accept the element of unpredicatbility and to cooperate with other group members to achieve the best results. There is no definitive way to approach it. The skills are learnt by doing, and require observation, patience and a sense of adventure. For me, the processes of working with clay and fire represent a holistic experience, teaching me many practical and philosophical lessons. The photographs in this section illustrate some of the smoke firing possiblities for groups.

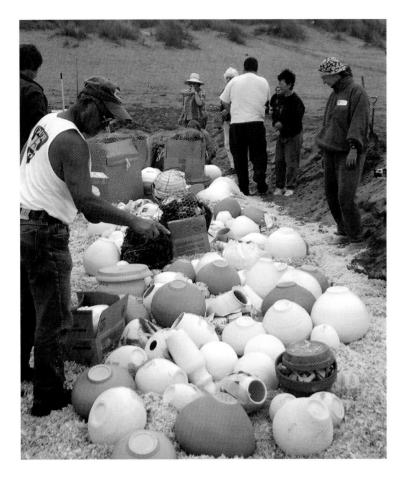

Potters' group at Dillon Beach, Northern California preparing a pit firing.
Photo: Jane Burton

Potters' group at Dillon Beach, Northern California lighting the fire.
Photo: Jane Burton

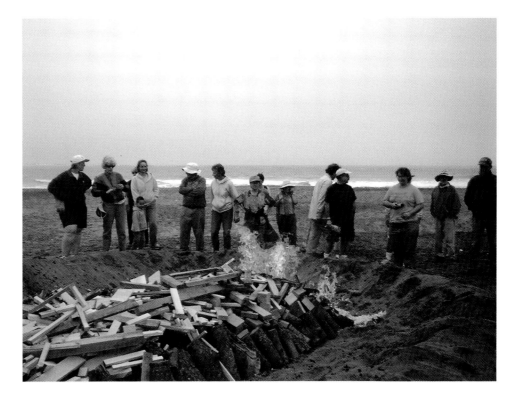

After the cardboard sheets have been secured, the surface is insulated with six layers of newspaper painted with slip.
Photo: Jane Perryman.

Construction of a cardboard kiln supervised by Anne James (based on a design by Ian Gregory) at Jane Perryman Workshops, Suffolk, 2006. A cylindrical container has been made from cardboard to contain the pots, which have been treated with salts and oxides. It is surrounded with chicken wire and lengths of wood to form a conical wigwam shape which is wrapped with sheets of cardboard and secured with tape.
Photo: Jane Perryman.

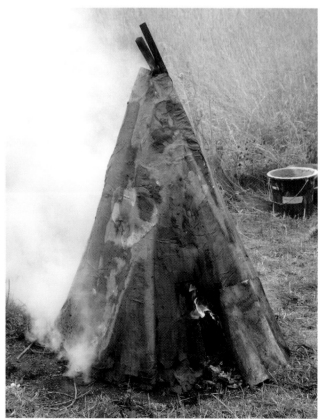

Kindling has been fed into the opening and lit.
Photo: Jane Perryman.

Constructing woven paper kilns -
making paper rolls from several
sheets of tightly rolled newspaper
secured with tape. Jane Perryman
Workshops, 2005.
Photo: Jane Perryman.

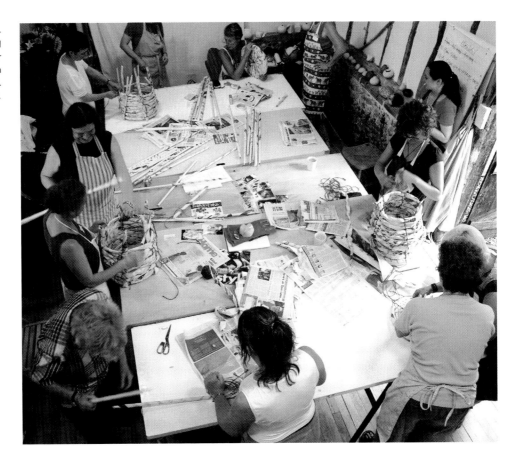

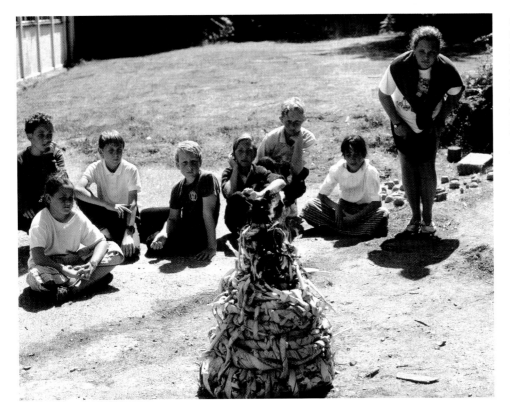

Newspaper kiln built with
Sebastian Blackie at Frencham
Middle School, Surrey, UK, c.1991.
Blackie introduced paper kilns to
the UK in the late 1980s inspired
by the work of Swiss ceramicist
Aline Favre. This tightly woven
newspaper kiln was able to fire
raw pots up to a temperature of
750°C (1382°F).
Photo: Sebastian Blackie.

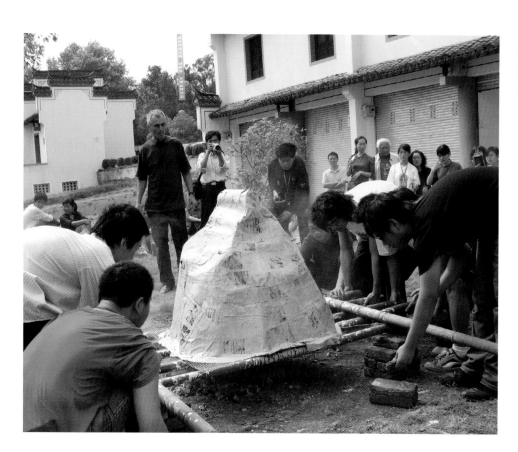

Sebastian Blackie overseeing a paper/slip kiln in Jingdezhen, China, 2006.
Photo: Sally Edwards.

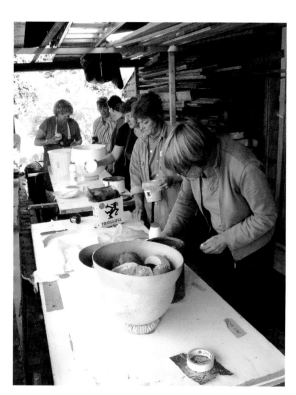

Preparing for a saggar firing with salts, oxides, copper wire and sheeting, and wire wool. Jane Perryman Workshops, 2004.
Photo: Jane Perryman.

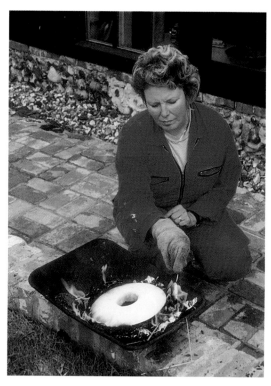

Smoke firing in the open using sawdust impregnated with flammable white spirit (turpentine). Jane Perryman Workshops, *c.*1999. *Photo: Jane Perryman.*

CONCLUSION

Traditional firing techniques that originate in antiquity have hardly changed in much of the developing world today. Seeing pots made and fired in the open or in rudimentary kilns in such countries as India, Africa and Mesoamerica can illustrate an immediate and powerful connection with our own history. The artists from contemporary western society presented in this book have expressed both their individual ideas and their cultural identity through adapting raw materials and approaches from their local environments. The special characteristic of smoke firing which they find so captivating lies within its endless possibilities for improvisation. The dictionary defines improvisation as 'to make or do on the spur of the moment with makeshift materials.' There is no right or wrong way. I have introduced the reader to just some of the many improvised approaches and materials around the theme of smoke firing. The work of this international group of artists will develop and change, perhaps leading them into other directions, but at this moment it has been created by the magic of earth, fire and smoke.

Acknowledgements

Thanks to all the ceramic artists I met and corresponded with, who gave their time and hospitality as well as their generous suggestions for further contacts and material. Thanks to the Nigoumi family and Moira Vincentelli, who provided images of Siddig El'Nigoumi's work; to Catherine Metas and Esther Viros, who helped to trace the work of Pierre Bayle; and to Nesrin During, who kindly provided her photographs of him. Thanks to John Leach and Joy Voisey, who agreed to lend their photographs of Nigeria, and to Susan Peterson, who shared her photographs of a black firing at San Ildefonso Pueblo.

Thanks to Ana Fitzpatrick and Susanna Brown, who helped with translations. Thanks to Linda Lambert at A&C Black, who commissioned the first book, *Smoke-fired Pottery*, and has continued to be a support; also to Alison Stace, my editor. Lastly, thanks to Kevin Flanagan, my husband, who has been there to solve regular problems with my (lack of) computing skills and to give advice on the text.

HEALTH & SAFETY

Smoke firing is fun, but open fire is always a risk and needs to be approached with common sense and caution, such as choosing a site away from wooden buildings, fences and other flammable materials. Different countries have different rules and regulations concerning open fire; it is advisable to check what they are and work within the law. Extra vigilance is required during hot weather when the ground is dry; buckets of water and a fire extinguisher at hand are sensible precautions. Wind can be another dangerous hazard in spreading fire as well as causing uneven temperatures during firing which can encourage cracking and dunting of ceramic work.

During hands on smoke firing appropriate clothing should be worn, avoiding loose dresses/skirts and open sandals. Long hair should be tied back and a smoke mask is recommended to avoid inhaling noxious fumes. Thermal gloves and or raku tongs are useful to handle hot pieces either when extracted from the raku kiln or from open firings. Specific safety strategies need to be planned when smoke firing with groups of people such as fencing off firing areas and keeping flammable materials away from the fire.

SUPPLIERS LIST

Apart from a kiln for bisque firing or raku firing, and raw materials such as clays and oxides, smoke firing relies on found and improvised materials.

Fuel can be any locally sourced combustibles such as sawdust from the wood mill, agricultural or garden waste such as straw and wood, or household refuse such as newspaper and animal dung.

Smoking chambers can be built from bricks, sheet metal or adapted from oil drums and galvinised metal containers. These can often be found at re-cycling centres, at the local dump or in a skip. In the UK galvinised metal bins can be bought from the hardware shop.

Saggars can be built from clay, constructed from firebricks or improvised from metal containers such as paint tins, stainless steel sinks ect.

Suppliers in France

Enitherm
Rue des Papeteries
25960 Deluz
Tel (00 33) 03 81 55 57 79

Ceradel Socor
Z.I.N. 17 à 23 Rue Frédéric Bastiat
B.P. 1598
87022 Limoges Cedex 9
Tel (00 33) 05 55 35 02 35

Solargil
89520 Moutiers-en-Puisaye
Tel (00 33) 03 86 45 50 00

Suppliers in the UK

Bath Potters' Supplies
Unit 18, Fourth Ave,
Westfield Trading Estate,
Radstock, Bath BA3 4XE
Tel (00 44) 01761 411077
www.bathpotters.demon.co.uk

Brick House Ceramic Supplies
Cock Green, Felstead,
Essex CM6 3JE
Tel (00 44) 01376 585655
www.members.lycos.co.uk/
brickhouse

Potterycrafts Ltd
Campbell Road, Stoke on Trent,
Staffs. ST4 4ET
Tel (00 44) 01782 745000
www.potterycrafts.co.uk

Ceramatech Ltd
Units 16&17, Frontier Works,
Queen Street,
London N17 8JA
Tel (00 44) 020 8885 4492

Suppliers in the USA & Canada

Axner Pottery Supply
P.O. Box 621484, Oviedo,
Florida 32762
Tel (001) 407 365 2600
www.axner.com

American Art Clay Company
4717 W.16th St, Indianapolis,
IN 46222
Tel (001) 317 244 6871
www.amaco.com

Laguna Clay Co.
1440 Lomitas Avenue, City of
Industry, CA 91746
Tel (001) 626 330 0631
www.lagunaclay.com

Mile Hi Ceramics, Inc.
77 Lipan Street,
Denver,
Colorado 80223
Tel (001) 303 825 4570
www.milehiceramics.com

Tucker's Pottery Supplies Inc.
Unit 7, 15 West Pearce Street,
Richmond Hill,
Ontario, Canada L4B 1H6
Tel (001) 905 889 7705

REFERENCES

GENERAL BOOKS

Barnett, William K. and Hoopes, John W. , *The Emergence of Pottery* (Washington, DC: Smithsonian Institution Press, 1996).

Barley, Nigel *Smashing Pots: Feats of Clay from Africa* (London: British Museum Press, 1994).

Dassow, Sumi von (ed.), *Barrel, Pit and Saggar Firing, a Collection of Articles from Ceramics Monthly,* (American Ceramic Society, 2001).

Freestone, Ian and Gaimster, David, *Pottery in the Making* (London: British Museum Press, 1997).

Le Free, Betty, *Santa Clara Pottery Today,* (School of American Research, University of New Mexico Press, 1975).

Riegger, Hal *Primitive Pottery* (Van Nostrand Reinhold, 1972).

Rye, Owen S., *Pottery Technology: Principles and Reconstruction* (Taraxacun, Washington, 1981).

Perryman, Jane, *Traditional Pottery of India* (London: A&C Black, 2000).

Peterson, Susan, *The Living Tradition of Maria Martinez* (Kodansha International, 1977).

Trimble, Stephen, *Talking with the Clay or the Art of Pueblo Pottery* (School of American Research Press, 1987).

Vincentelli, Moira, *Women Potters Transforming Traditions* (London: A&C Black, 2003).

Vincentelli, Moira, *Women and Ceramics: Gendered Vessels* (Manchester University Press, 2000).

REFERENCES

ARTISTS REFERENCES

ALISON TINKER
Dolors Giral, *El Vendrell I Biennal de Ceramica 2002* exhibition catalogue.

ANN MARAIS
Ann Marais, 'African Connections', *Ceramics Art and Perception*, 55 (2004).

Ann Marais, 'African Dreams', *National Ceramics Quarterly*, Association of Potters of South Africa, 66 (2003).

ANNE JAMES
Tim Andrews, *Raku* (London: A&C Black, 2005).

ANTONIA SALMON
Sebastian Blackie, 'A Marriage with Clay', *Ceramic Review*, September/October 1997.

Sebastian Blackie, review of an exhibition at the Harley Gallery, *Ceramic Review*, 162.

Paul Vincent, review of an exhibition at the Harley Gallery, *Studio Potter* magazine, July/August 1997.

Moira Vincentelli, *Women Potters Transforming Traditions* (London: A&C Black, 2003).

DUNCAN ROSS
Duncan Ross, 'Clay: Tenacious Earth', *Ceramics Art and Perception*, 30, 1998.

ELLEN SCHOPF
Walter H. Lokau, 'The Aura of the Vessel', *Neue Keramik*, September/October 2001.

EVA MARIE KOTHE
Moira Vincentelli, *Women Potters Transforming Traditions* (London: A&C Black, 2003).

GABRIELE KOCH
Gabriele Koch, ceramic monograph published by Marston House in association with Alpha House Gallery, 2002.

Emma Clegg, 'Gabriele Koch', a review of an exhibition of her work at Hart Gallery, *Ceramic Review*, March/April 1998.

David Briers, 'Gabriele Koch', a review of an exhibition of her work at Yorkshire Museum, *Crafts* magazine, September/October 2003.

Maria Schuly, 'The Movement of Silence', *New Ceramics*, May/June 2005.

GIOVANNI CIMATTI
'The Passion and the Method', ceramics by Giovanni Cimatti, essay for catalogue, 1998.

Luca Cato, catalogue for an exhibition at the Civic Museum of Archaeology, Bergamo, 2004.

Maria Grazia Morganti, catalogue for the exhibition Sirens 'Enchanting Leap' at Palazzo Bellini, Ferrara, 2001.

Maria Grazia Morganti, catalogue for the exhibition 'As Soft as Leaves' at Galleria del Carbone, Ferrara, 2000.

Translations by Ana Fitzpatrick.

JANE PERRYMAN
Jane Perryman, *Traditional Pottery of India* (London: A&C Black, *2000*).

Jane Perryman, *Naked Clay: Ceramics without Glaze* (London: A&C Black, 2004).

JIMMY CLARK
American Craft magazine, August/September 1998.

Ceramics Monthly magazine, October 1997.

Studio Potter magazine, 28, June 2000.

Studio Potter magazine, 29, December 2000.

MAGDALENE ODUNDO
Magdalene Odundo, *Ceramic Vessels*, catalogue for exhibition by British Council in Nairobi, Kenya, 2005.

PAO FEI YANG
Beth Purcell, 'Quest for Healing – Inward and Outward Journey', exhibition review for *Newton TAB Massachusetts* (local newspaper), September 1999.

Beth Purcell, 'Images', review for *Newton TAB Massachusetts* (local newspaper), December 2003.

PIERRE BAYLE
Yvonne Brunhammer, catalogue for Prix Liliane Bettencourt pour l'intelligence de la main, 2002 (translated by Susanne Brown)

Nesrin During, 'Quest For Beauty', *Ceramics Monthly*, January 2001.

Elke Blodgett, 'Pierre Bayle', *Ceramic Review*, 121.

Lucien Curzi, 'Les pots du Pierre Bayle, pureté du desert, nuages de fumée', *Demeures et Cafeaux*, 34, March-April 1986.

Catherine Humblot, 'Les gestes du potier', *Le Monde*, 28 July 1986.

Michel Moglia, a conversation recorded at Ginestas, 1991, *La Revue de la Céramique* Translations by Margaret Whittaker.

RICHARD NOTKIN
Mark Del Vecchio, *Postmodern Ceramics*, Thames & Hudson, 2001.

Richard Notkin, *Small, Tight and/or Precious: Why the Hell Not?*, 1997

NCECA Journal (National Council on Education for the Ceramic Arts).

Richard Notkin, 'Smoke Firing', *Studio Potter* magazine, 29, December 2000.

SEBASTIAN BLACKIE
Sebastian Blackie, *Dear Mr Leach* (London: A&C Black, 2004).

Sebastian Blackie, 'A Paper Kiln', *Ceramic Review*, 115.

Sebastian Blackie, 'More Paper Kilns', *Ceramic Review*, 130.

Sebastian Blackie, 'Saggars, Sawdust and Semiotics', *Ceramic Review*, 156.

Jane Perryman, *Naked Clay Ceramics without Glaze* (London: A&C Black, 2004).

SIDDIG EL'NIGOUMI
Sebastian Blackie, *Dear Mr Leach* (London: A&C Black, 2004).

The Ceramic Artist Archive, www.ruffordcraftcentre.org.uk

Moira Vincentelli, *Ceramic Series: Siddig El'Nigoumi*, no. 11, Aberystwyth Arts Centre.

SUSAN HALLS
Peter Dormer, 'Emotion Transfigured', *Crafts*, Jan/Feb 1994.

Susan Halls, 'Animal Crackers', *Ceramic Review*, 146.

Nick Lees, 'Animal Behaviour', *Ceramic Review*, 177.

INDEX